CHASING DRAGONS

An Uncommon Memoir
in Photographs

Bill Hayward

Foreword
by Sam Barzilay

Glitterati
INCORPORATED

New York | London

For Janet, Jessie, and Chuck

First published in 2015 by

New York | London

New York Office:
630 Ninth Avenue, Suite 603
New York, NY 10036
Telephone: 212 362 9119

London Office:
1 Rona Road
London NW3 2HY
Tel/Fax +44 (0) 207 267 8339

www.GlitteratiIncorporated.com | media@GlitteratiIncorporated.com for inquiries

First edition, 2015

Library of Congress Cataloging-in-Publication data is available from the publisher.

Hardcover edition ISBN 13: 978-0-9891704-9-9

Design: Sarah Morgan Karp | smk-design.com

Printed and bound in China by C P Printing, Limited

10 9 8 7 6 5 4 3 2 1

CONTENTS

Foreword 4
Sam Barzilay

The Master of Ceremonies 6
Gordon Lish

Prologue 7
Bill Hayward

Introduction 8

Mise-en-Scène 12
Postscript 27
The Making of Meaning 29
The Tangle Dragon 31

Act 1: Traditional Portraits 34

Act 2: Disruption and Risk 48
Rackety Opinion 50
Acts and Expressions 58
Gesture and Invention 72
Shouts and Songs 84
A Hundred Words 92
Certain Dances 106
Dismantled Myth 116
Broken Odalisque 132
Consider the Flesh 140

Act 3: Portraits of the Collaborative-Self 150
the human bible 150
The Portrait Process 160
The Thing Itself 168
17 Bedrooms 180

Act 4: Going Live 188
Dance and Performance 188
The Intimacies Project 190
Bent 192

Act Five: Film 194
Asphalt, Muscle and Bone 194

Index of Artworks 212

One-of-a-Kind Books 218

Annotated Appendix 220

Index 232

Credits 236

Acknowledgments 238

FOREWORD

At the very heart of the photographic practice lies a fissure, caused by the inherent contradiction between its physical and ethereal states. Reveling in capturing each decisive moment frozen in time, photography strives to rise beyond its earthly bounds, a non-object constructed of pure, frozen light. Its material existence, its impressionable and malleable surface, little more than an inconvenience and an afterthought. But not for Bill Hayward.

To study Hayward's photographic journey is to revel in his joy of acknowledging the photograph's existence as moment, emotion, and physical object. He wastes no time in disrupting what others hold sacrosanct. "The photographic surface as unquestionable truth:" a false idol to be scratched, cut, painted, folded, manipulated; dismantled, and reconstituted.

This is not a path chosen lightly. This is a journey; a quest for survival. Conceptually driven, he pushes against the grain, deploying the visual artist's full range, combining and overlaying a variety of media to question acceptable practice, distort photography's implied spatial relationships, and see what's possible. The alternative—to blindly accept the status quo— is to suffocate.

In thinking about Hayward's work, I often come back to the words of Marco Breuer, a contemporary German photographer whose most famous photographic creations do not involve the use of camera equipment and yet are deeply photographic in nature: "I am interested in the intersection of photography and drawing: the negotiation of the illusionistic space of photography versus the concrete space of the physical mark."

Though occupying radically different spaces within the photographic realm, one cannot fail to sense the kinship of thought in their drive to transcend the traditional confines of accepted photographic practice, and blur the boundaries between visual image and sculptural construct. And that bounding line all but disappeared in "the human bible," a series of collaborative portraits that allowed its subjects to incorporate and interact with physical manifestations of their innermost emotional and mental states.

One particular photograph always stands out to me: a young woman, on the side of a mountain, surrounded by brambles. She is standing tall, defiant in the afternoon light, engulfed in glorious flames, made of paper and paint. Paradoxical information in three dimensions.

Here we are then—Mount Horeb. The burning bush re-imagined. A burning heart of purity, love and clarity —illuminating, but never consumed. She, a self-anointed messenger of God gazing upon us from within the flames. And us? A modern-day Moses, standing speechless in reverence and fear before the divine presence.

Subversion! God is a woman, a woman is God: I am that I am. Existing by herself, for herself. Womankind's immeasurable force, a recurring theme in Hayward's oeuvre, subtly surfacing once more.

And the archetypal photographer, safe behind his lens, calmly in control? No longer. By choosing the path of open collaboration in the creation of his images, Bill Hayward welcomes the transformation of his subjects into active participants and artistic partners. Mixing reality and visual allegory we are presented with a new kind of photographic image: the record of an artistic interplay, supplanting the one-sided transaction of a photograph taken. A tribute has been offered and an image is freely given in return.

—Sam Barzilay

6 THE MASTER OF CEREMONIES

"But I said: Enter, Bill Hayward.

Now go ahead, start turning pages—and
see for yourself what an artist can do when
it comes to doing the impossible."

—Gordon Lish

PROLOGUE

"To speak of knowledge is futile. All is experiment and adventure. We are for ever mixing ourselves with unknown quantities."

— Virginia Woolf, *The Waves*

When I think about going home, I am out on the road, stashed with my sister, Janet, in the back of the family's black (was there any other color?) 1940 Chevy. My formative years were of a life on the road. Before I entered grade school, I had lived in or traveled to more than 17 states. Besides the endless games of 20 Questions, the constants in our car were the haunting, mysterious float of the directional headings in the egg-shaped travel compass suction-cupped to the windshield and two Duncan Hines travel guides (one for lodging and one for restaurants). Both of these travel directories, neatly wrapped in a faded, blue Western bandana and stowed in the sacrosanct glove compartment, were heavy with marginalia appended by my mother. The prepared text of the guides was full of marketed glamorous promise; my mother's appended text recorded the reality of the experience and our encounters with the tastes, textures, sights, and extravaganza of personalities along the road.

This was an exciting practice of thousands of miles of roam and encounter around the country. From my dedicated seat in the right-rear of the Chevy, I could scan the panorama of window frames. I could "see" whenever and wherever—to engage with the vast and vigorous ways of light and shadow, color at dawn, midday, evening, at night, soft, hard, and with the sky and stars. The scrappy shapes and colors of the earth. Antelope, bears, eagles, ants, and snakes. At food, fuel, and hotel stops, I participated in the dimensions of an endless cast of players that came in and out of frame along the way. And when you program in the comedies and dramas of the car radio in the '40s and Janet's promise of the possibility of dragon smoke over the hill, this was the magical mystery and imagination tour. Unmediated seeing, hearing, and first-hand experiencing...such freedom to play. Adventure and the promise and possibility of the unknown.

—Bill Hayward

INTRODUCTION

Scene 1: The Camera Story

It was the summer of '56—the continuing convergence of imagination, alchemy, and magic, camera unto camera.

Late morning: my father's office on the 21st floor of the Chrysler Building. I had just traded the imaginative play of my prized Lionel electric trains for my first full-on 35mm camera. Treasure for treasure between myself and a business associate of my father's. My best friend, Phil Wade, had encouraged me to join the school camera club.

Scene 2: Faces...Fellini, *La Strada*

Later that same afternoon: Janet took me farther up Lexington Avenue to the Trans-Lux 52nd Street Theater to see Fellini's *La Strada*. More dragon smoke (and more than a little cigarette smoke also). A foreign film and foreign revelation, personal revelation big time. This screening proved a visual, musical, and spiritual haunting that has stayed with me as indelibly as my witnessing the trek of those fire ants "driving" about with their beads in the summer of '48.

In the stunning, gritty convergence of the coarse textures of Fellini's scratchy, leathery settings and unrelenting faces (and Nino Rota's rending music), I came to a first sense of the incredible depth of expressive possibility available in working with and shaping visuals. I found myself pulled forward into a new, exciting language. Here was "story" wherein words were secondary. It was atmosphere, the delicious incandescence of visuals that carried the day (and afternoon and night). The extraordinary beauty of Fellini's black and white imagery, a world beyond explanation. An emotional expression in visuals with no need of words, only improved seeing and feeling. Sensory understanding, art and heart, compassion. The incredible, stark atmosphere of beauty and drama of the final image in the film. A deserted beach at night. The collapsed, fallen figure of Zampanò clawing, pawing into the sand, and in the background the disinterested roll of sea and wave, the same relentless waves that I would encounter some years later in Virginia Woolf's *The Waves*. Things ancient and primal.

Following the magical assertions of the fire ants of '48, the watching of this film of '56 was my second encounter with wonder, but also my first encounter with the spirit, personality, touch, and taste of hand-made wonder. The fire ants were of Nature; *La Strada* was communion with the intangibles, the mystery of the human heart, art, and hungers. Desire and faces, the unrelenting enchantment of faces. And compassion.

An archive of faces was so much a part of my early years on the road. And then here was the master of the face and body, Fellini.

Trans-Lux indeed. I was off with my new camera...

Short Lecture on Shakespeare

"They say there are no known facts about Shakespeare, because if it were his pen name, as many believe, then whom that bed was willed to is a moot point. Yet there is one hard cold clear fact about him, a fact that freezes the mind that dares to contemplate it: in the beginning William Shakespeare was a baby, and knew absolutely nothing. He couldn't even speak."

—Mary Ruefle, *Madness, Rack, and Honey*

An Overture of Sorts

Throughout this read, I call out the shout and song of artists who have had, and who continue to have, a significant influence on the gaze of my heart and eye. It was in the testimony and witness of their conjuring with the genie of creativity that I found the permission to "risk" and "disrupt" and "play" and be in "process." The combined chorus of their voices form an important part of this production, my story, and these images. Of call and response. My compositions are foremost a transcription of my response to their call.

Indeed, I don't go anywhere without the chroma, measure, and meter of the cry of their chorale in my head and heart.

Tune time...

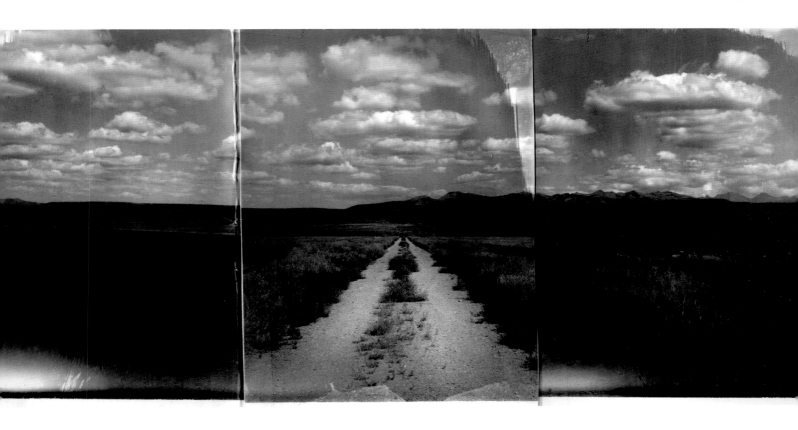

"I have lived a thousand lives already. Every day
I unbury — I dig up. I find relics of myself in the
sand that women made thousands of years ago..."

—Virginia Woolf, *The Waves*

MISE-EN-SCÈNE

"I dwell in Possibility—...To gather Paradise—"

—Emily Dickinson, *1382*

It was the summer of '48, and Janet had promised
the possibility of dragons.

Janet said that where there are dragons,
there is magic and great beauty.

I knew nothing.

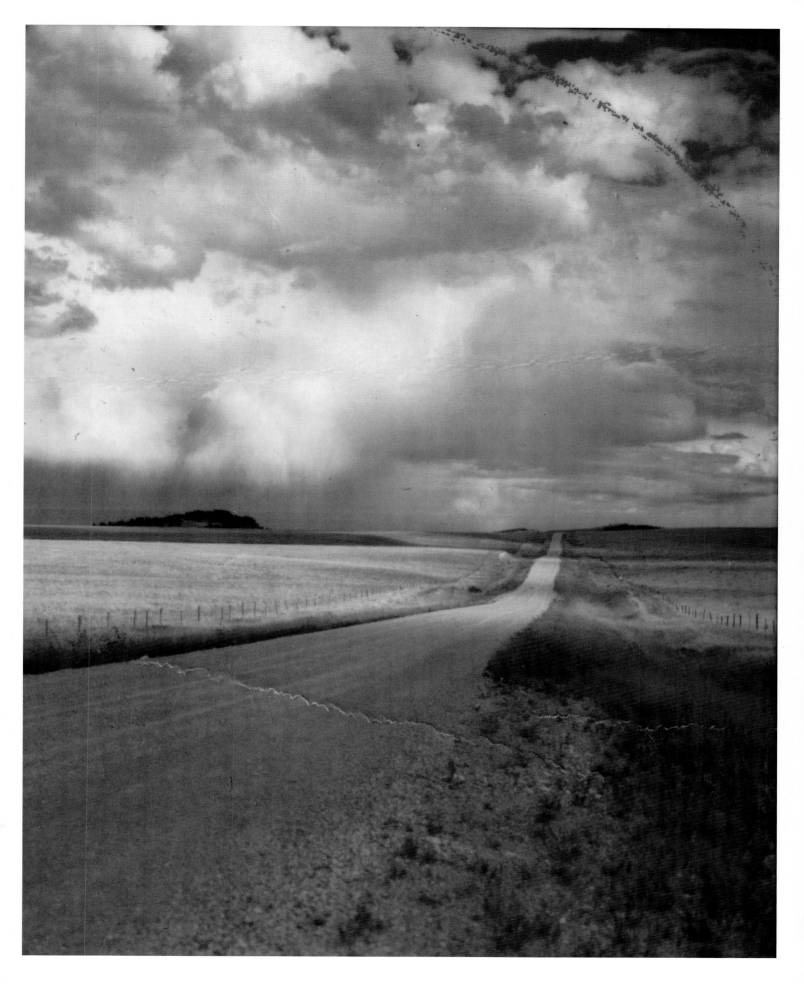

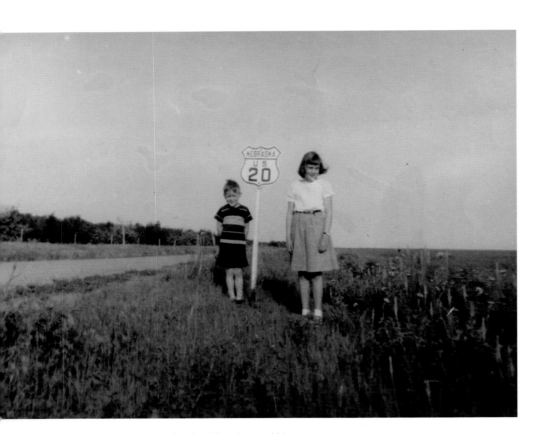

Travels from Illinois into Iowa, Nebraska, Wyoming, and Montana

Hell's Half Acre, Wyoming

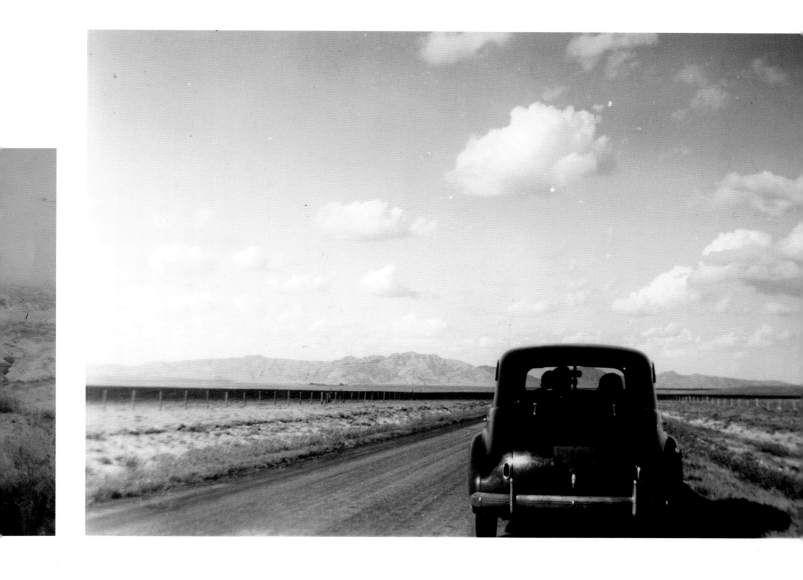

In a tumult of roads rutted and gutted,
the metallic clatter of numerous cattle guards,
a magnificent rooster tail of dust
we came to the edge of a remote, nameless, windy mesa.

Janet said that we were about to enter an enchanted labyrinth of goose eggs, poison spiders, ants of fire, and dragons.

Janet said seeing dragons depends;
we had to move in slow, serious silence, taking care not to frighten them.

Janet said we had to wait.

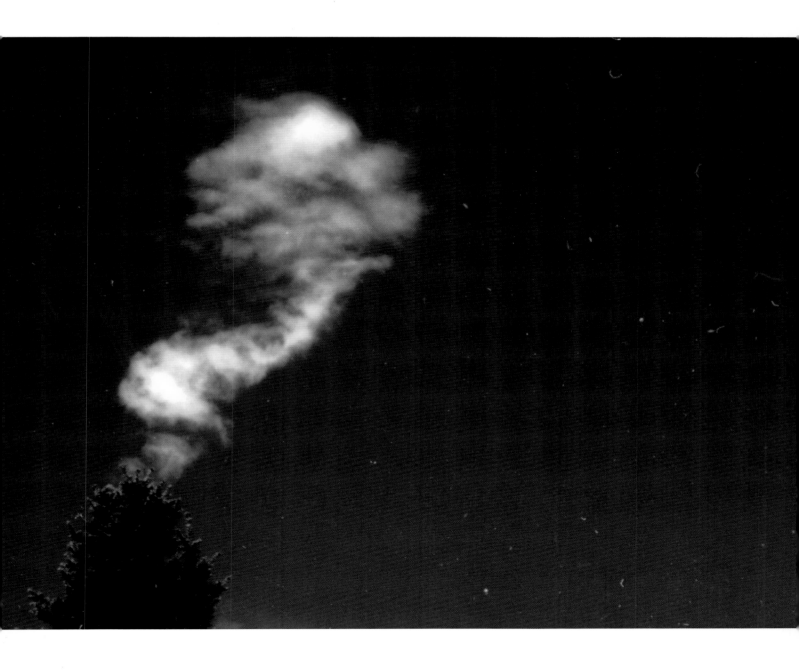

Janet said we had to wait and watch for Dragon
smoke—an explosion of art and beauty.

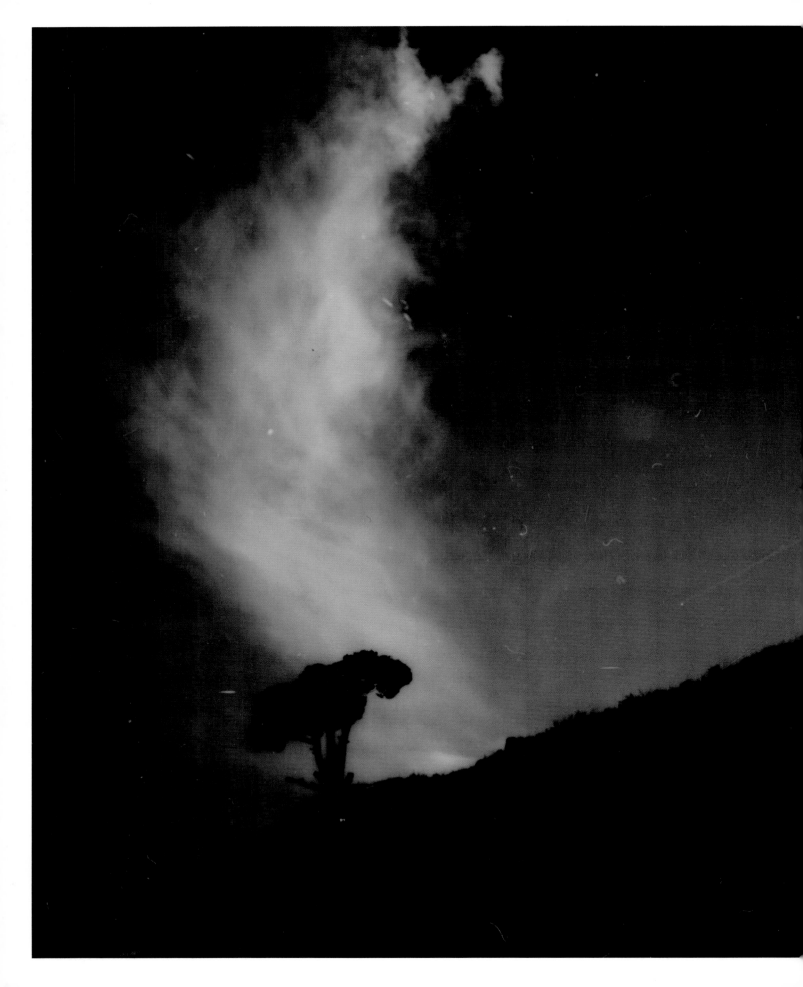

Janet said seeing dragons depends; just because
you have eyes doesn't mean you can see.

Janet said you can always tell there are dragons by
the smear of dragon smoke against the sky.

For my curious, six-year-old self, it was the edge of
the known world. If asked, I was only a stranger
looking for dragons.

19

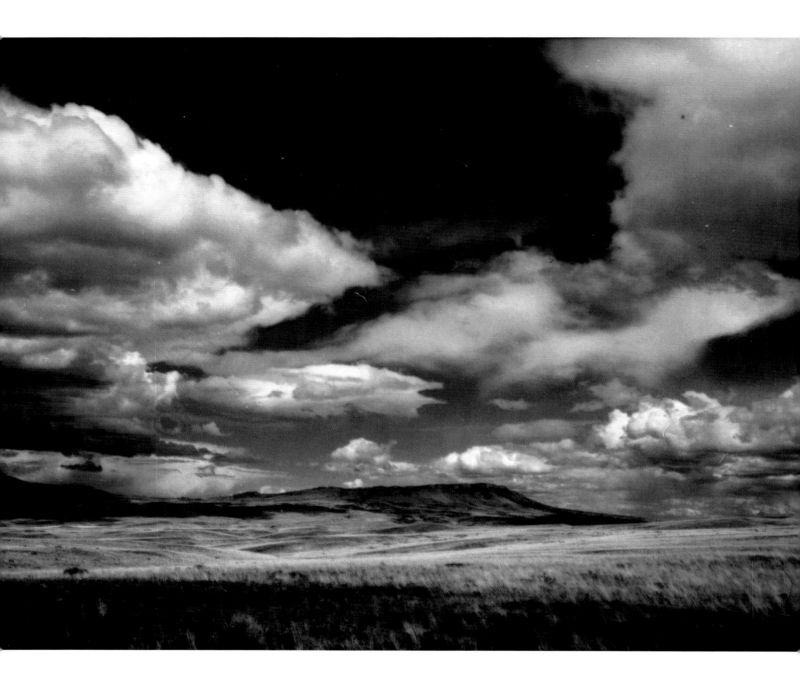

I am wandering a scrubby prairie of vacant
western mesa; clouds alone and absolute,
loosening in the epic sky, an intransigent
horizon of distant mountains,
low grasses and cacti
and vast colonies of fire ants

their nestings
gray splatters of worked earth spread
over the crisp yellow grasses.

It was the summer of '48...

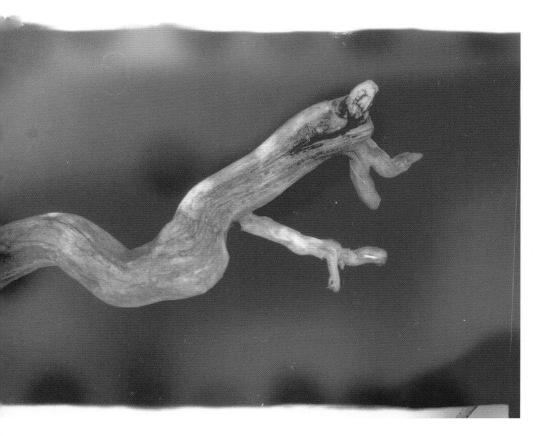

I knew nothing.

In the play and gaze of a found "drag'n stick."
I scratched at the gray, ant-fired earth and in the
random tug of wood, tiny specks of white and blue
rolled in the tilled soil. White beads, blue beads, and
an occasional red.

The fire ants were rolling time-past up into the light in
an invention of time-present.

The fire ants were "unburying" beads to adorn the
fabric of their grand palaces of art, sand, and fire.

The fire ants were re-animating anonymous relics of
lives already lived, ceremony of the persistent creative
process, mud and blood, life and death, death and life.

Janet said that the beads were memory searching out new spirit, new birth,
that the old land and the beads were sacred, guarded by fire ants and the dragons.

Janet said that the ants are famous artists and architects.

Prepared for nothing.

Watching.

The fire ants; obsessive, certain. incessant; their
immortal process of mining and building in mud
and blood.

Waves of the ride and roll of sand and earth in
which nothing is ever really erased,
just re-imagined, evolved in process and possibility.

Chasing the wait.
...The mutable telltale of dragon smoke,
invisible places, "reportless places."

I know nothing.
It's a gathering of senses. Beauty.

An elegy, an extravaganza,
light attached to things...
moving, passing, marrying.

We had seen beads.

Janet said that dragons had definitely been there.
They had accidentally burned some trees
'cause they're dragons...

Postscript

"In many and reportless places
We feel a Joy—
Reportless, also, but sincere as Nature
Or Deity—

It comes, without a consternation—
Dissolves—the same—
But leaves a sumptuous Destitution—
Without a Name—

Profane it by a search—we cannot
It has no home—
Nor we who having once inhaled it—
Thereafter roam."

—Emily Dickinson, *1382*

"In Cuba when you die / the earth that covers us / speaks..."

—Ana Mendieta, *artist*

"The moment was all; the moment was enough."

—Virginia Woolf, *The Waves*

The Making of Meaning

At six, I did not have (or need) discreet language. I possessed insatiable sense and sight. Pure seeing. This was the experience of meaning and moment, sensation that went directly to feeling before it became tethered by brain and thought. This was disembodied and dematerialized pure spirit in process...and it was so obvious that it was all the work and preparation of the dragons.

Art, always process. Art of the bead maker, art of the bead wearer, art of the ants, art in the seeing. And it was so obvious that it was all the work and preparation of the dragons.

Smoke of dragons, transport of ants. I inhaled the essence and enchantment of play, permission, and possibility—the heart of the creative process. Art.

I came to understand that the truly meaningful will be experienced outside the known world of fact and frame, in Emily's "reportless places."

A world that is everywhere and nowhere.

A world that is unsummonable, "without a name."

The essence of art is that nothing is etched in stone.

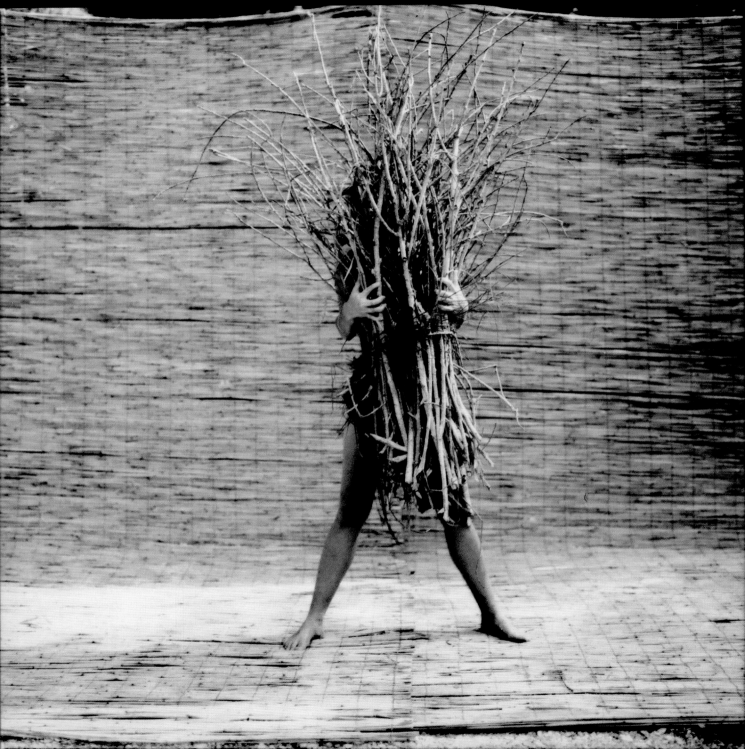

The Tangle Dragon

Roam and scratch.

It is little known that "drag'n sticks" are bequeathed by the Tangle Dragon who resides in nests of sticks deep in the earth.

The Tangle Dragons in whom the nourishment of the creative process is entrusted; their forbearance over life and death.

Tangle Dragons will favor those who have the audacity to wait in the strange at the edge of the known. In Dragon smoke.

Those who come with no inventory but a gathering of their senses. It is they who will be granted a "drag'n stick" with which to scratch in search of possibility and "reportless places."

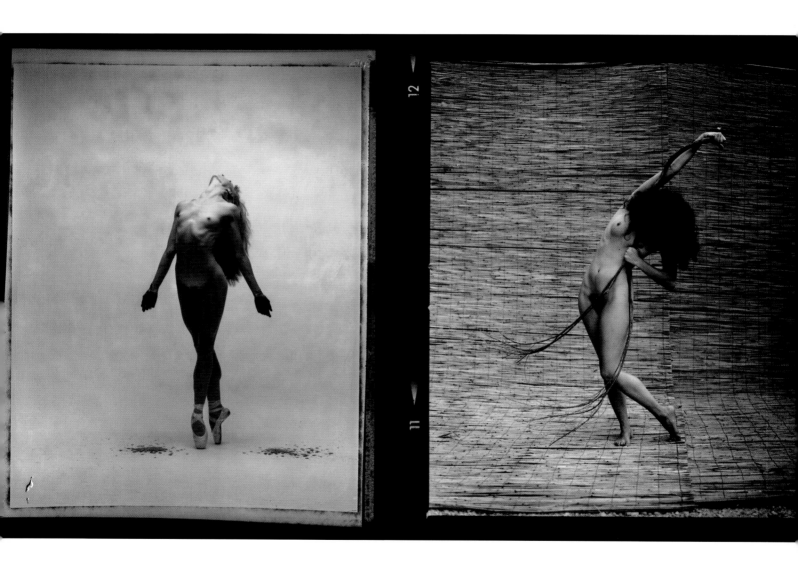

The blood of the Mother.

The making of a history.

That which binds us to the universe.
The union of nature and history, the creative
process of life and death, death and life.

Not to depict, but to materialize.

Living synonymous with giving birth...

ACT 1

Traditional Portraits

Doing it the usual way, but...

"And he whose soul is flat—the sky
Will cave in on him by and by."

—Edna St. Vincent Millay, *Renascence*

Yeah, good stuff had been happening for some years, but at some point I realized that Dragon smoke was strangely missing from the horizon, and the shape and fold of the sky had somehow changed. Was that a grind and torque in the tectonics of the heavens that I was hearing?

"I don't want any of this artificial superficial feeling stimulated by the choir."

—Flannery O'Connor, *A Prayer Journal*

"The world is not on the surface, it's hidden in its roots submerged in the depths of the sea."

—Clarice Lispector, *A Breath of Life*

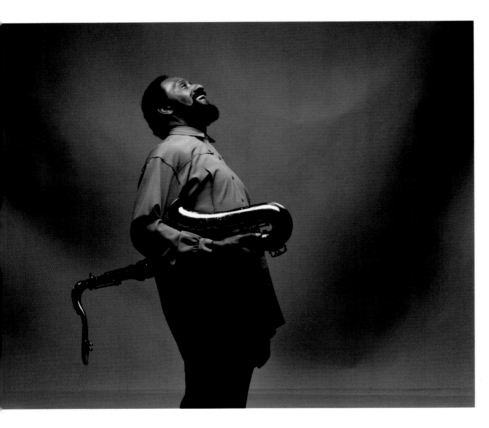

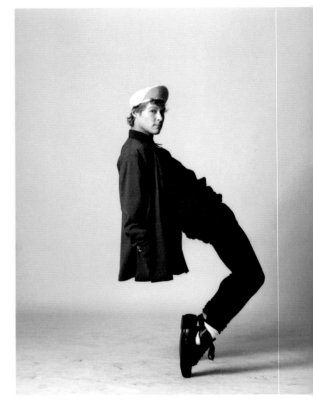

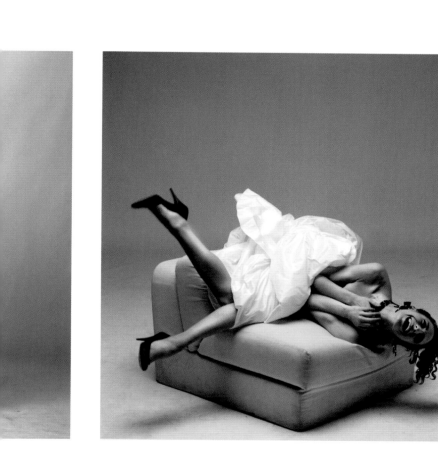

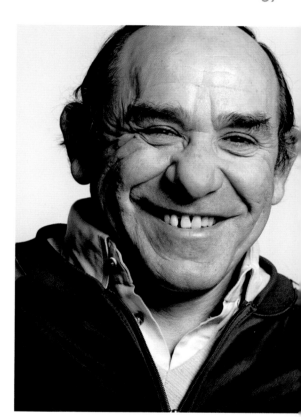

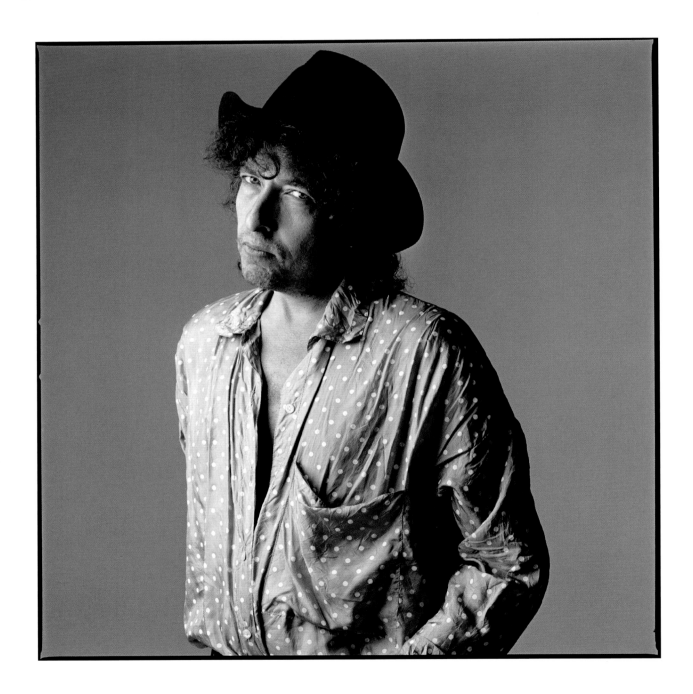

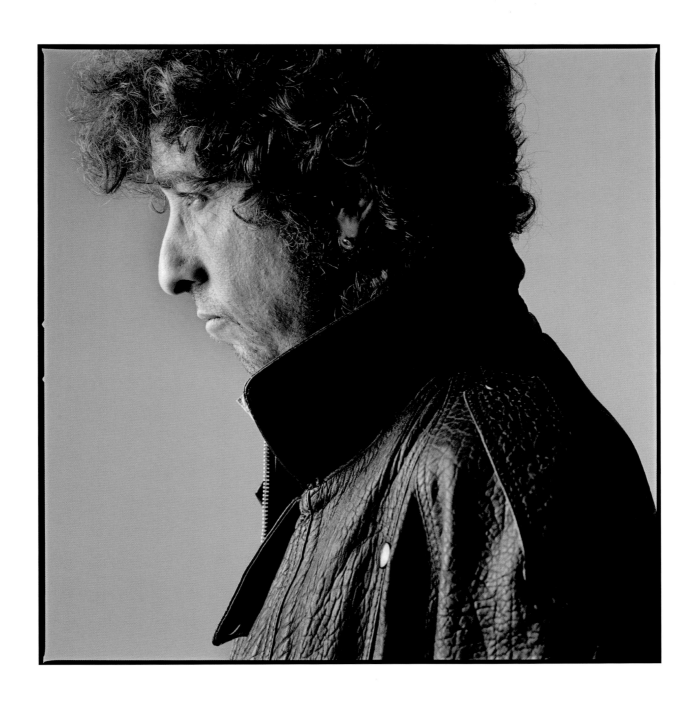

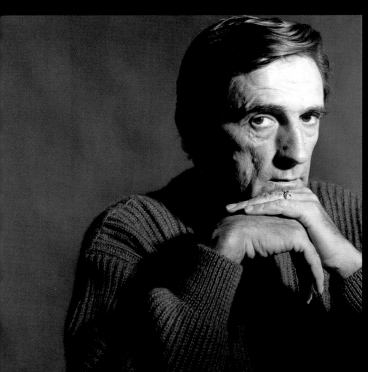
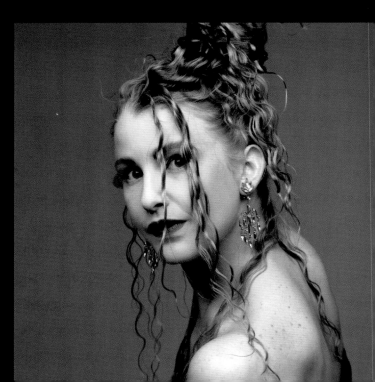

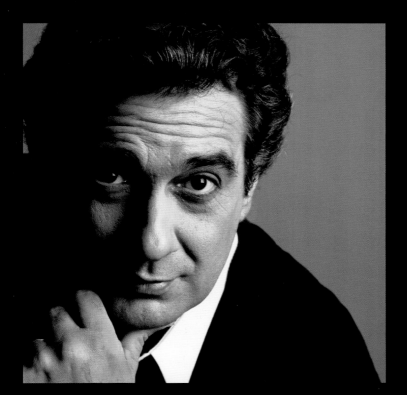
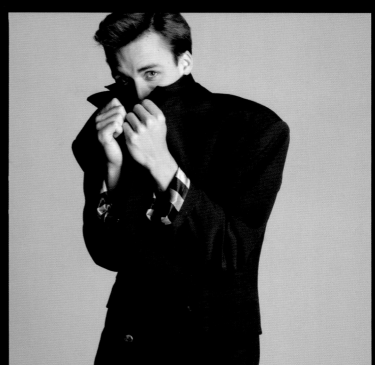

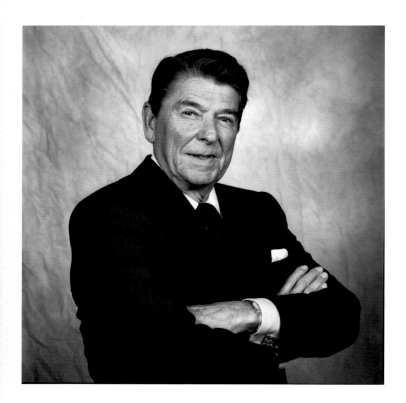

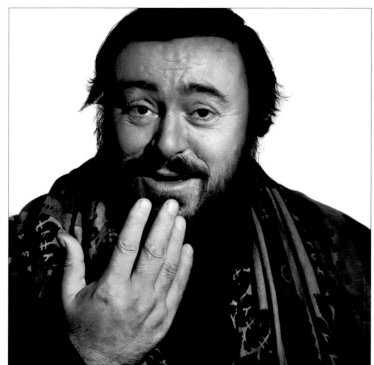

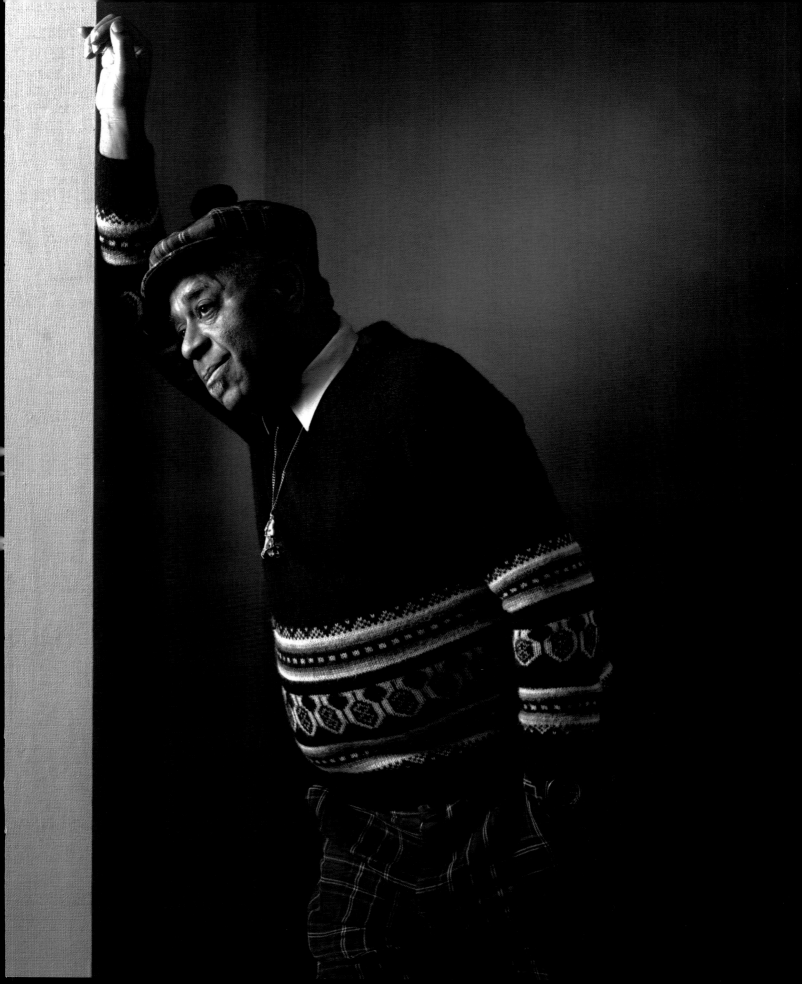

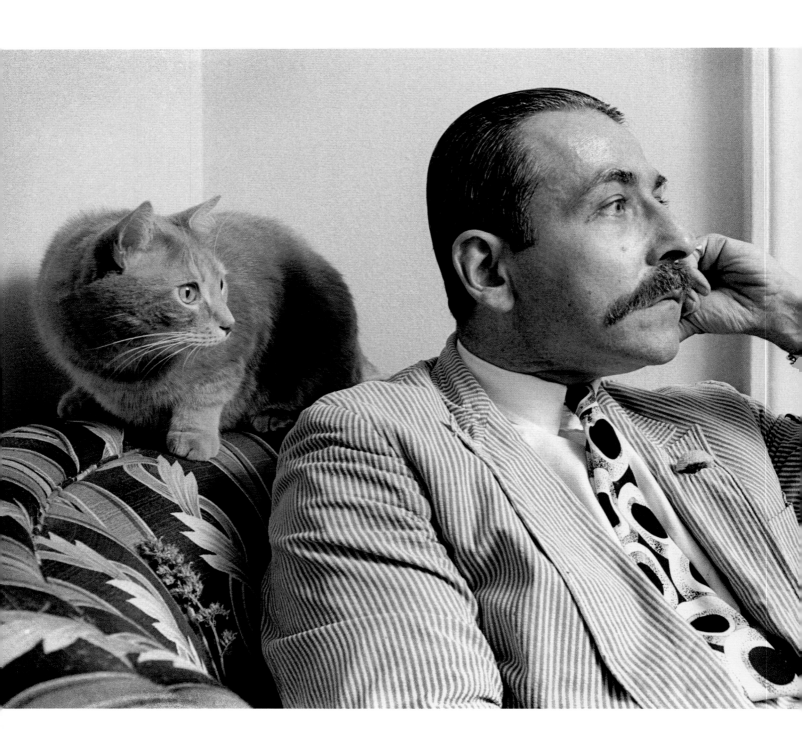

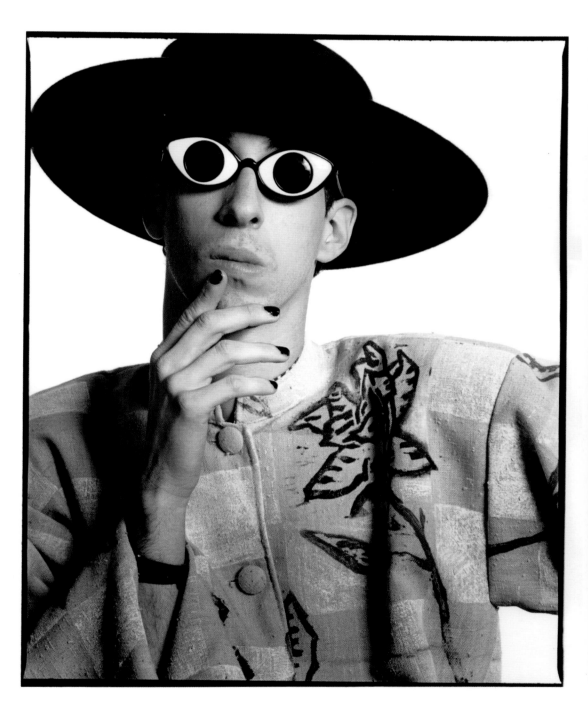

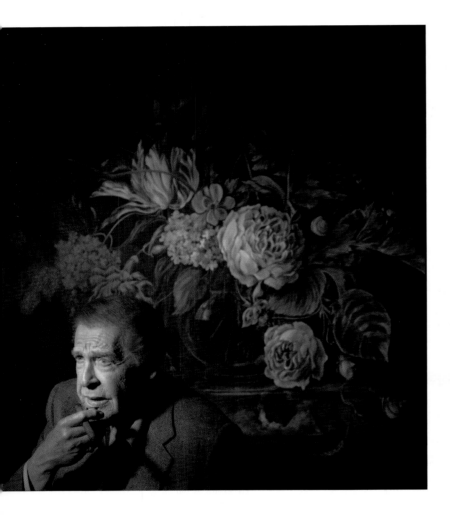
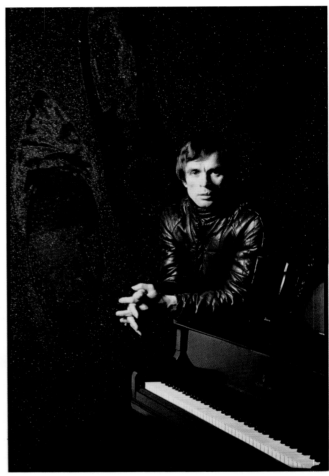

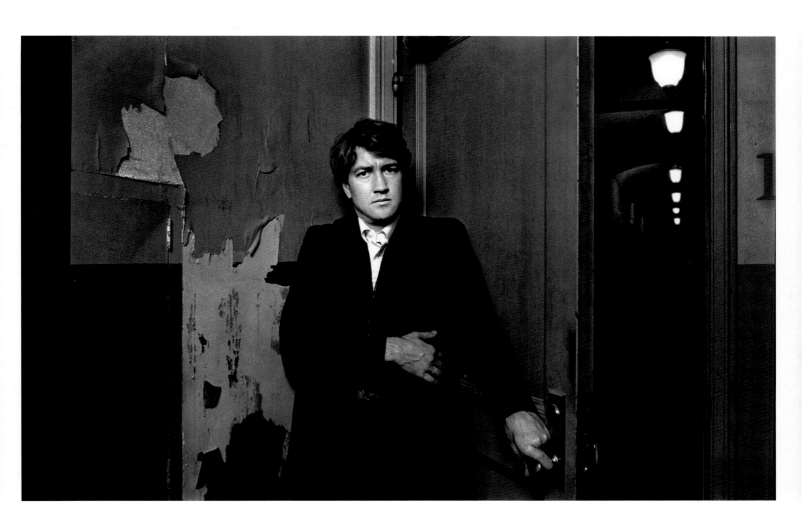

ACT 2

Disruption and Risk

Messing Around

Pieces of sky are falling, and the surface hereabouts is getting so damn slippery. Traditional portraiture is somewhat exciting and interesting, but in the final analysis, not lastingly fulfilling. As Clarice pointed out, "the world is not on the surface."

Have to get back to disruption and "digging" for possibility and Dragon smoke.

Experimentation and Disruption

Finding fire...keeping the dream fire going...

Robert Frost speaks of taking the road less traveled by, and that making all the difference. I would submit that it is even better to make your own damn road. Damn! Bushwhack it. Take someone else's road, no matter how lightly traveled, and you are instantly putting yourself at a big disadvantage.

To get anywhere close to the fiery heart of the creative act in any meaningful and fulfilling way, one can't spend a life in the framing of an endless series of cultural reproductions; repeating accepted poses and clichés. Get too comfortable in cozying up to the pillow of blindly accepted ways of behaving and you will soon find yourself suffocated by that same pillow.

The creative process lies in trusting in play, risk, vulnerability, body and blood, real emotions and real desires. The deluge of cozy tropes, advanced poses, and glossy surfaces of traditional myth and Hollywood don't make it. It is in fact a toxic rain. We are all going to die one day, and this downpour of visual imagery to which we are subjected is not, in the end, going to help us in that journey. Rather, it is a freezing sleet that is icing possibility and heart. A dragon and imagination killer if ever there was one.

Under the Influence

Tired of repeating myself and what I knew, I discovered the need to displace all of it. I threw in with the likes of Francis Bacon, Pina Bausch, Virginia Woolf, Clarice Lispector, Balanchine, Emily Dickinson, Flannery O'Connor, Hélène Cixous, and a lot of other risky desperadoes, and invested in dismantling traditional ways of approaching the empty canvas with face and body, heart and emotion. I commenced "bushwhacking" in the darkroom (this is way before digital) and experimenting with print, paint, paper and scissors and following real "brush strokes" of accident—disrupting what I knew of visual technique and tradition.

To quote Francis Bacon, "accident always has to enter into this activity, because the moment you know what to do, you're just making another form of illustration." Hollow hideouts.

Out of this period of sustained "messing around," a number of bodies of work evolved, some of portraiture and the others of the body.

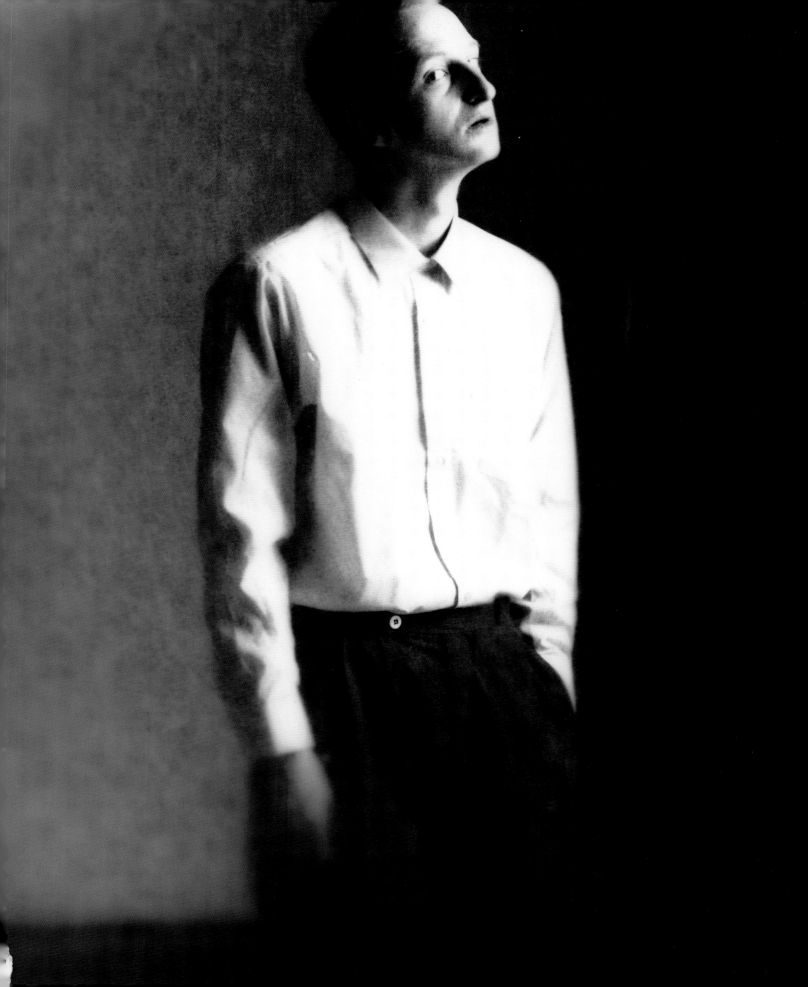

RACKETY OPINION

I'm not gonna say yes, I'm not gonna say no.

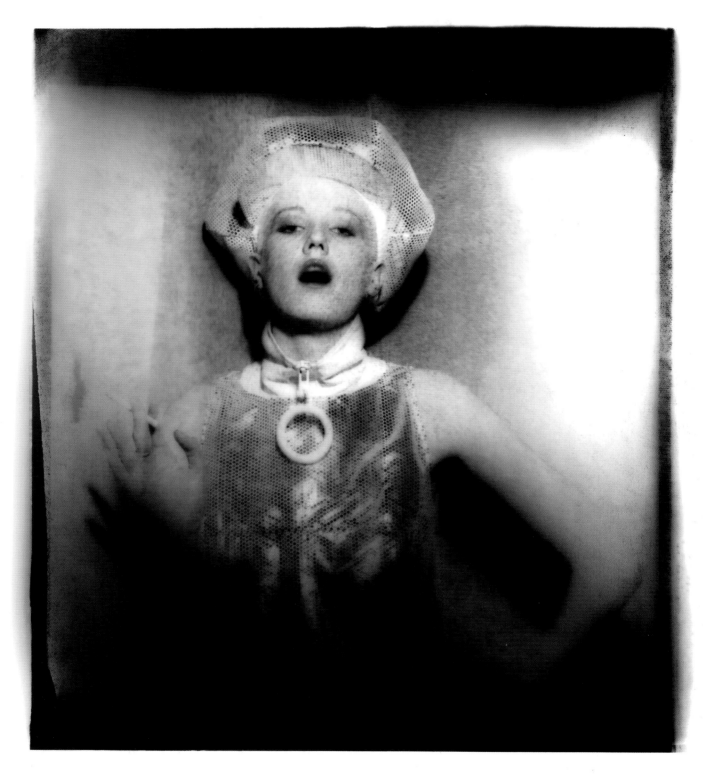

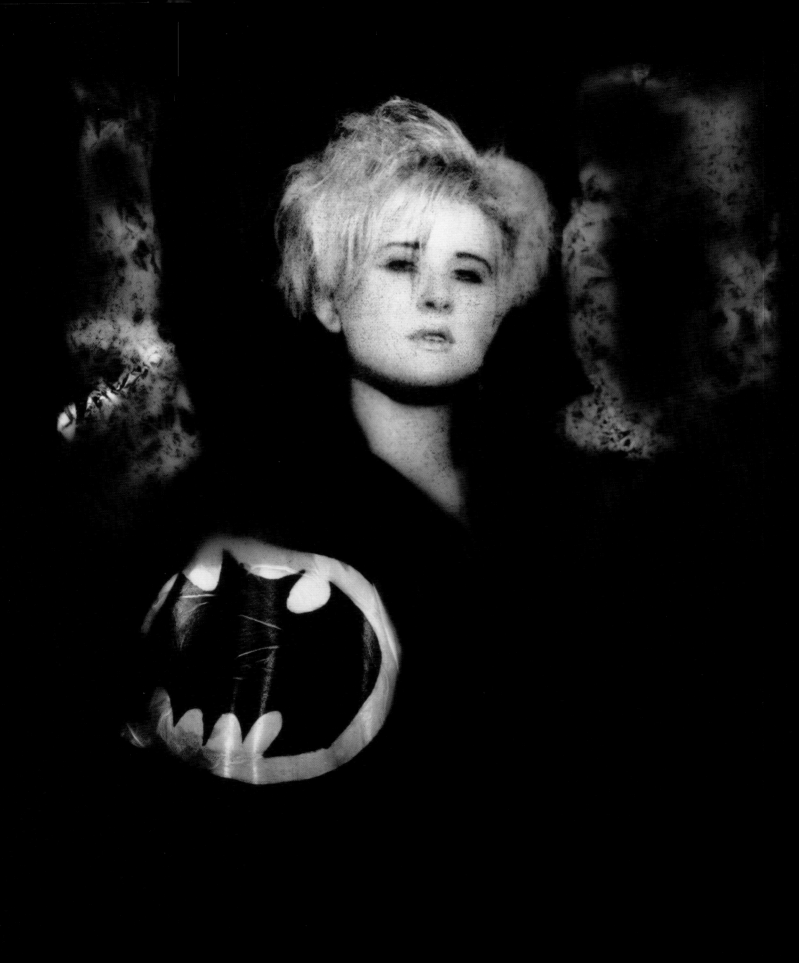

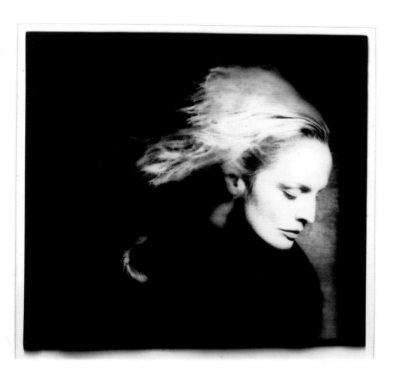

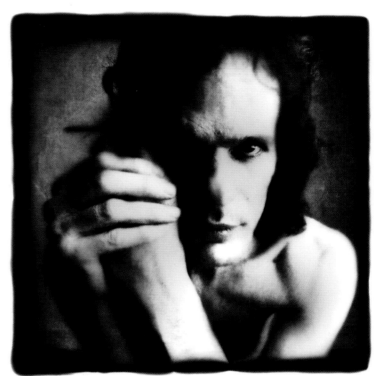

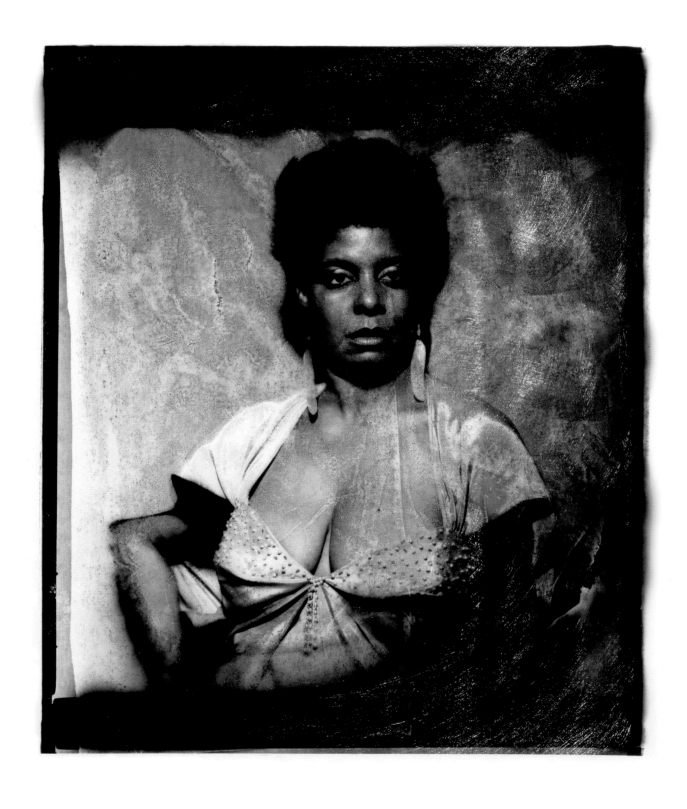

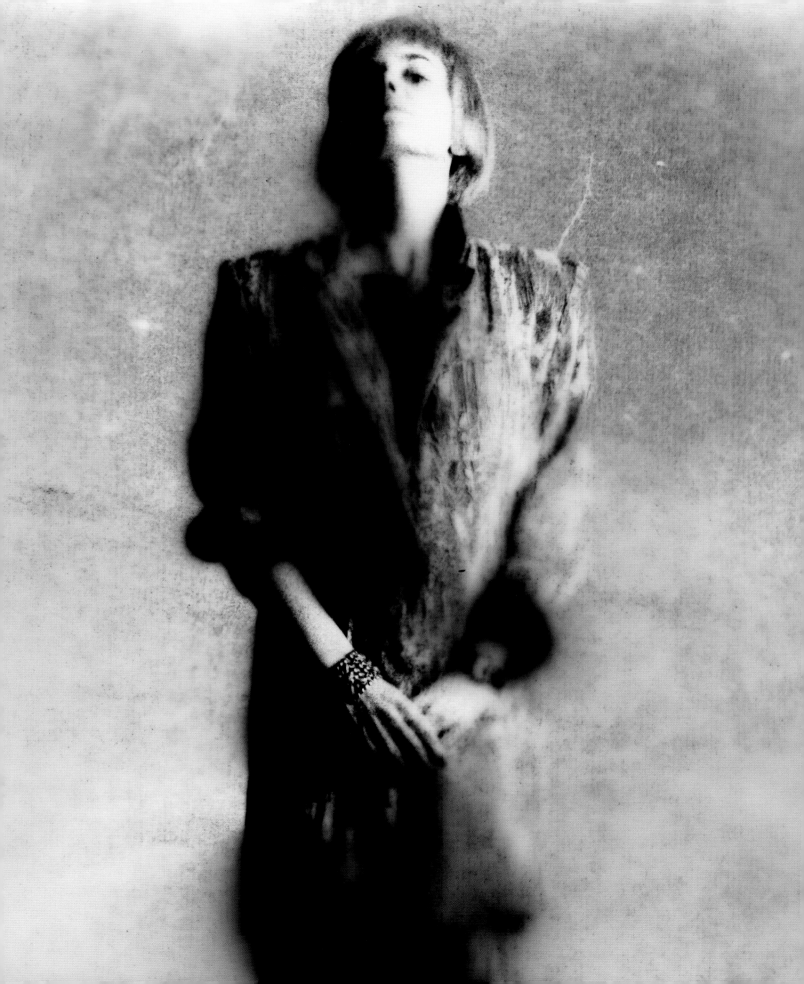

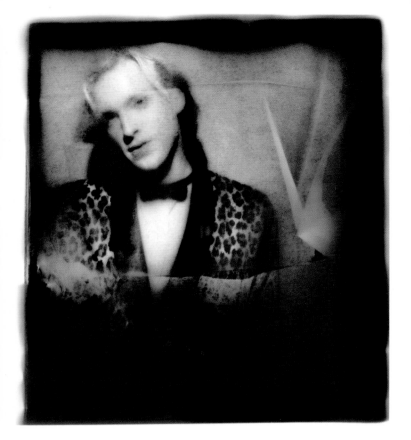
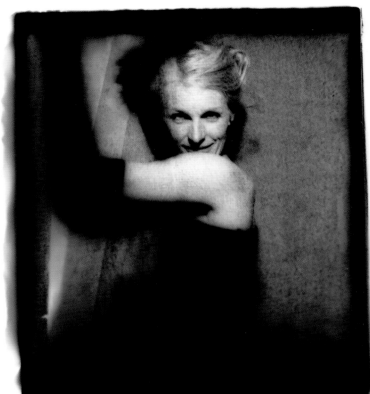
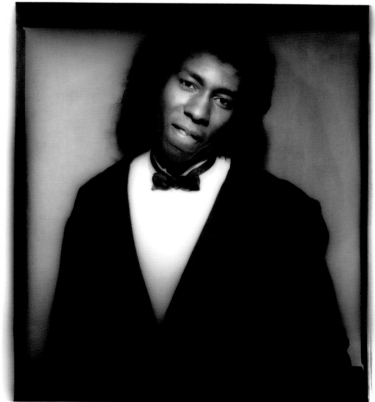
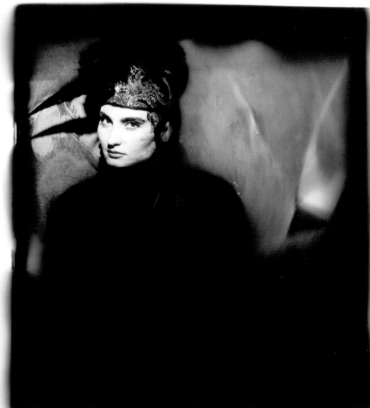

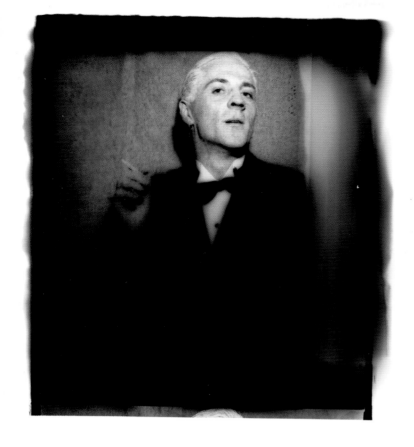
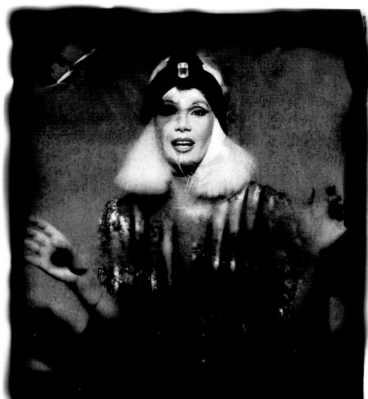
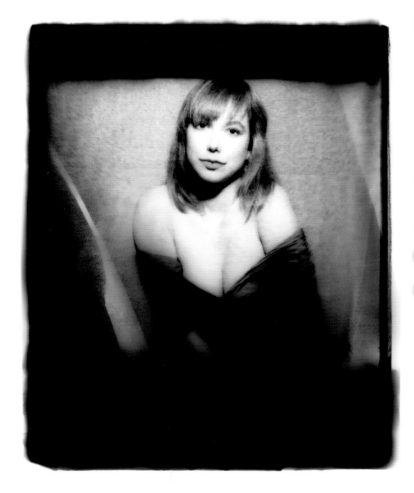
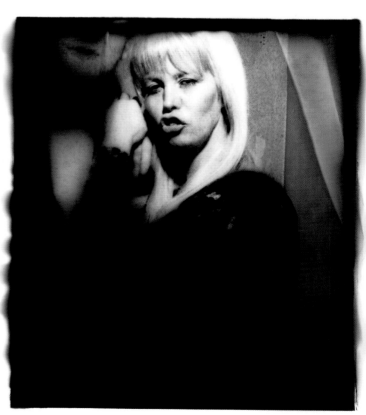

58 ACTS AND EXPRESSIONS

The calling of names.

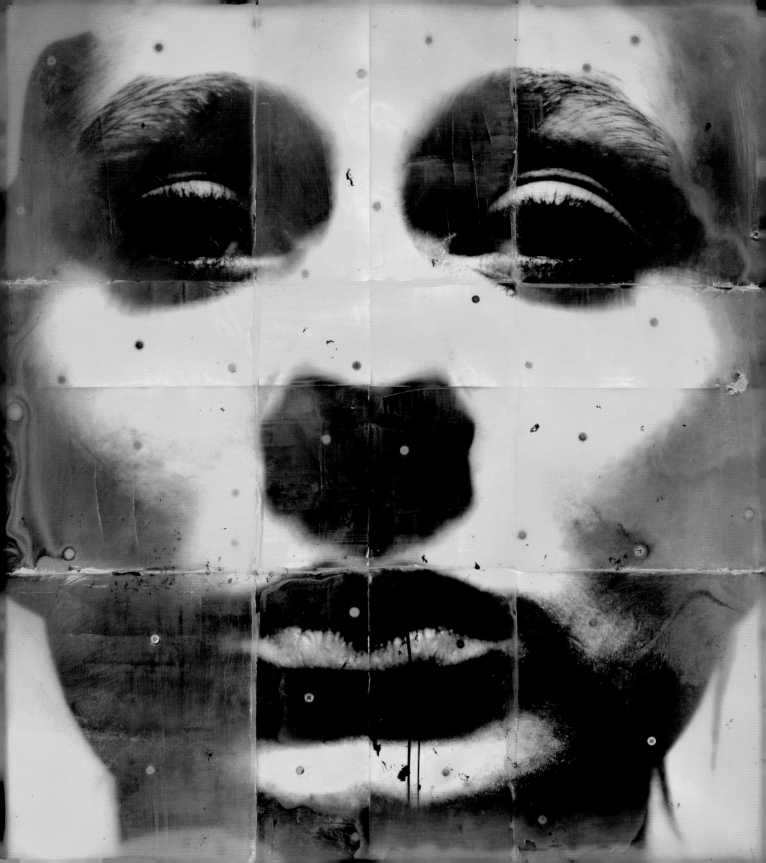

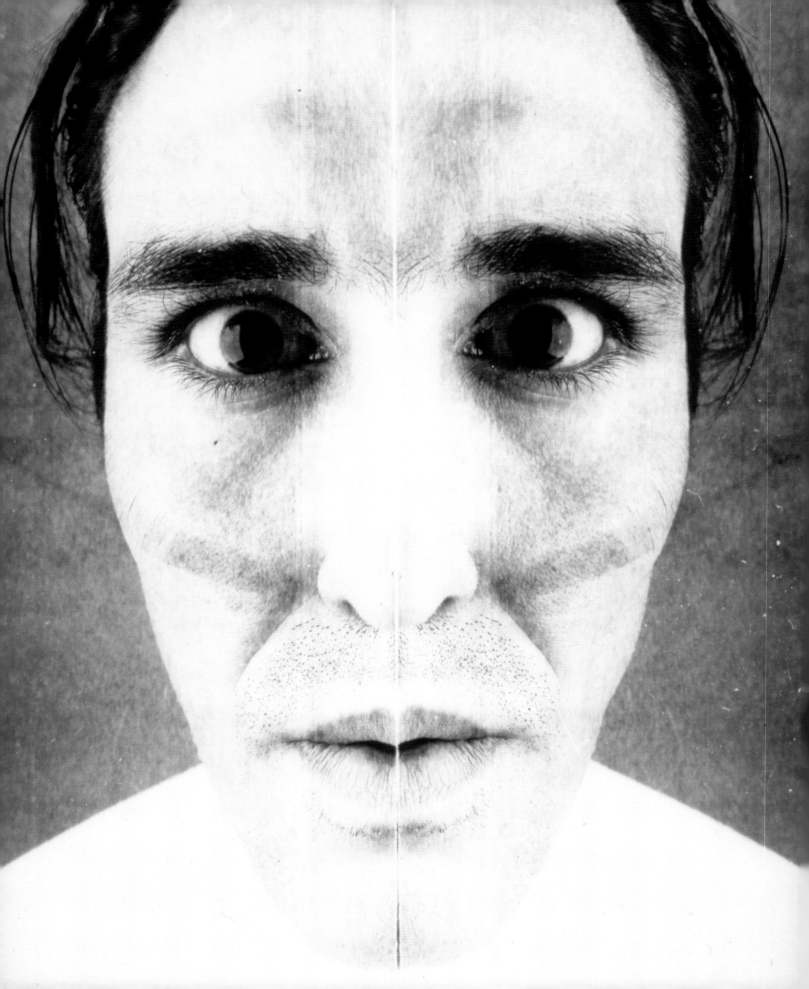

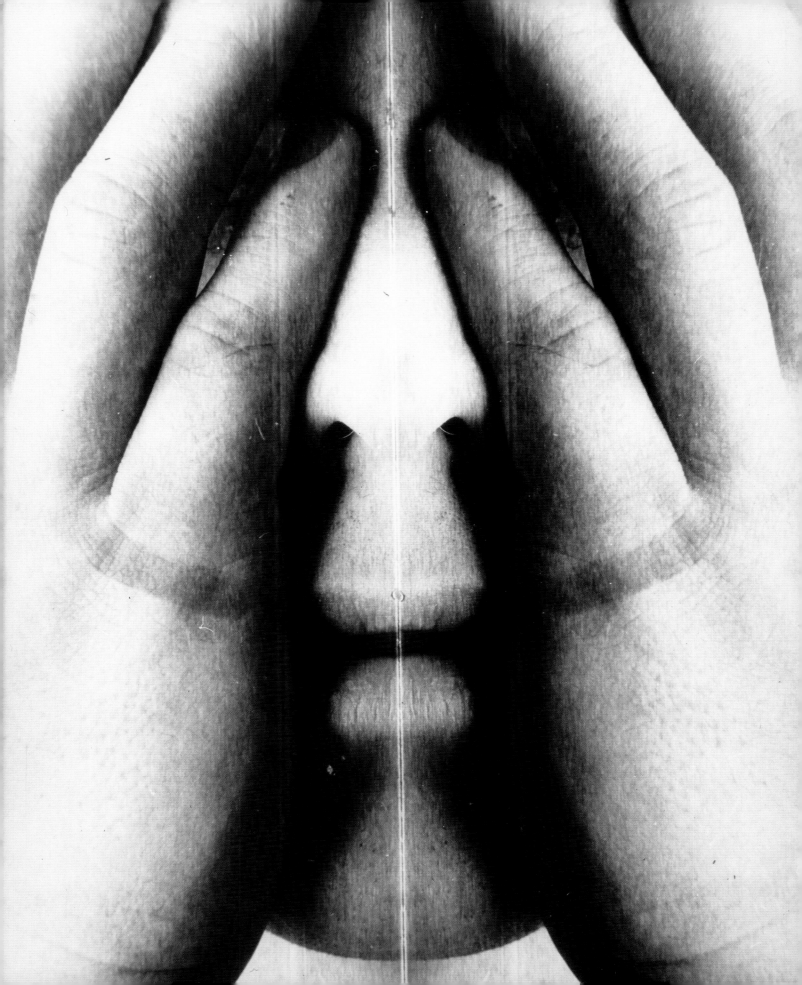

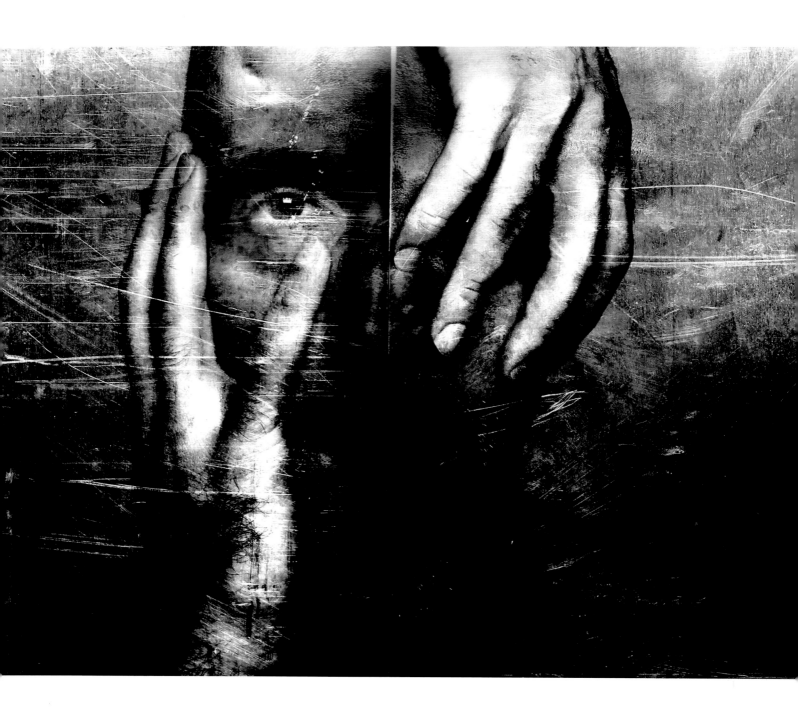

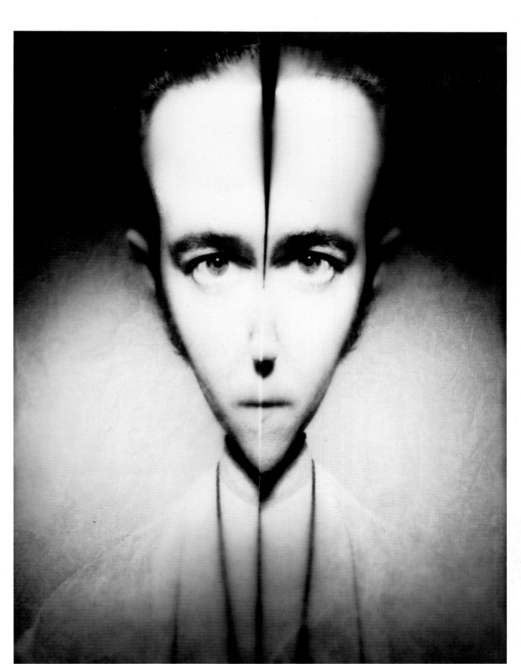

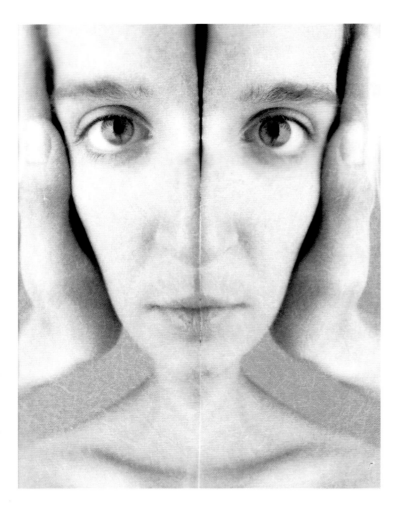
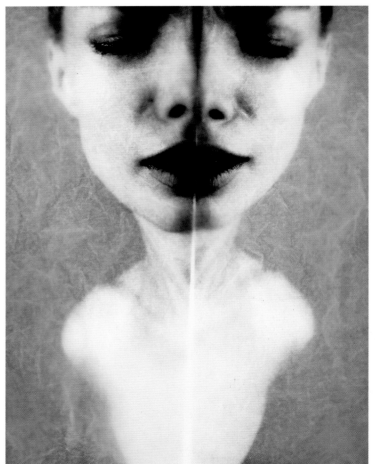

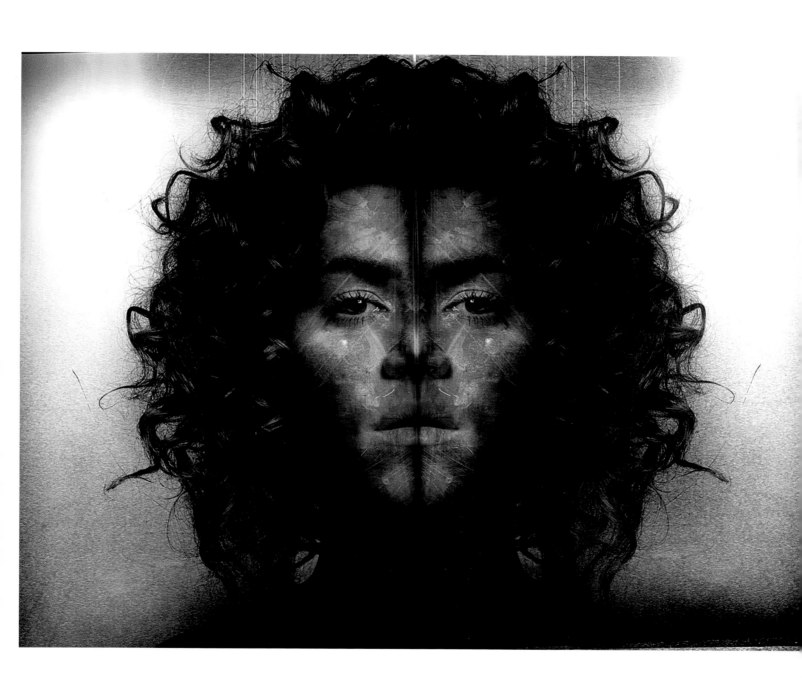

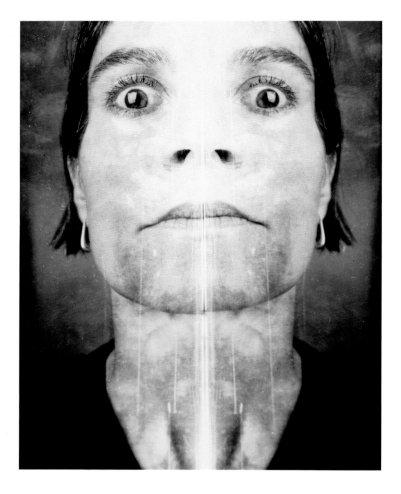
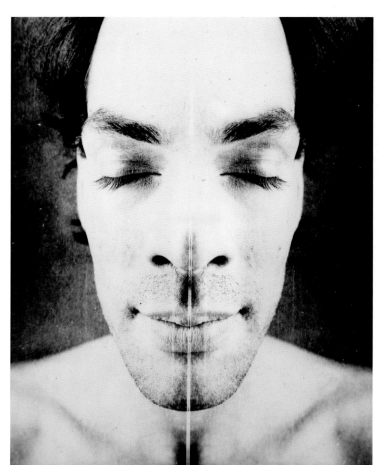
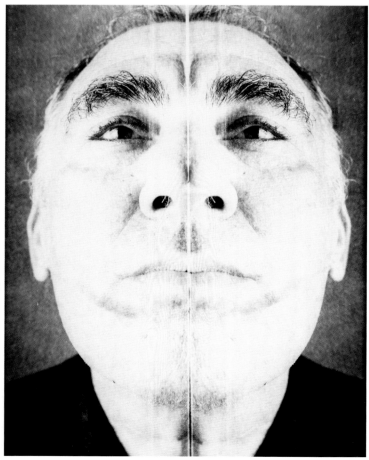
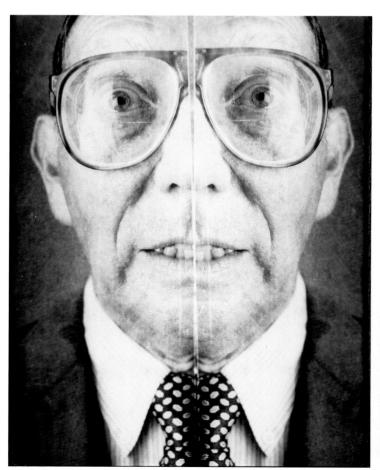

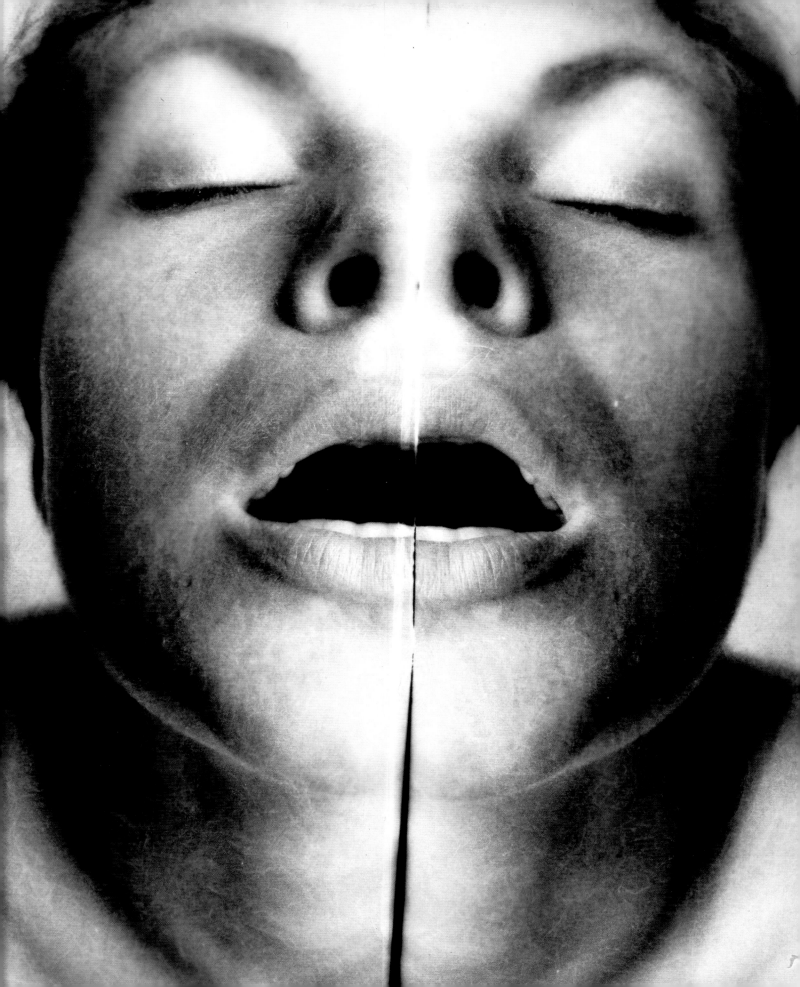

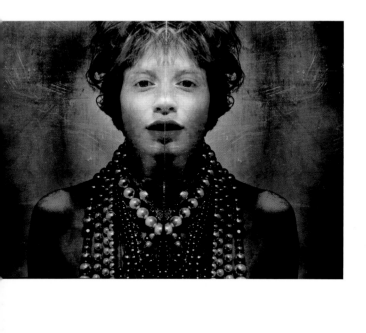
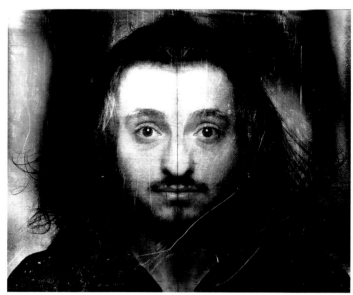
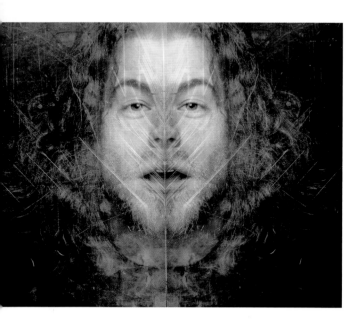
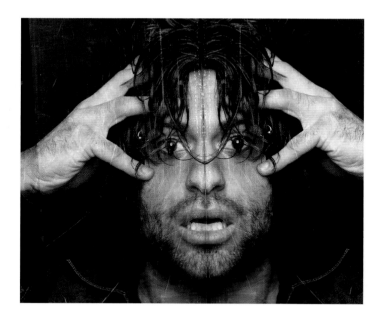

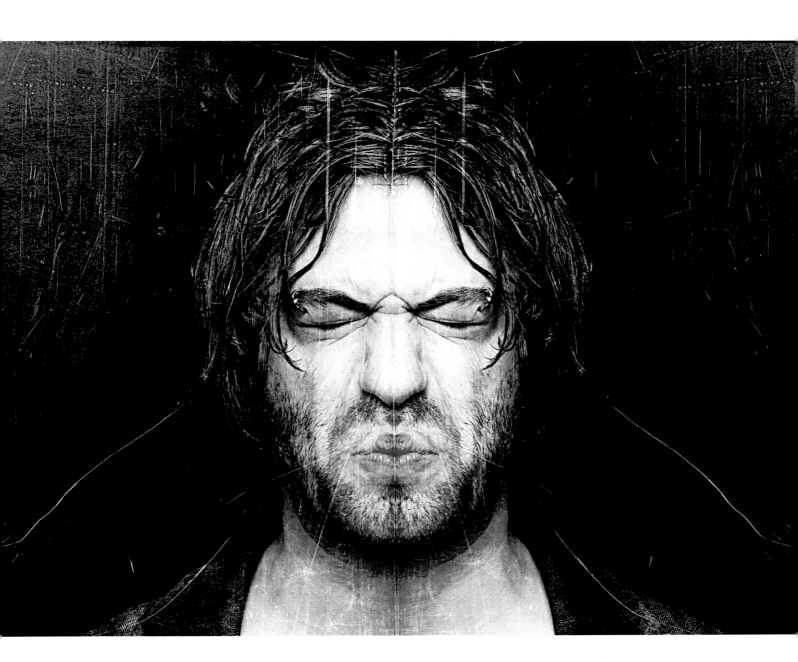

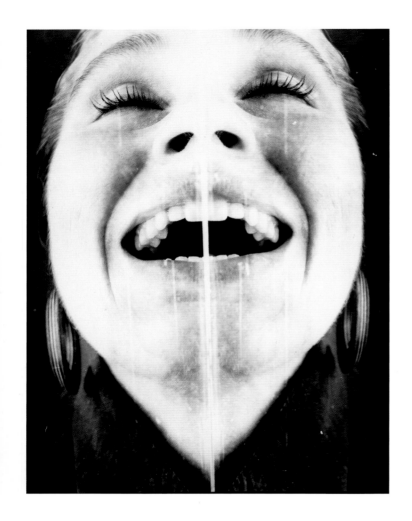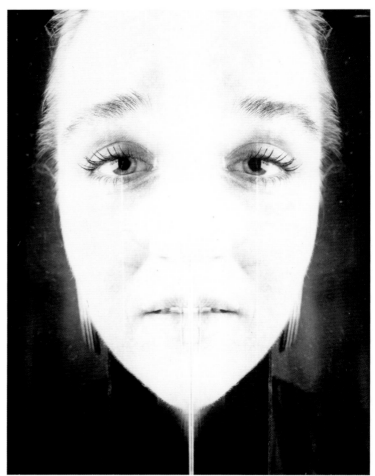

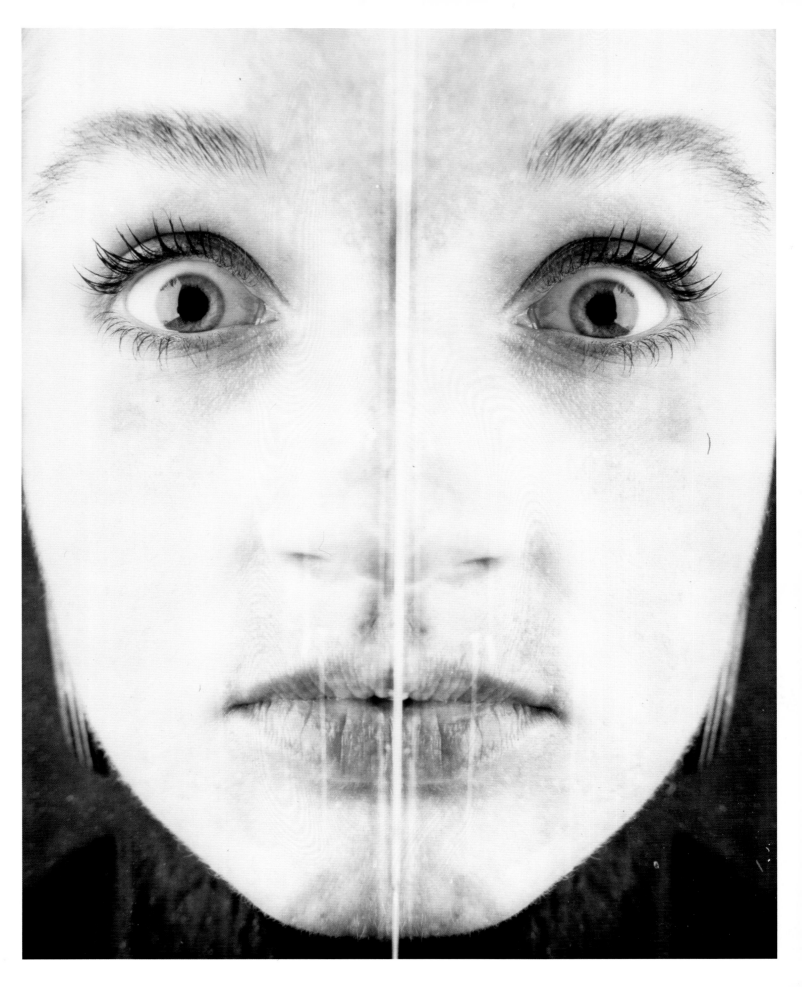

72 GESTURE AND INVENTION

What the body looks like,
and what looks the body likes.

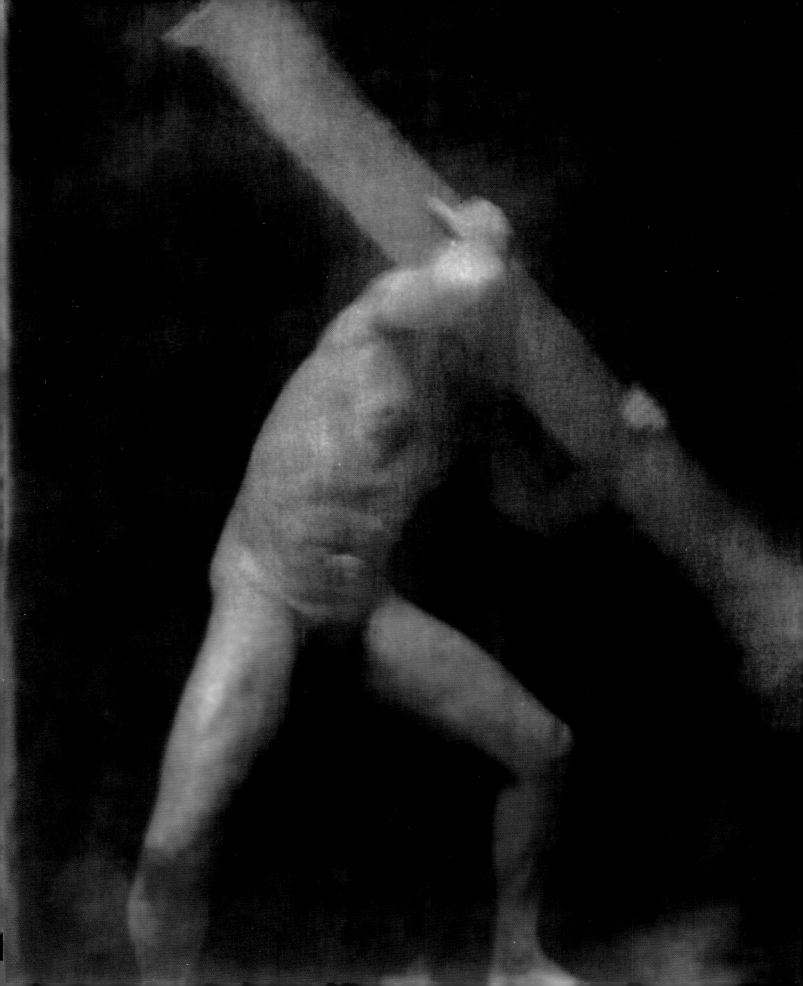

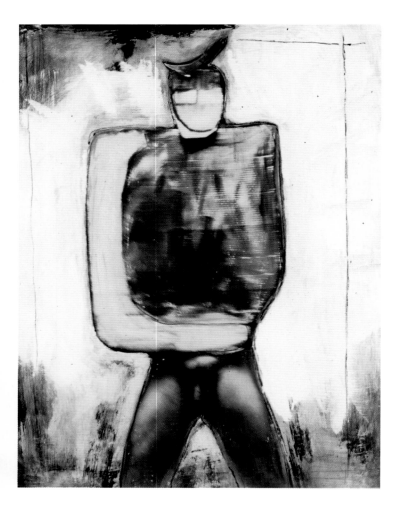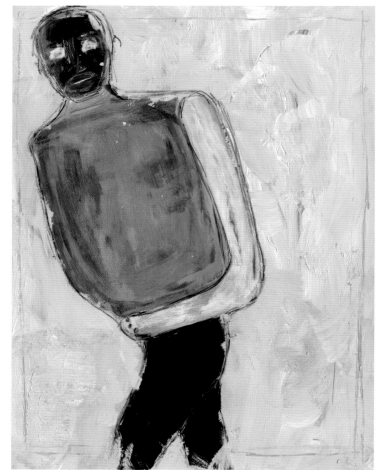

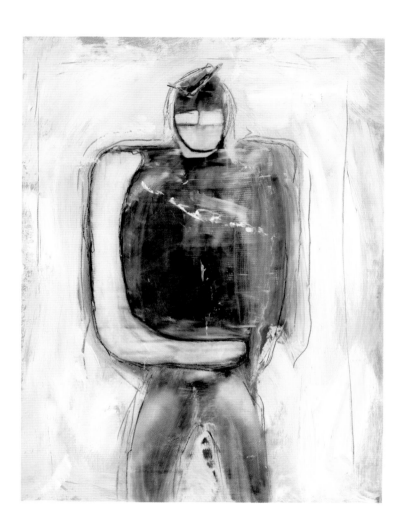
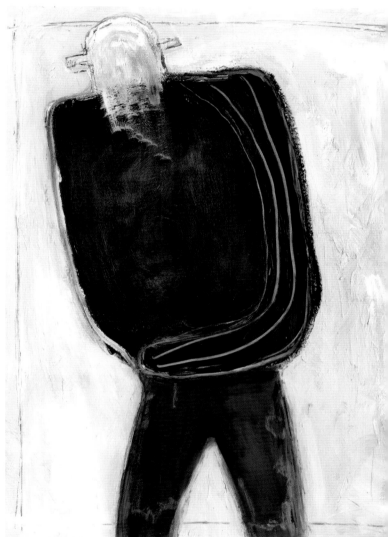

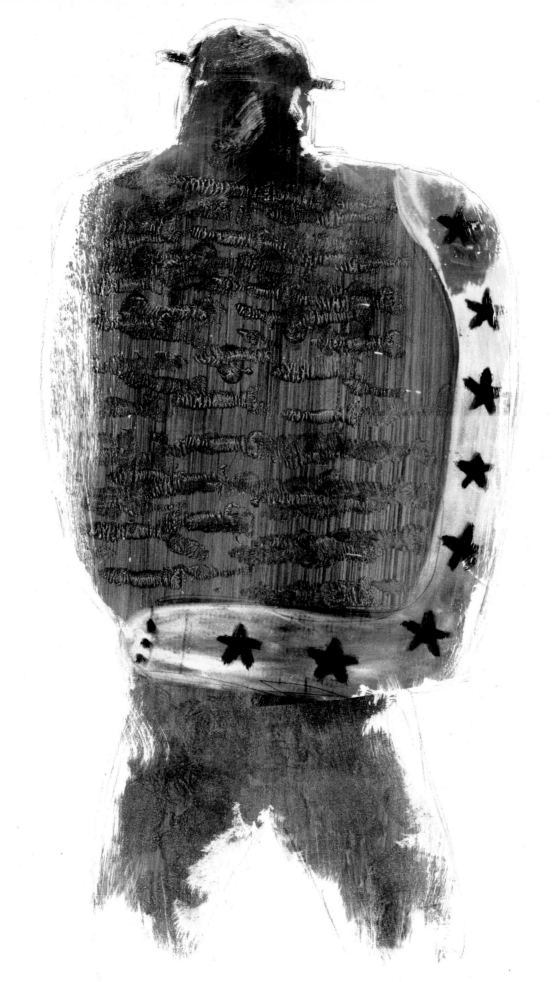

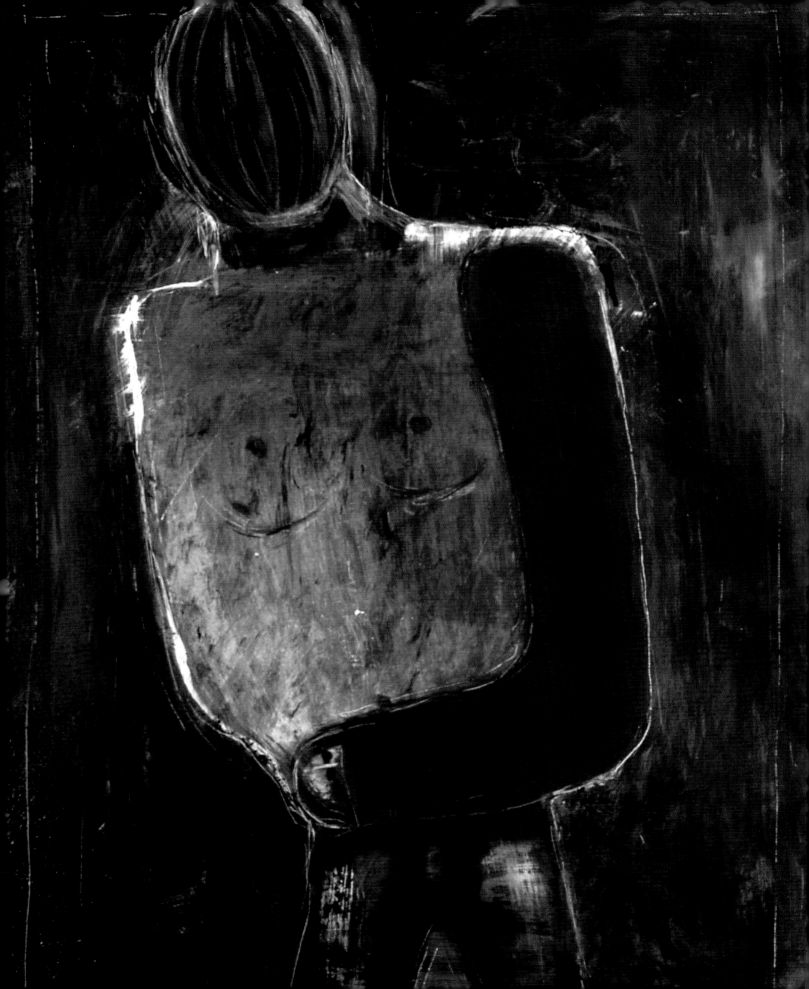

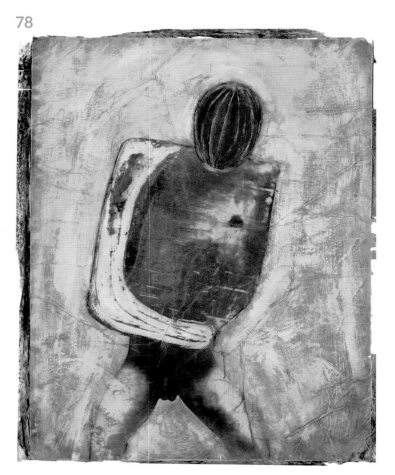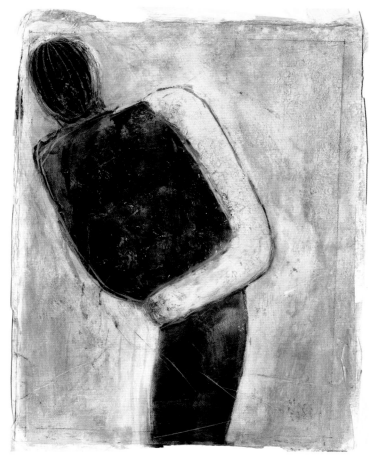

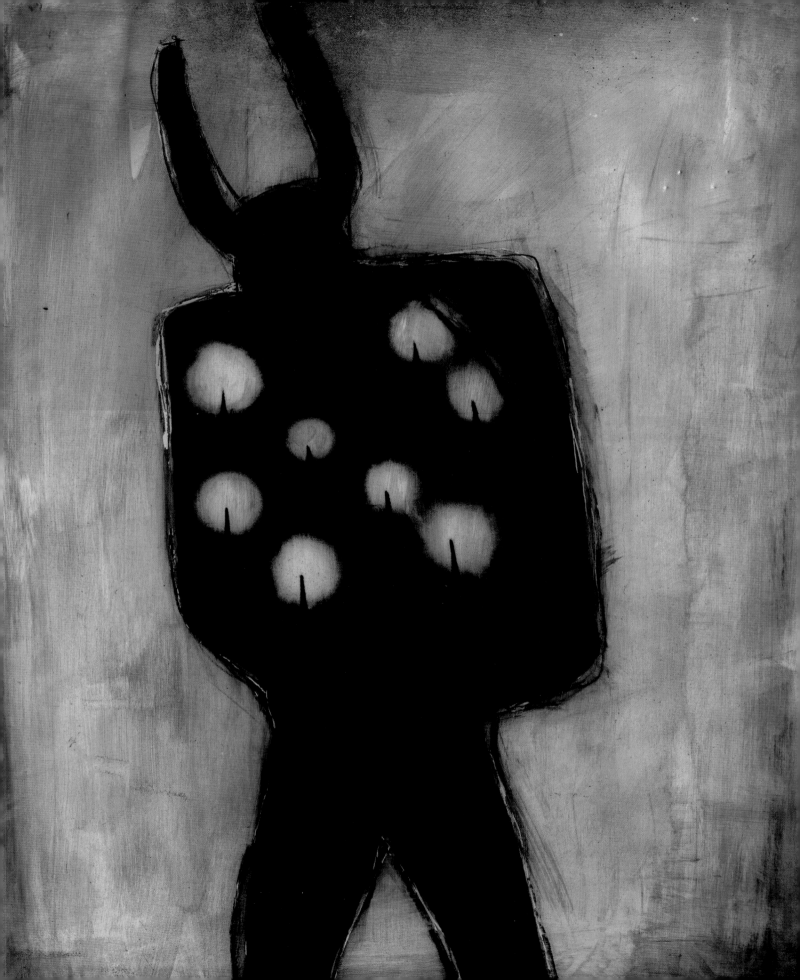

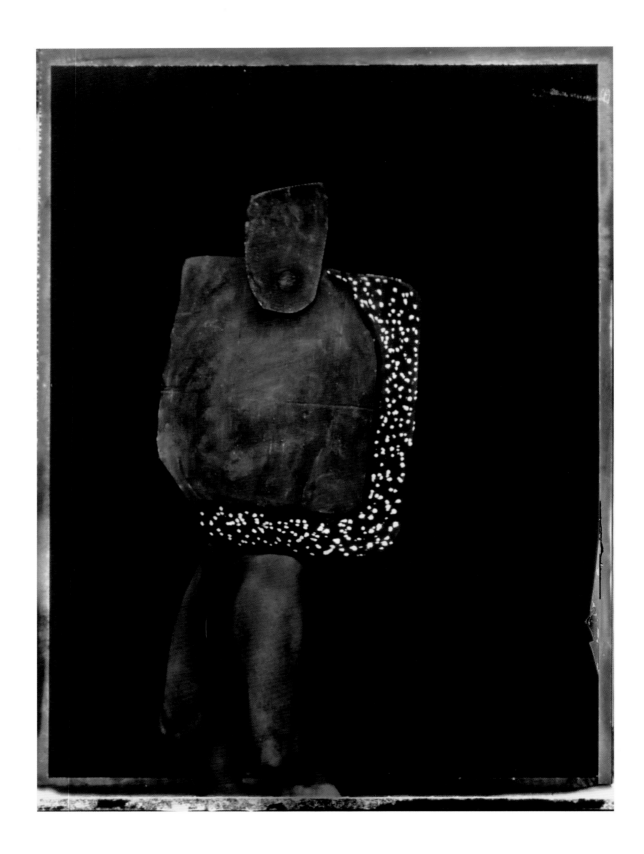

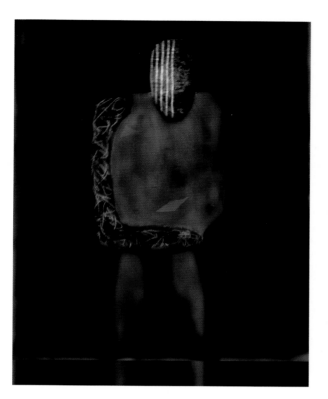

81

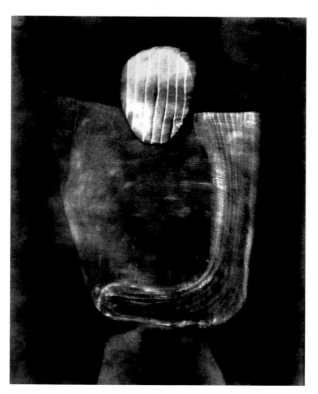
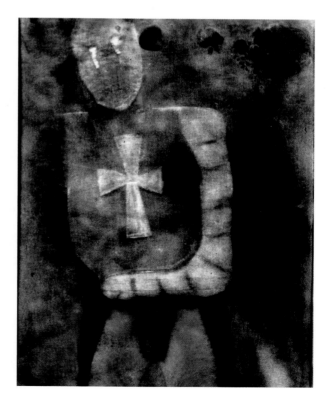

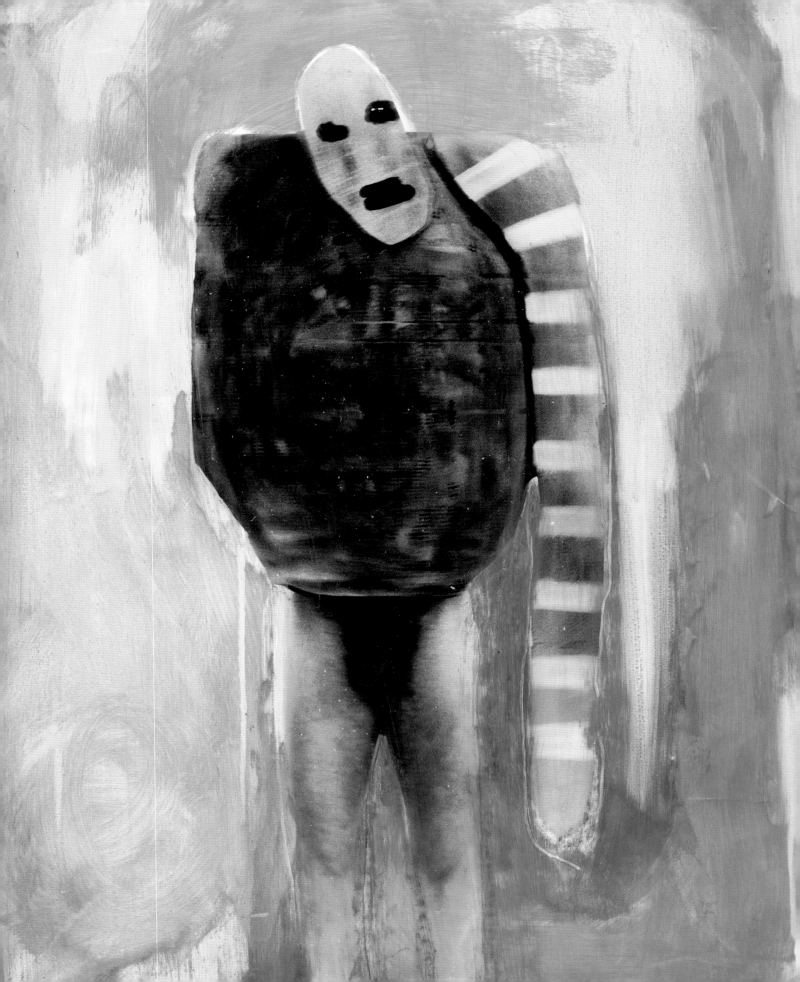

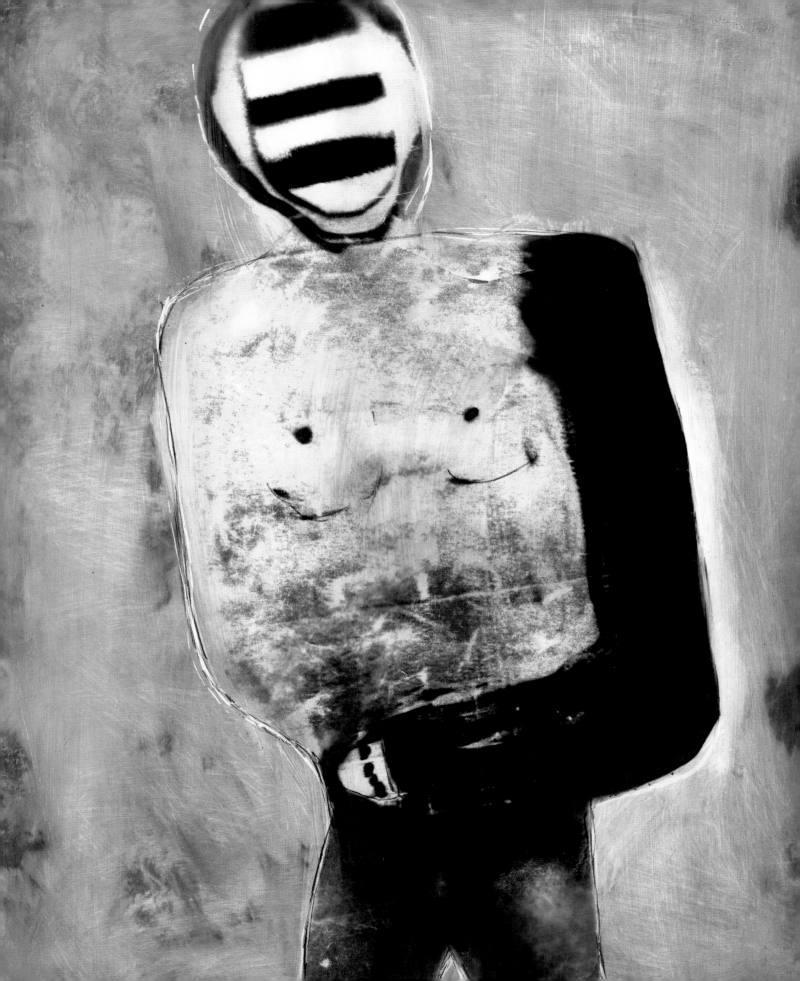

SHOUTS AND SONGS

The storytelling got out of hand.

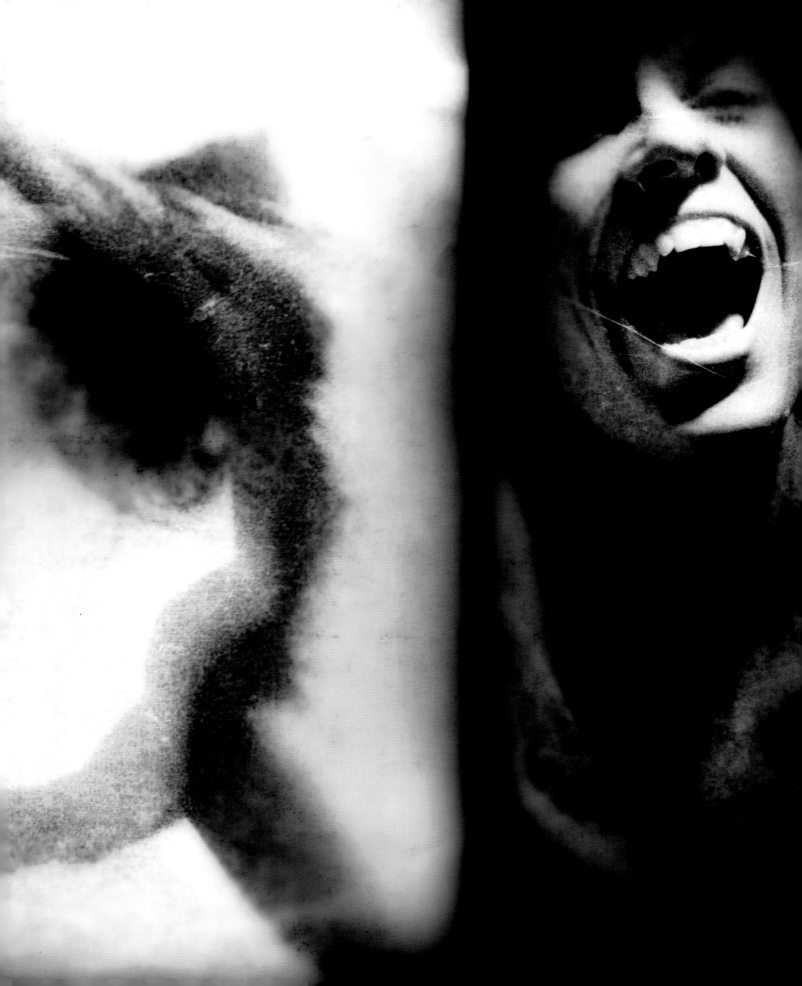

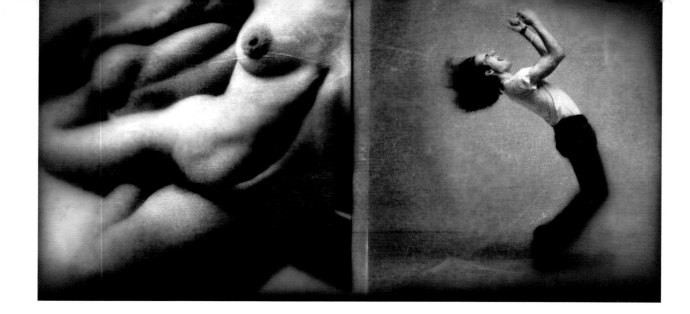

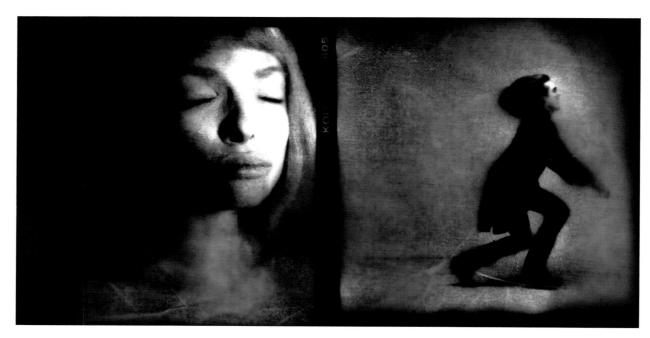

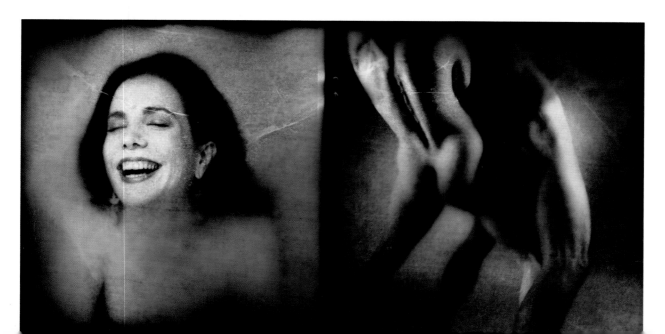

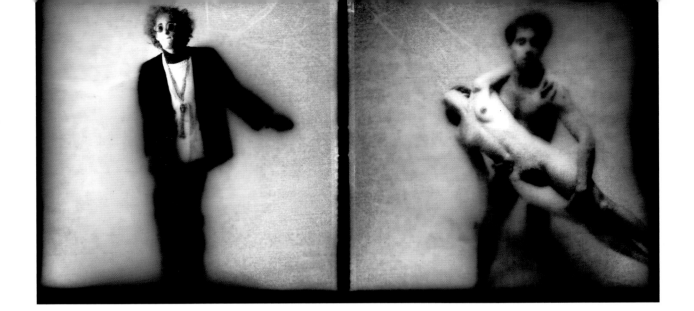

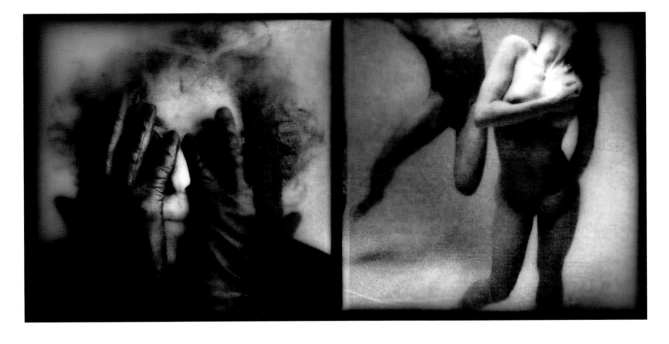

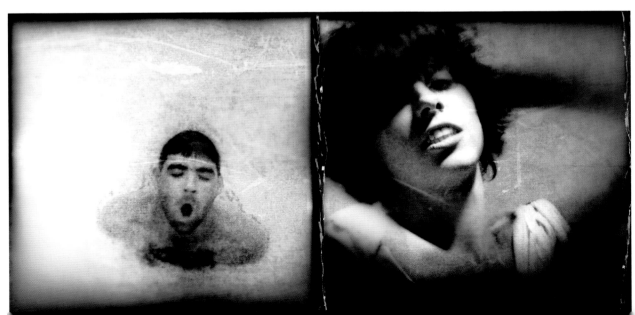

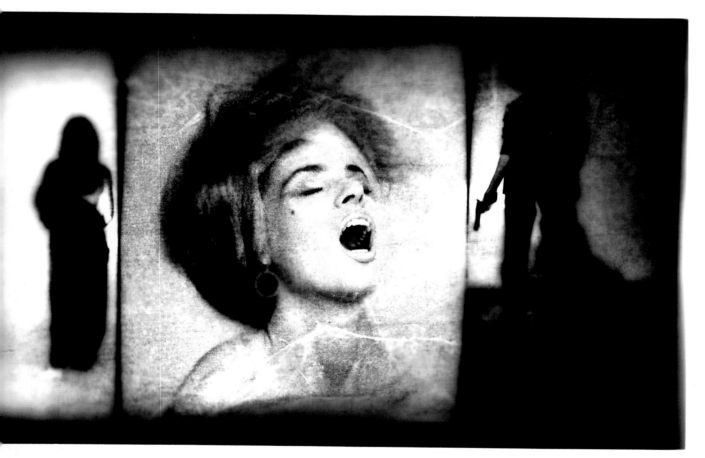

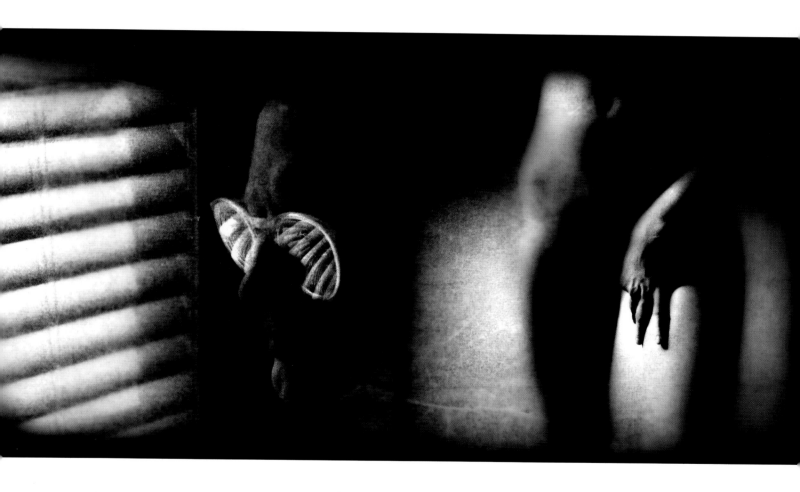

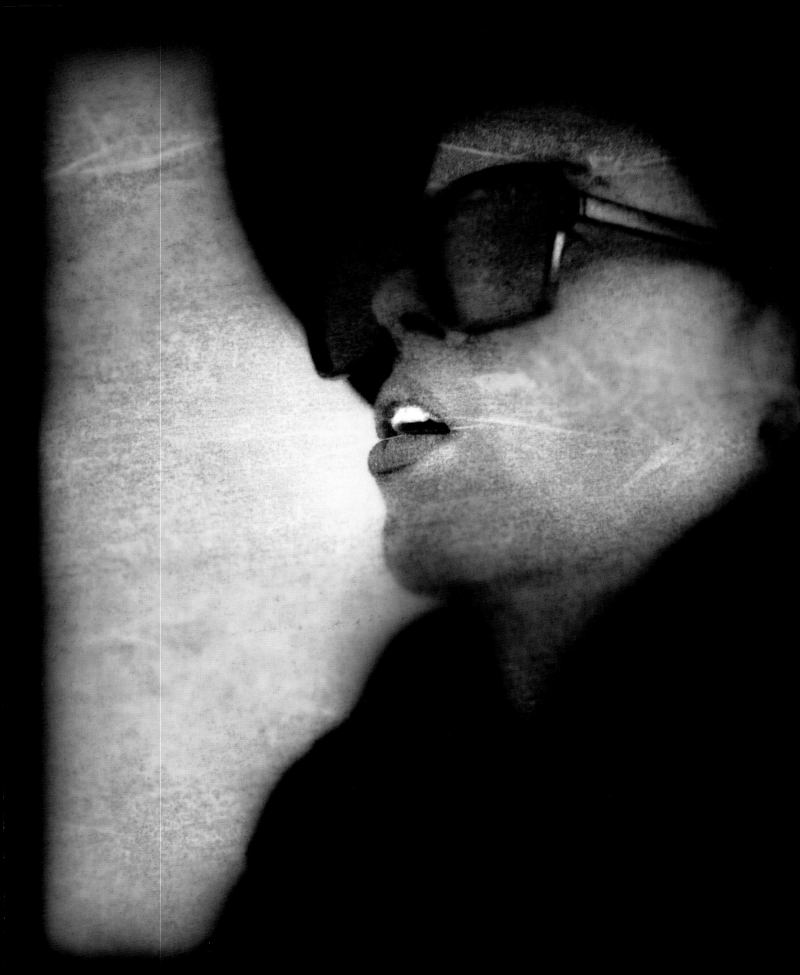

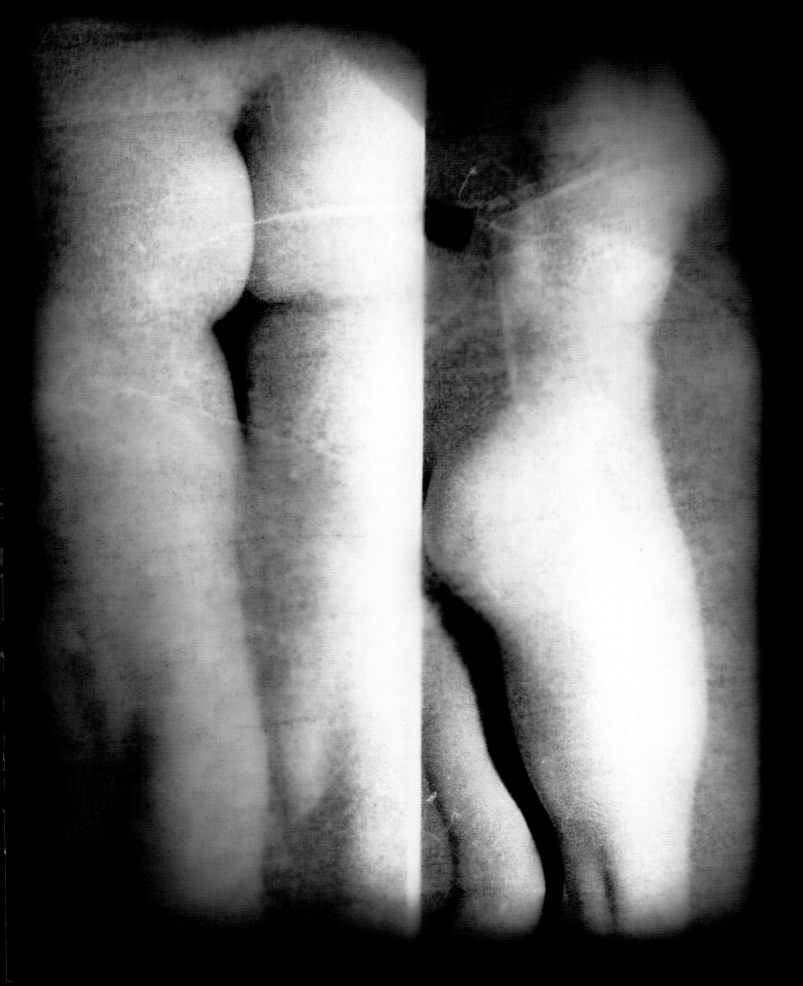

A HUNDRED WORDS

It all started with a deceptively blue sky.

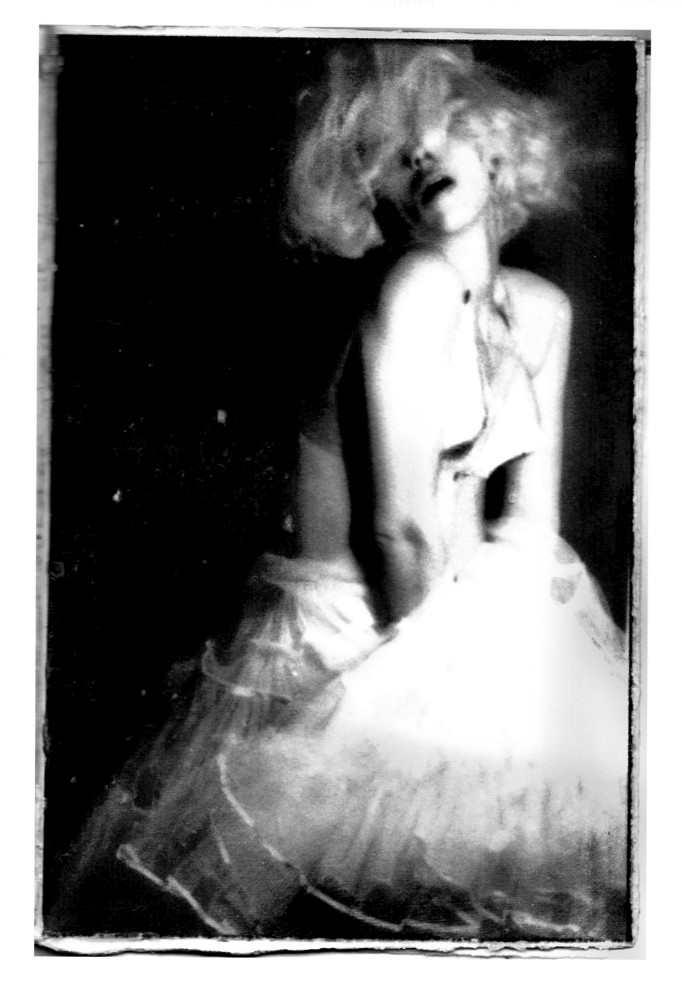

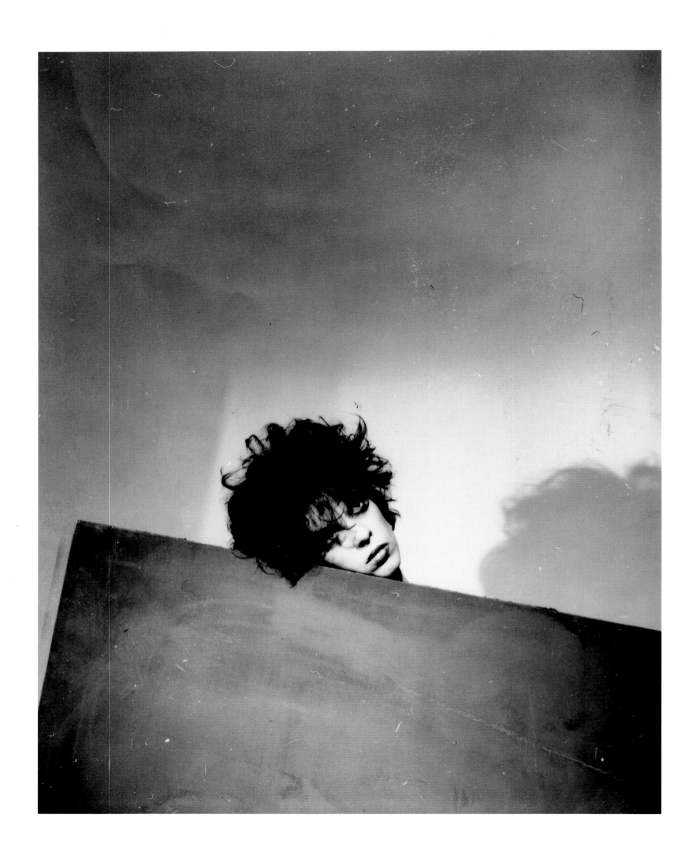

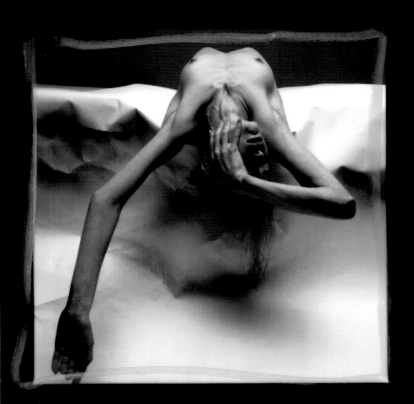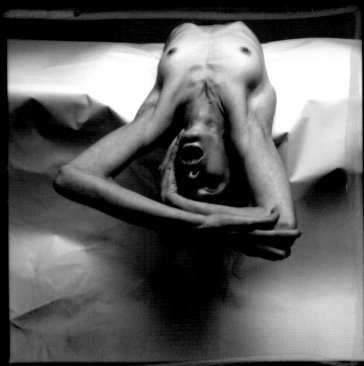

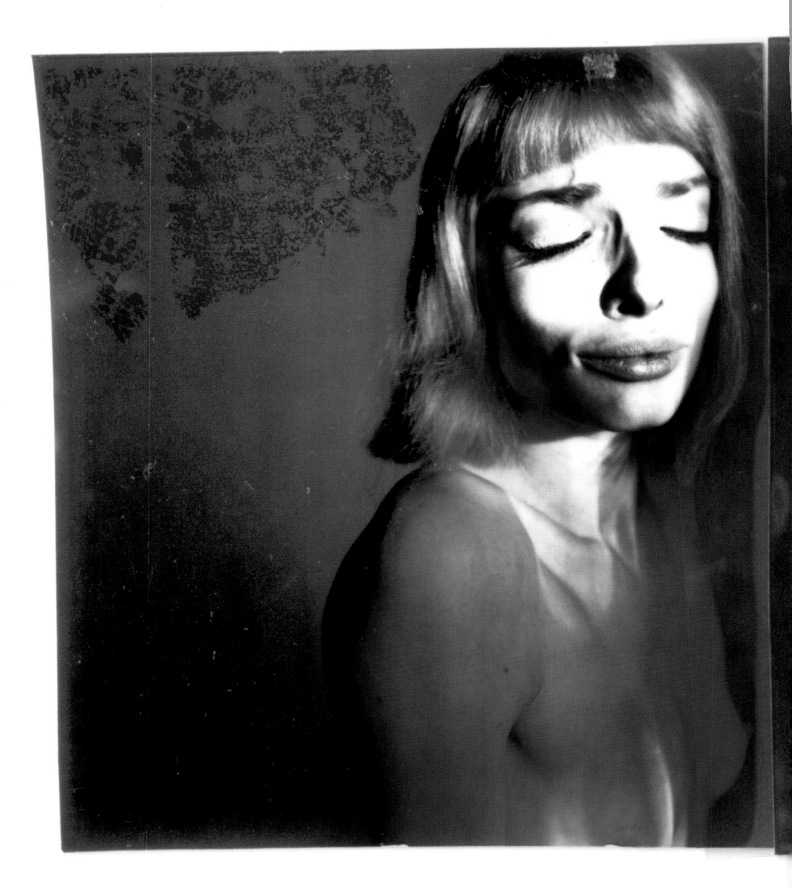

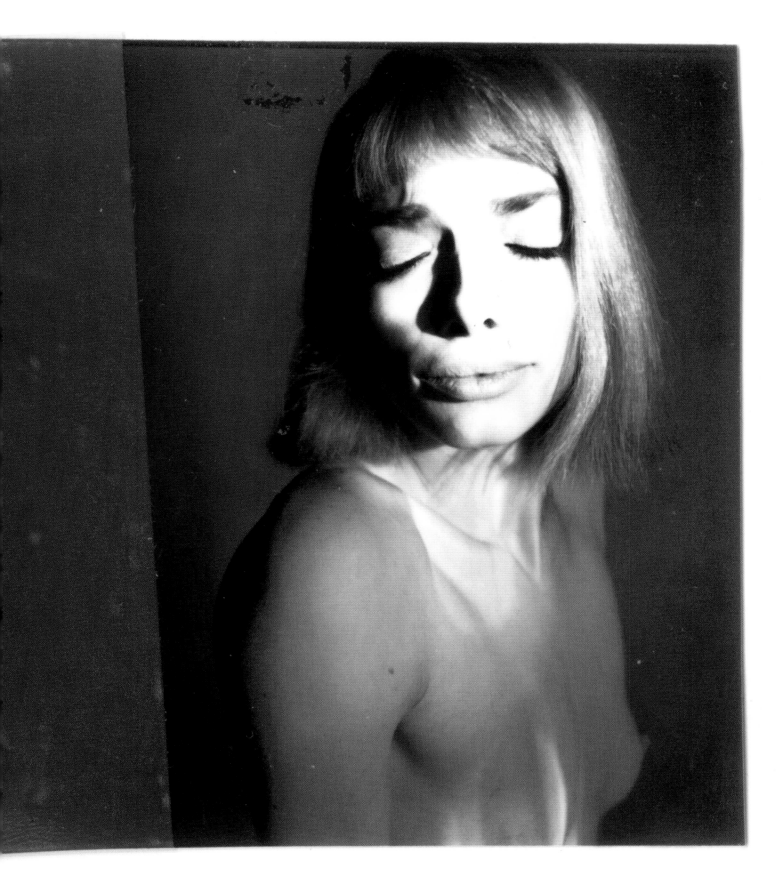

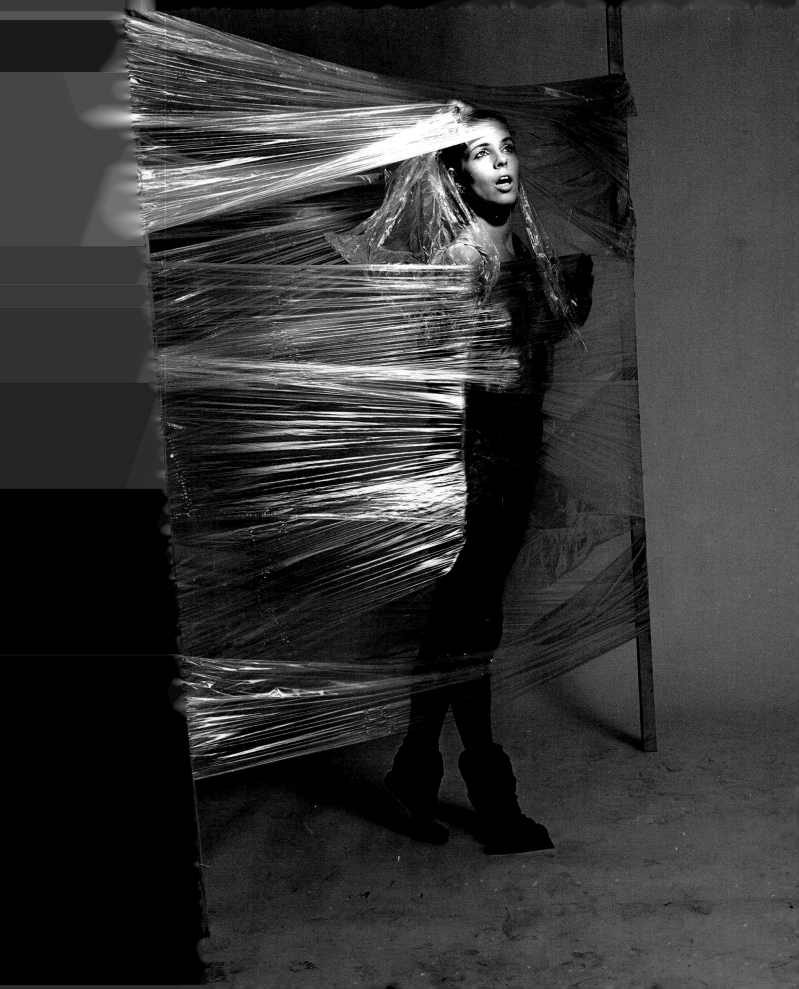

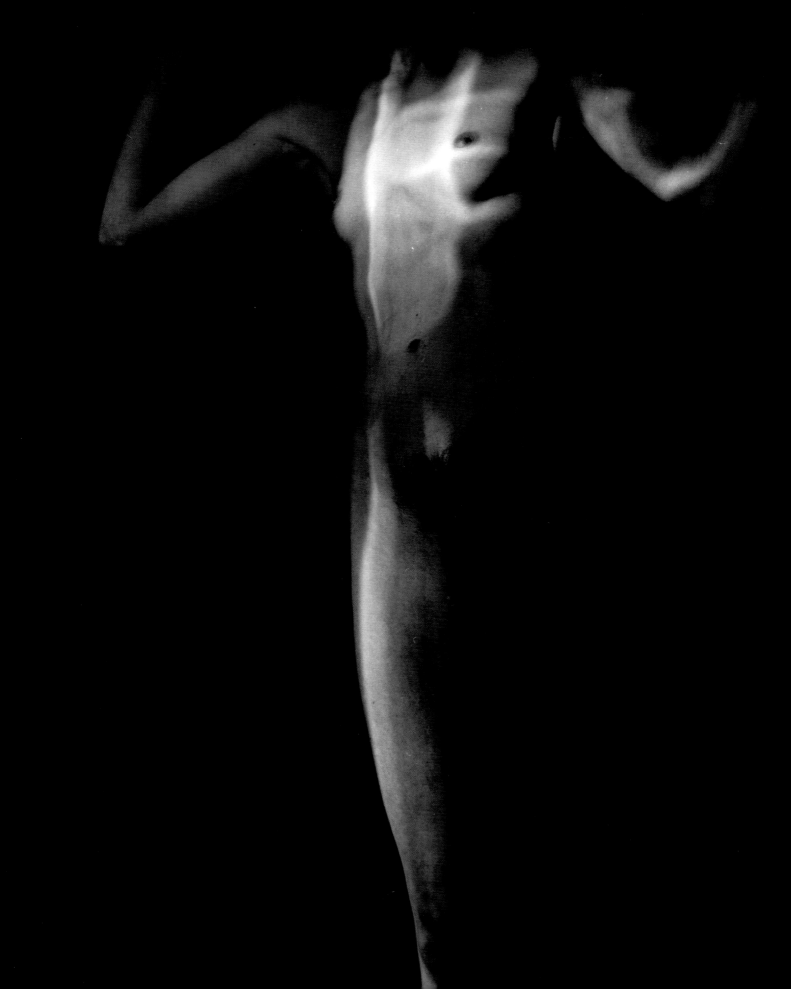

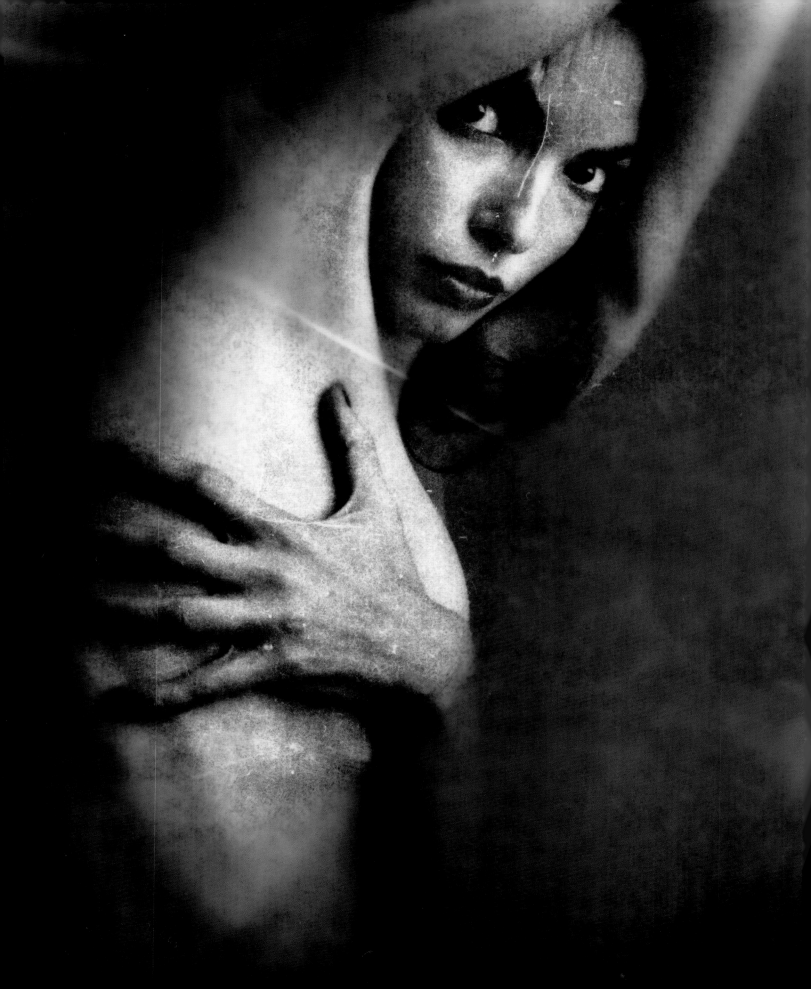

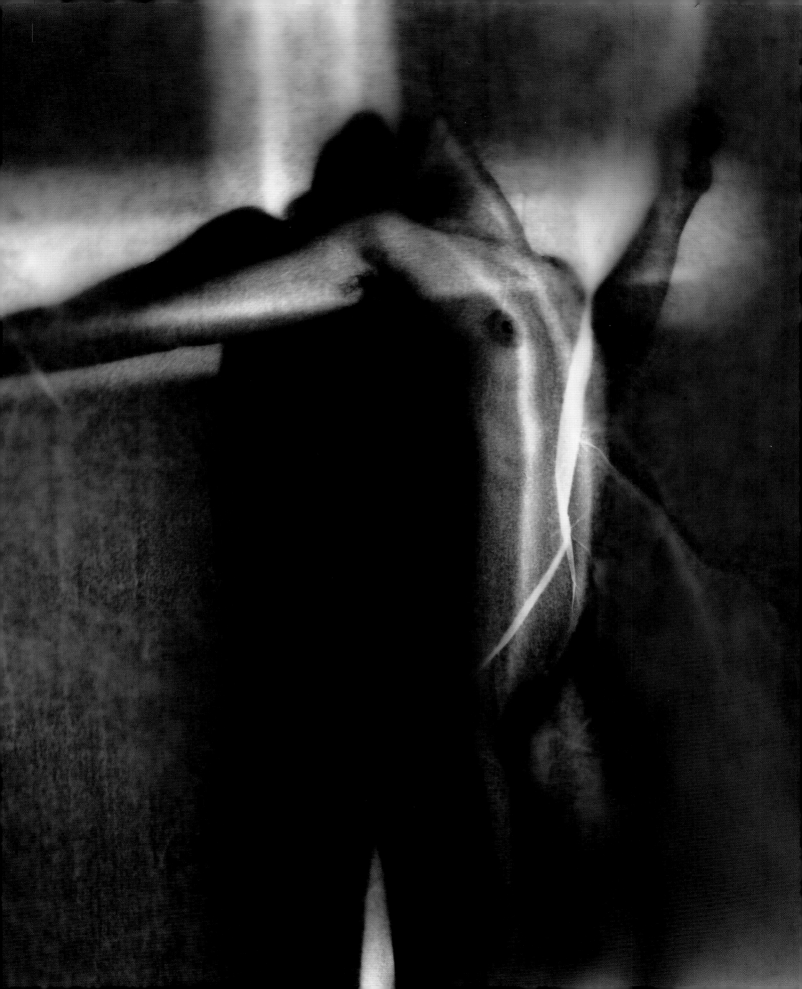

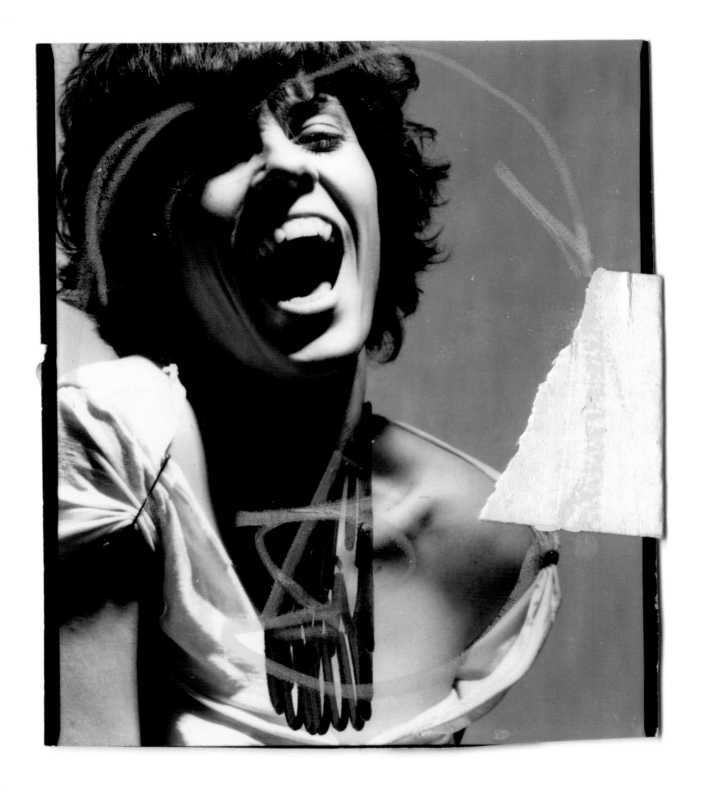

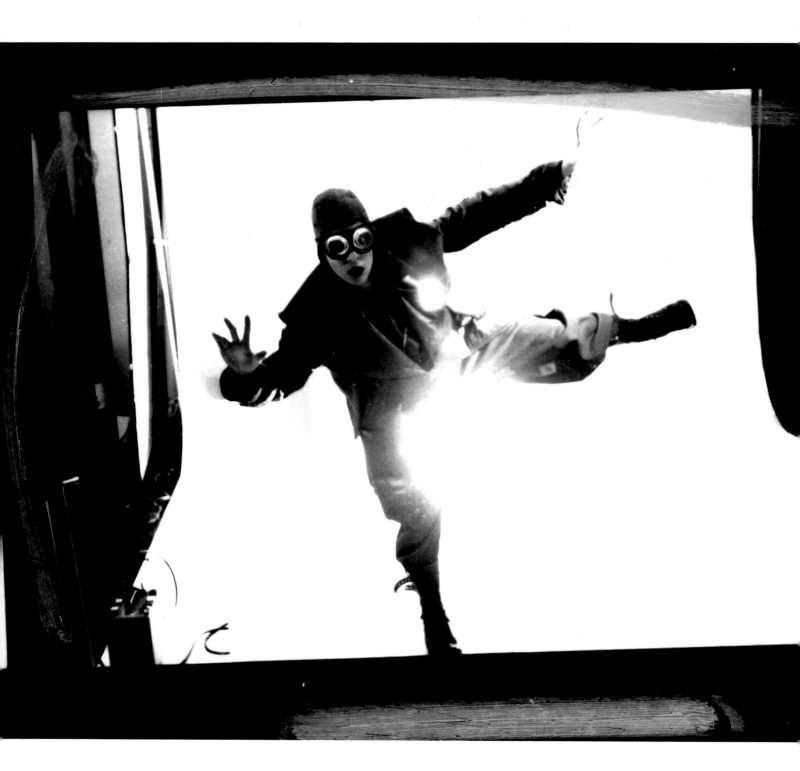

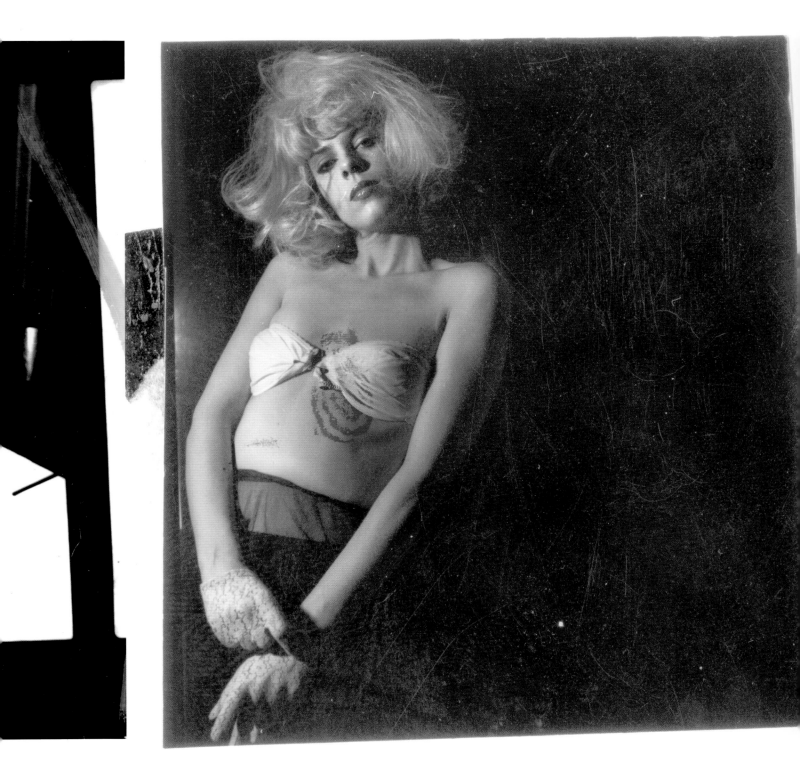

106 CERTAIN DANCES

Music finds us.

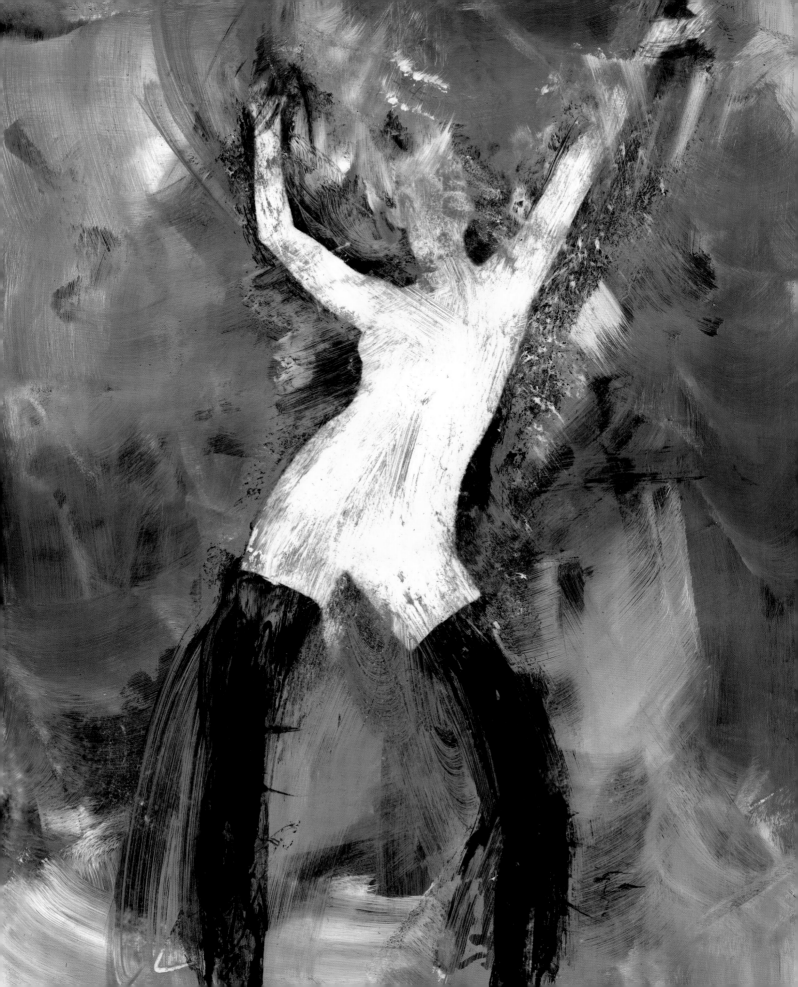

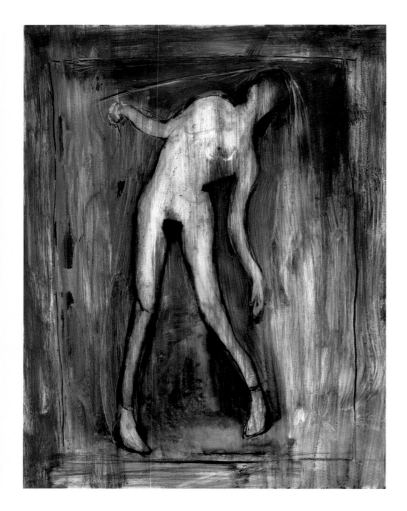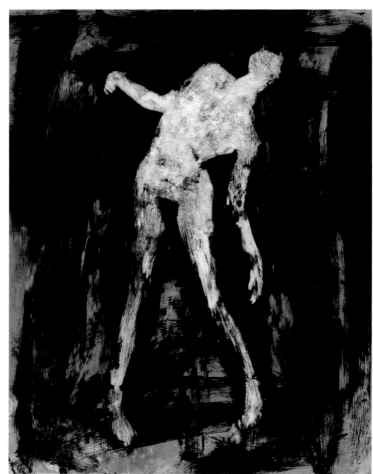

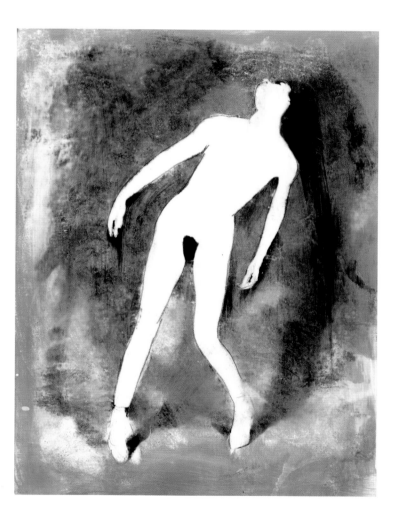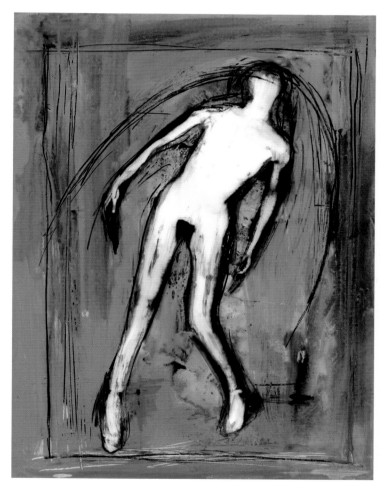

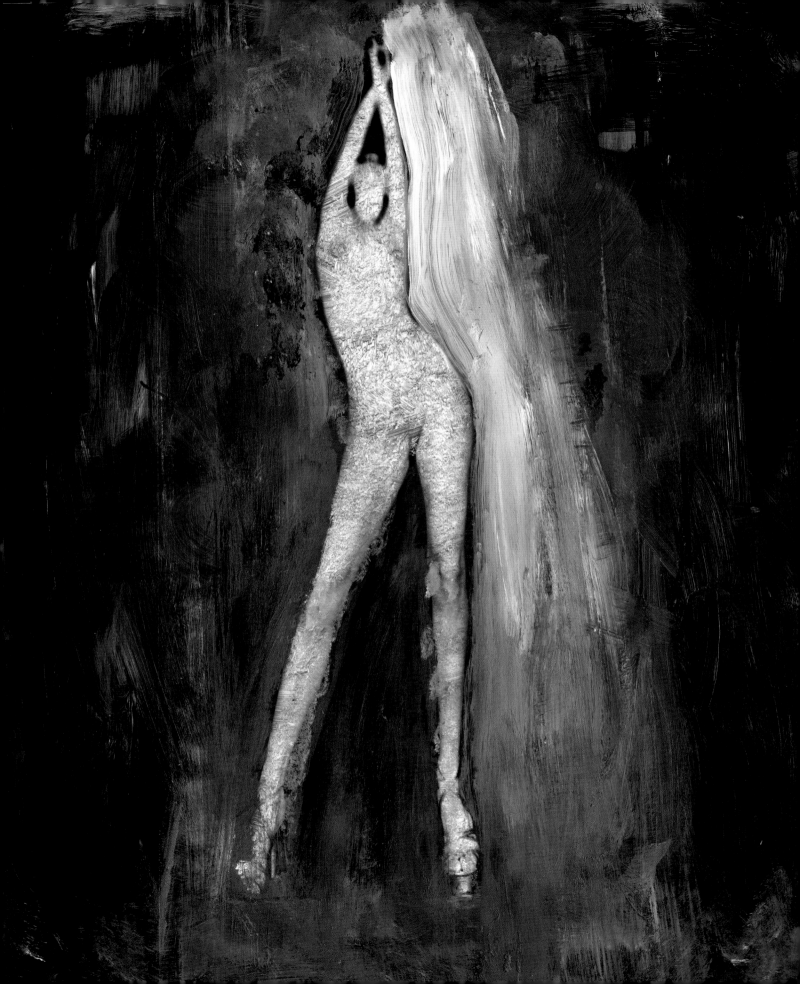

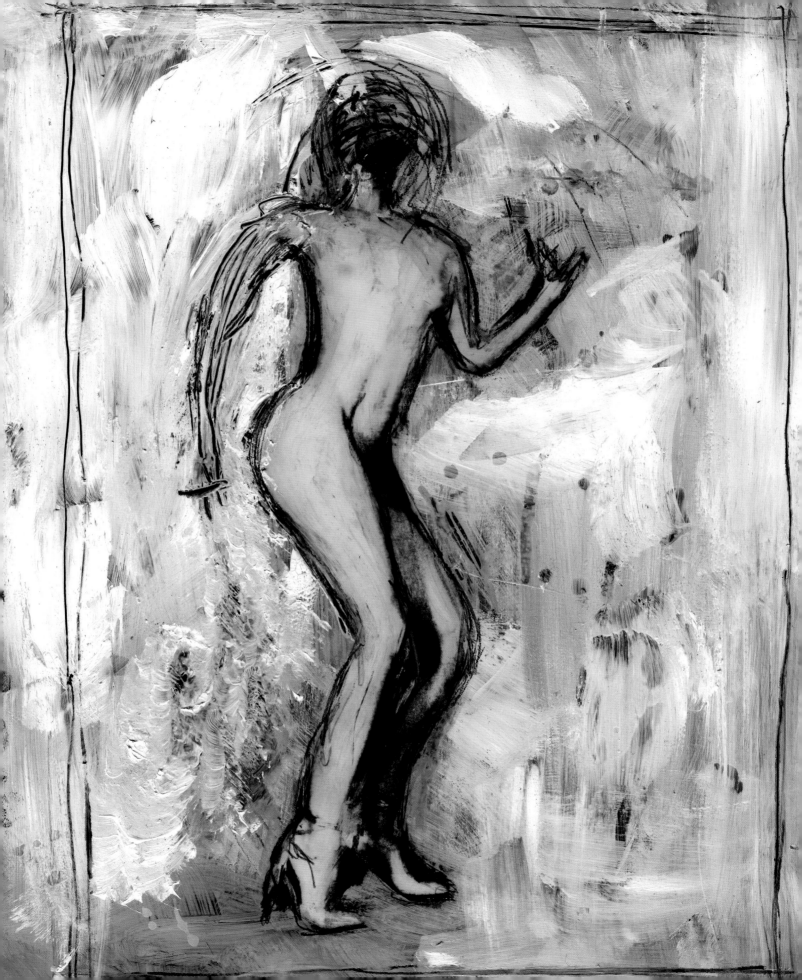

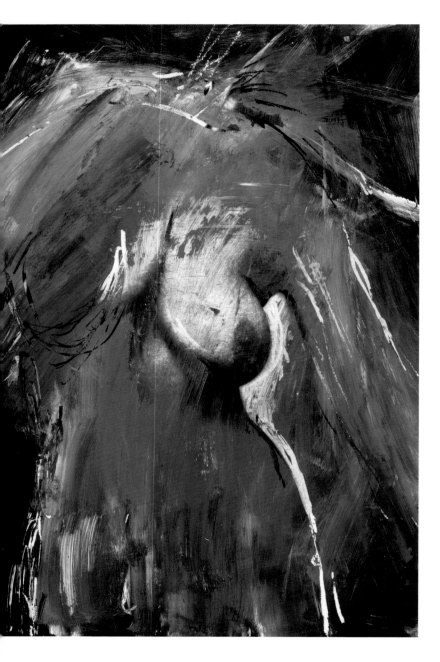
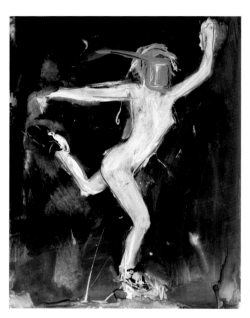

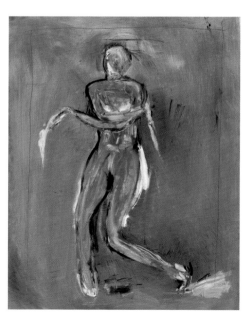

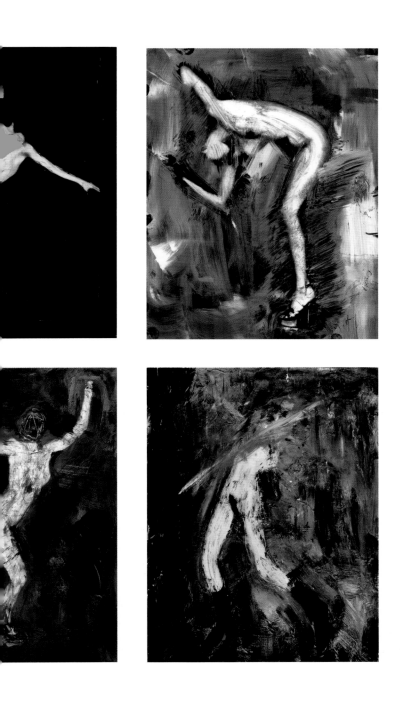
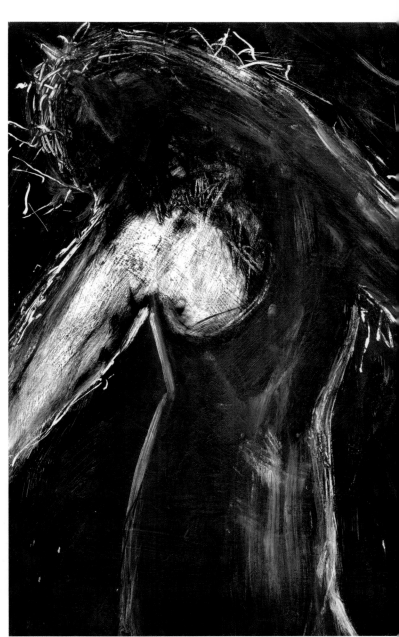

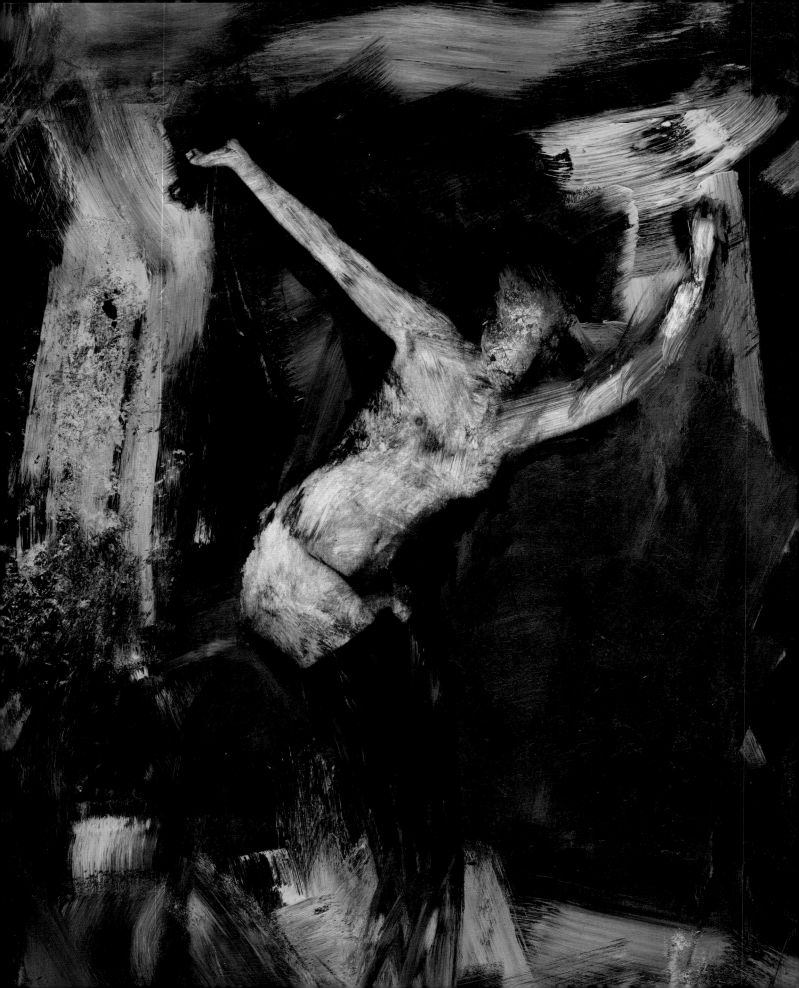

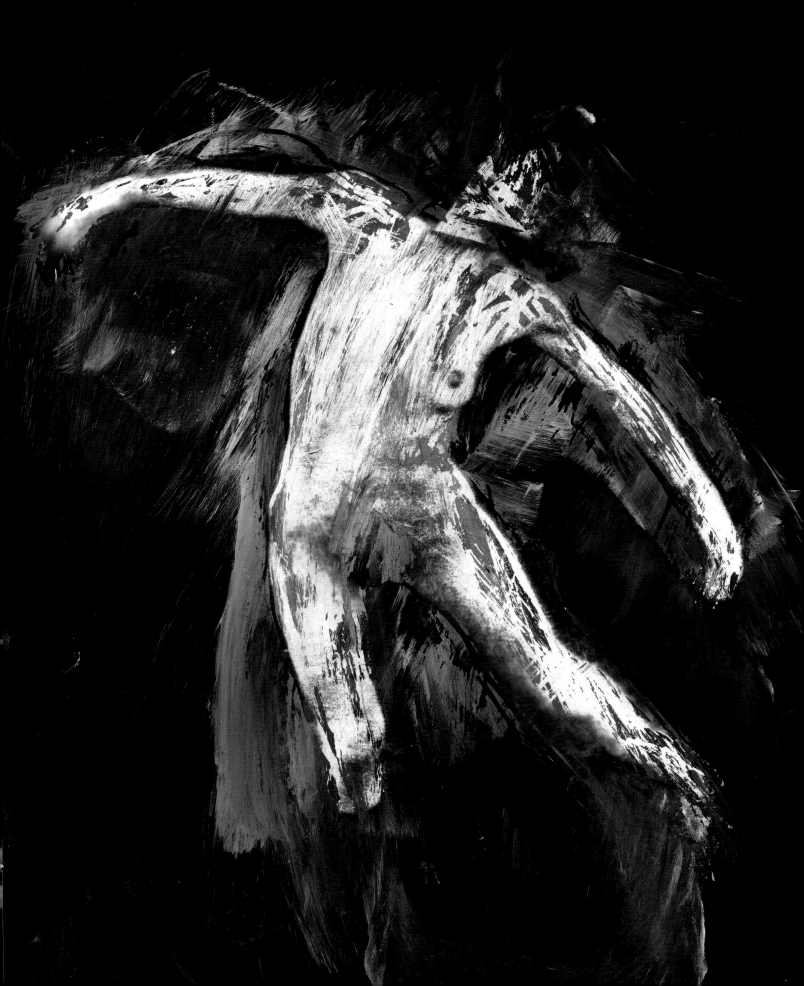

116 DISMANTLED MYTH

People as they are, not as they should be.
Not the limitations of convention.

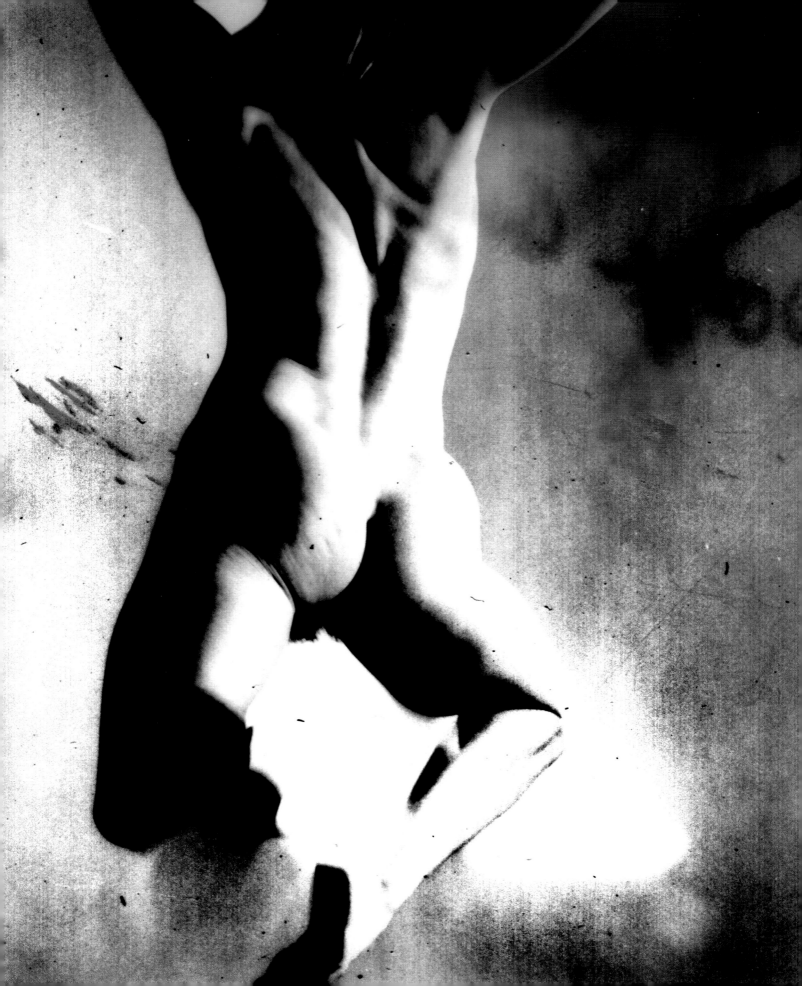

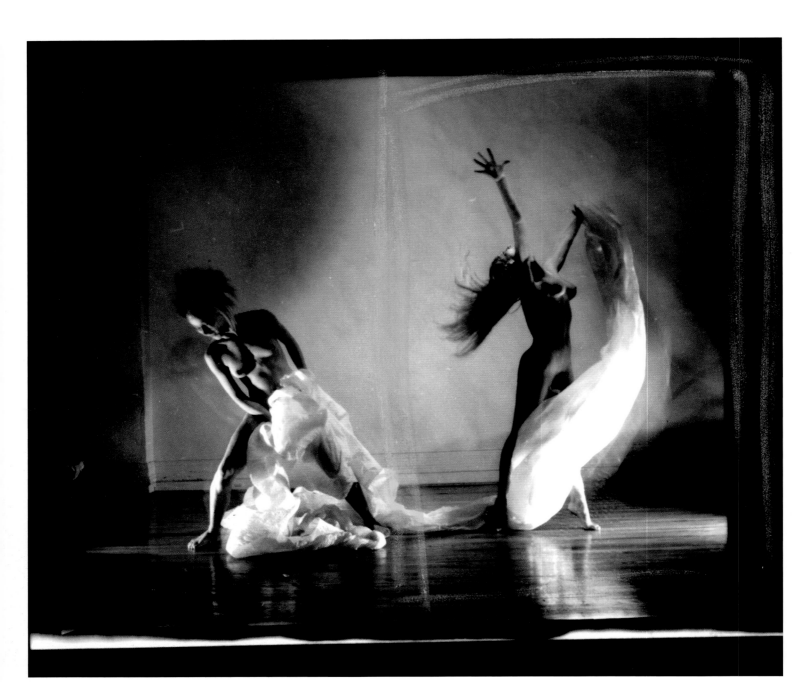

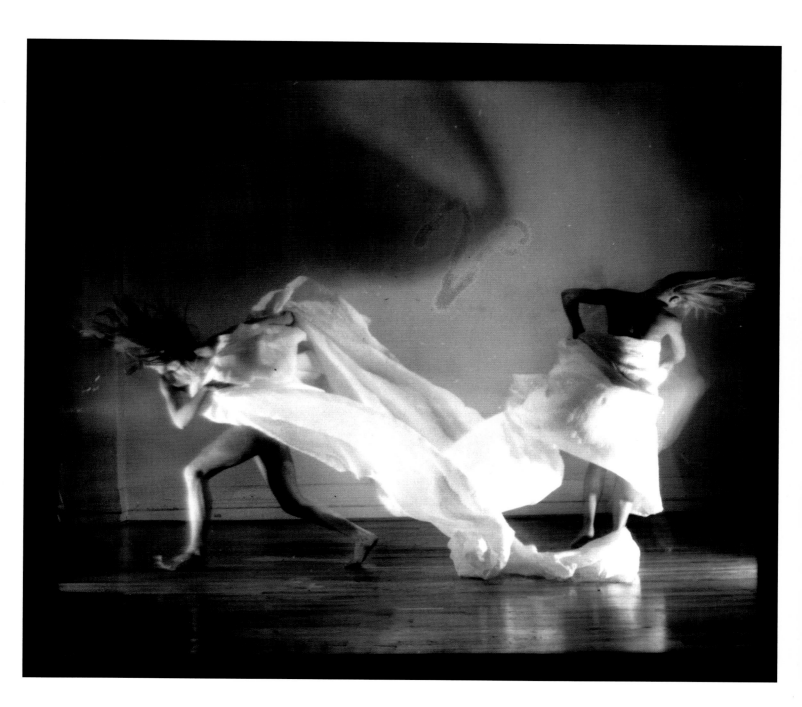

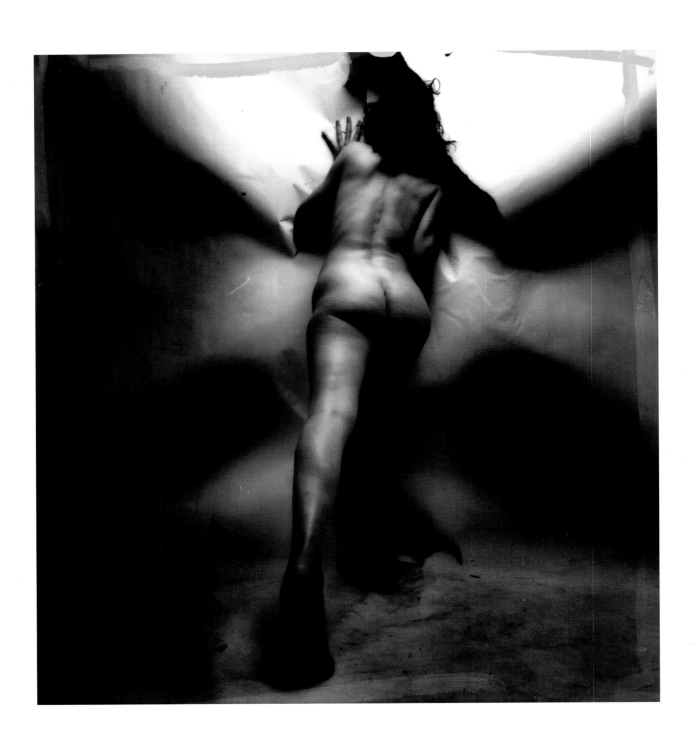

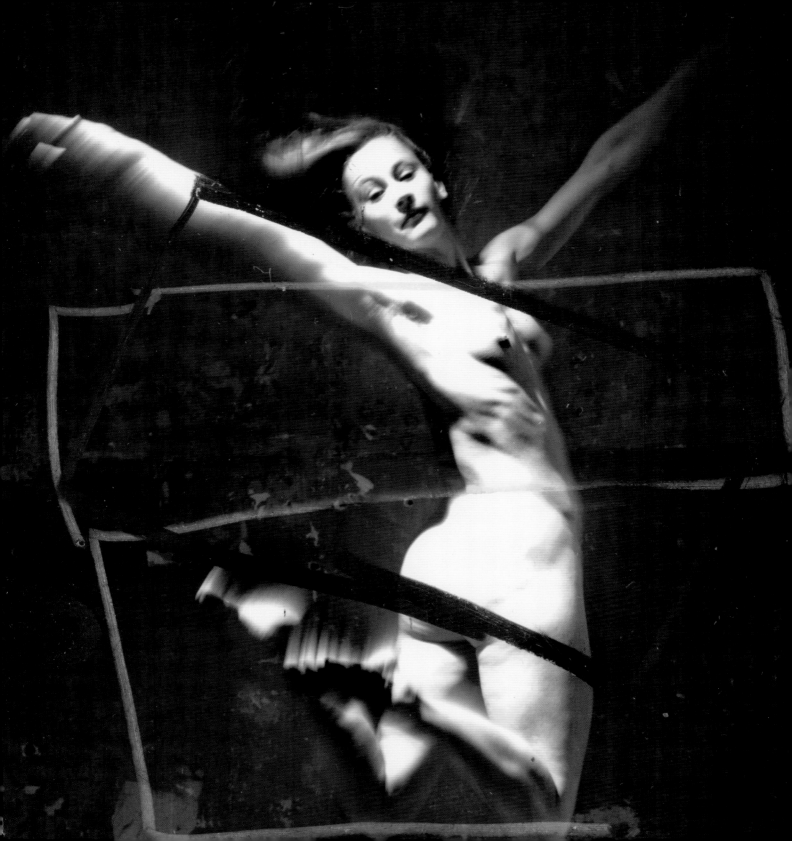

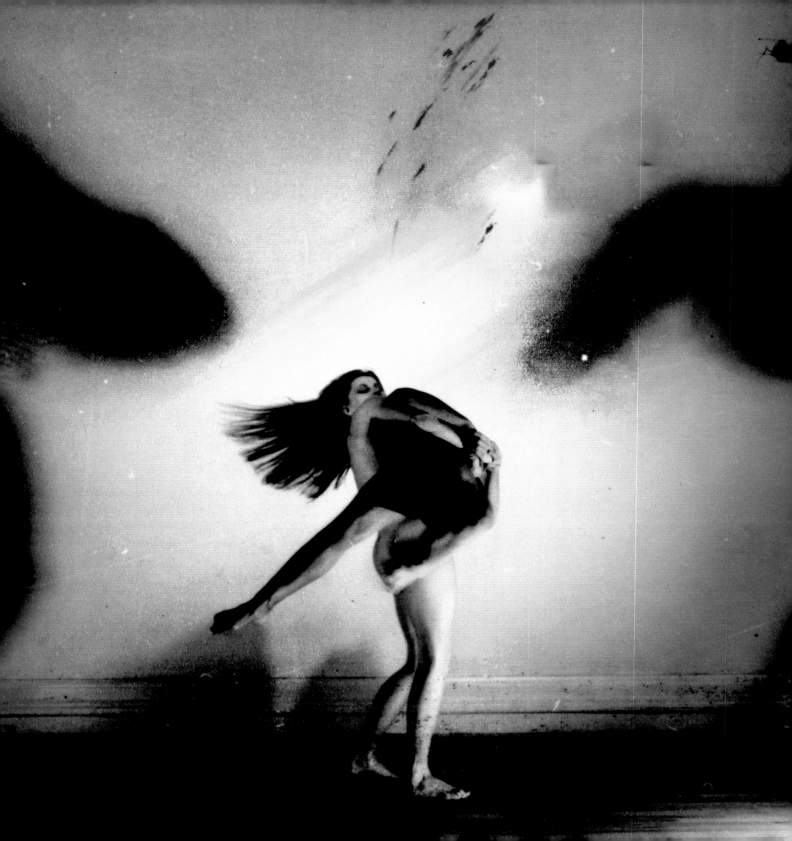

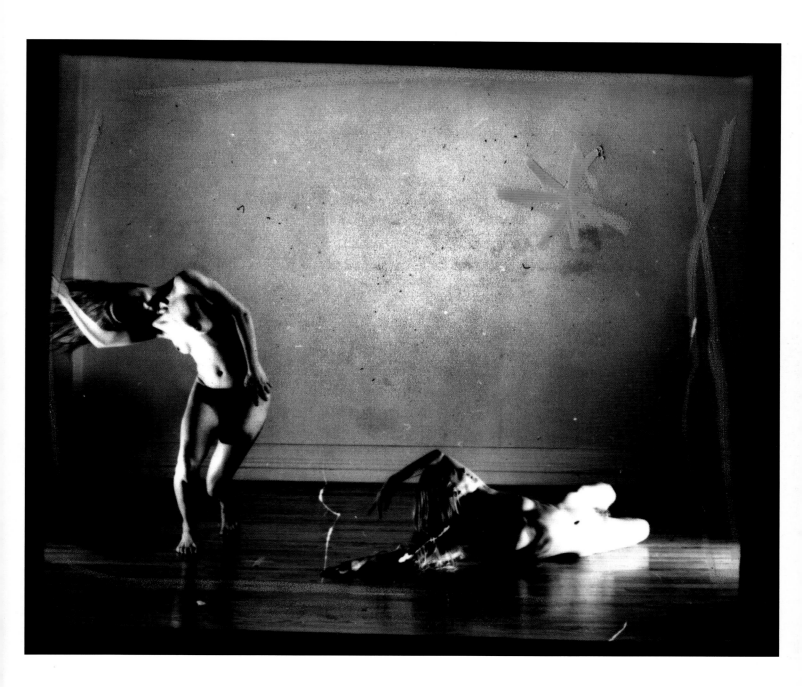

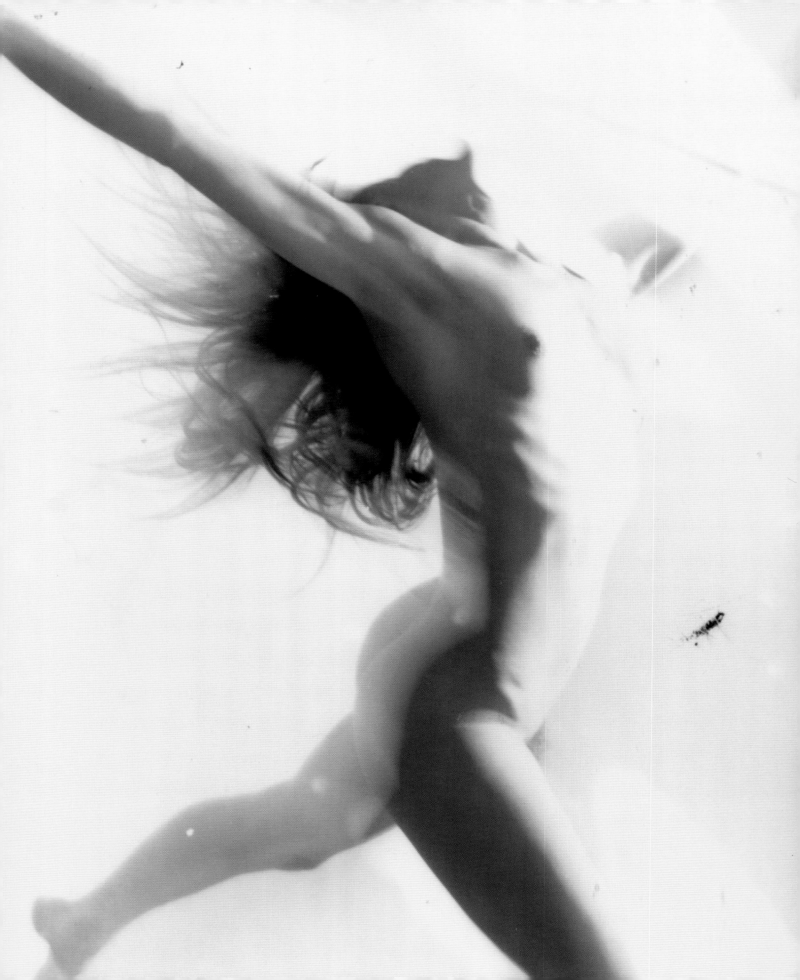

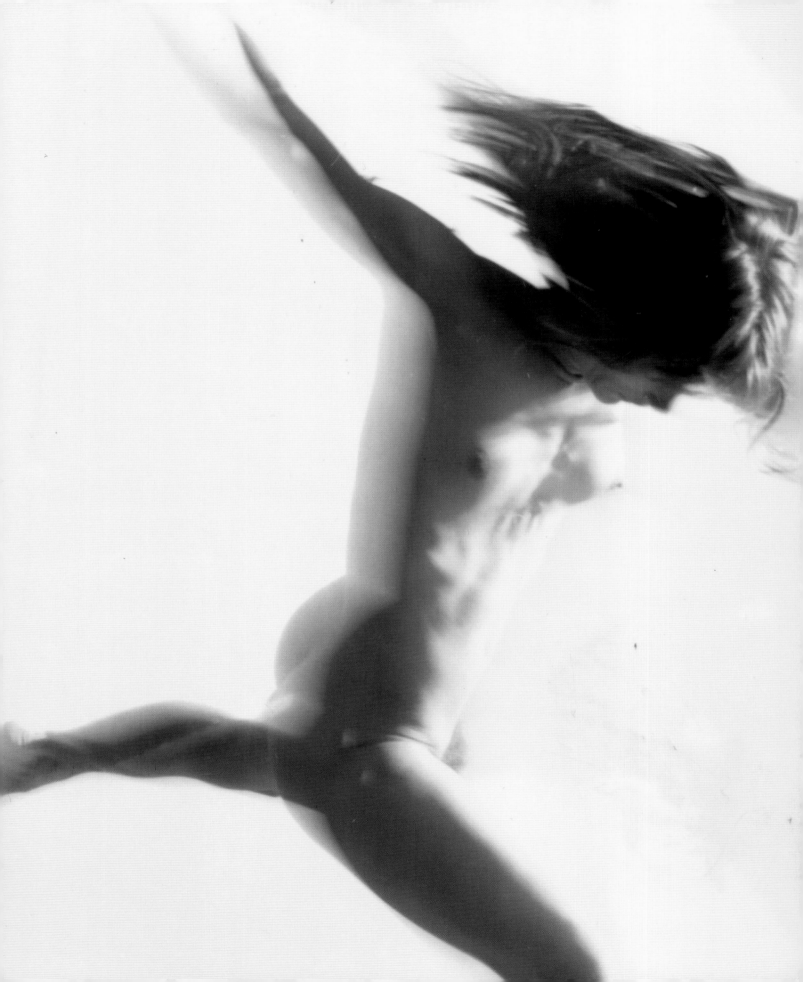

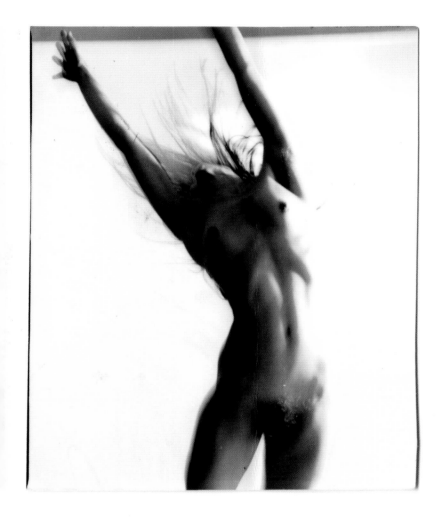

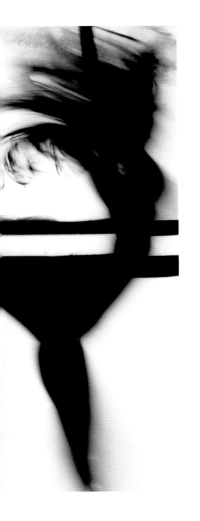
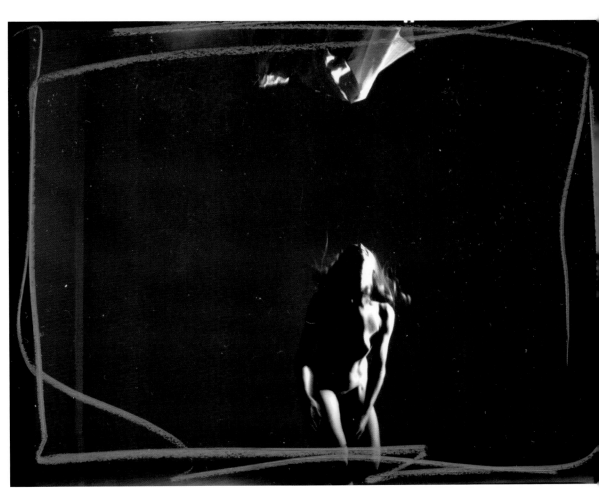

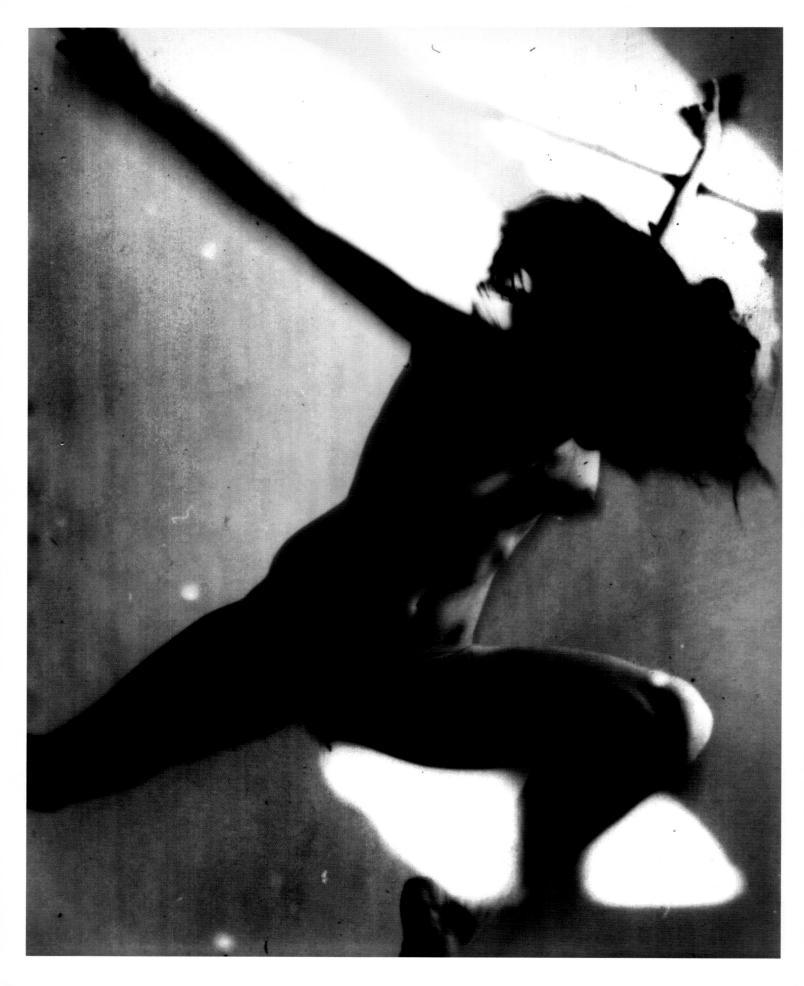

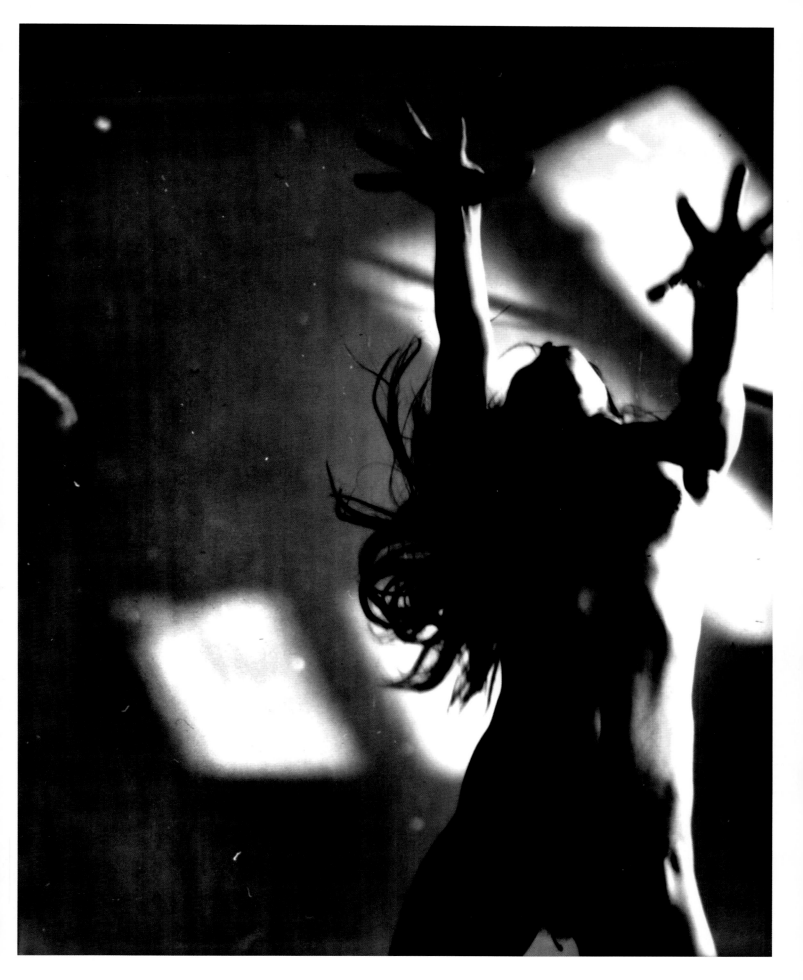

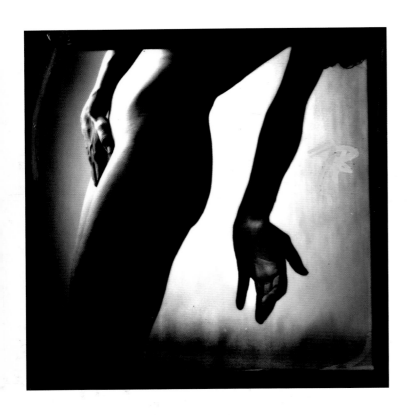
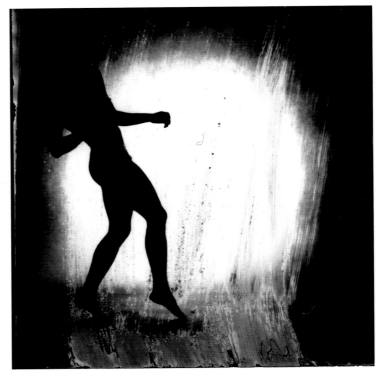

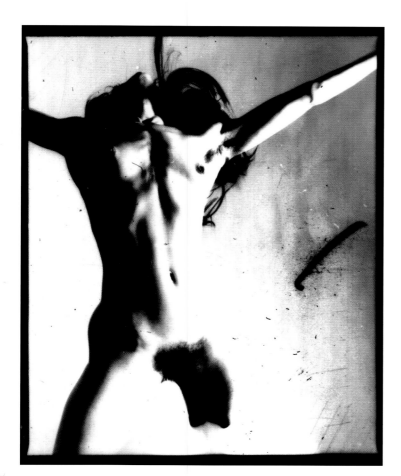

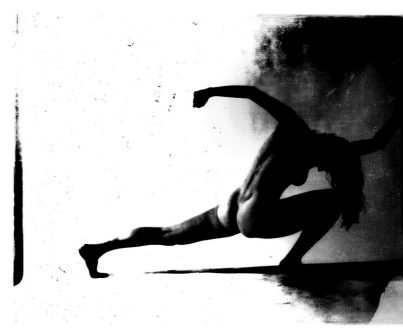

132 BROKEN ODALISQUE

A contrary take on the traditional view of "woman."

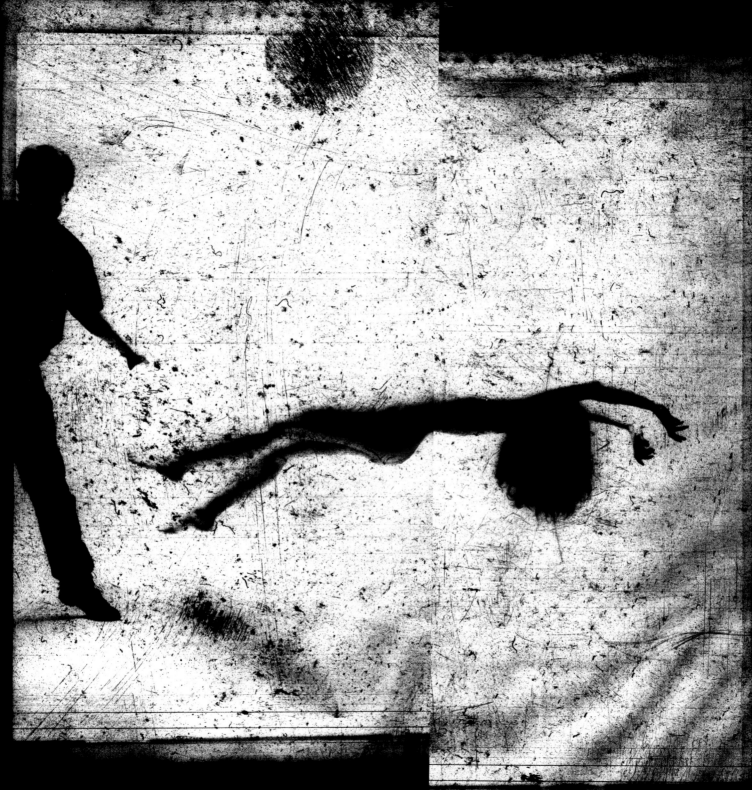

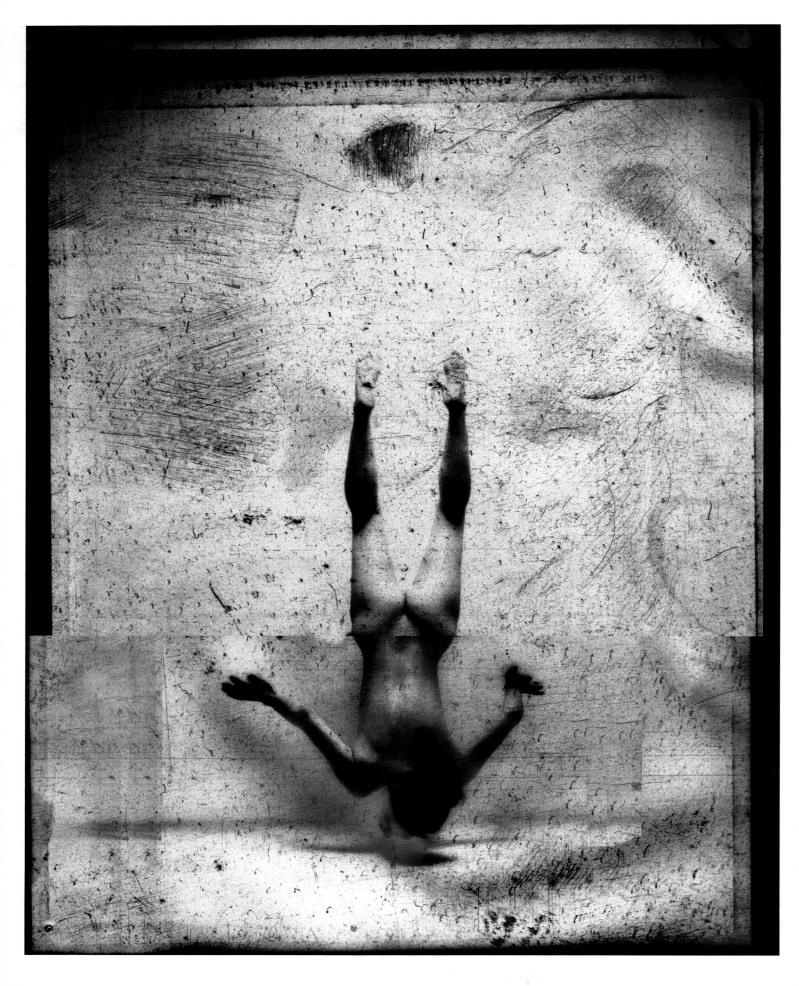

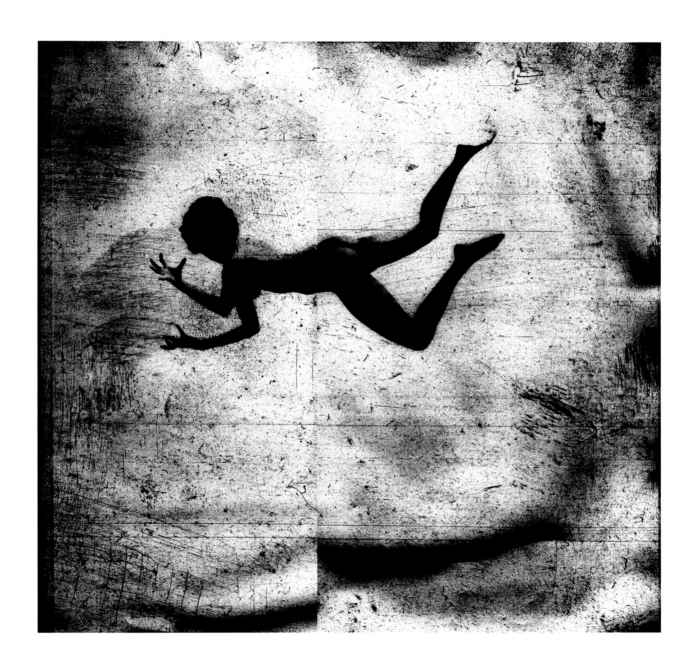

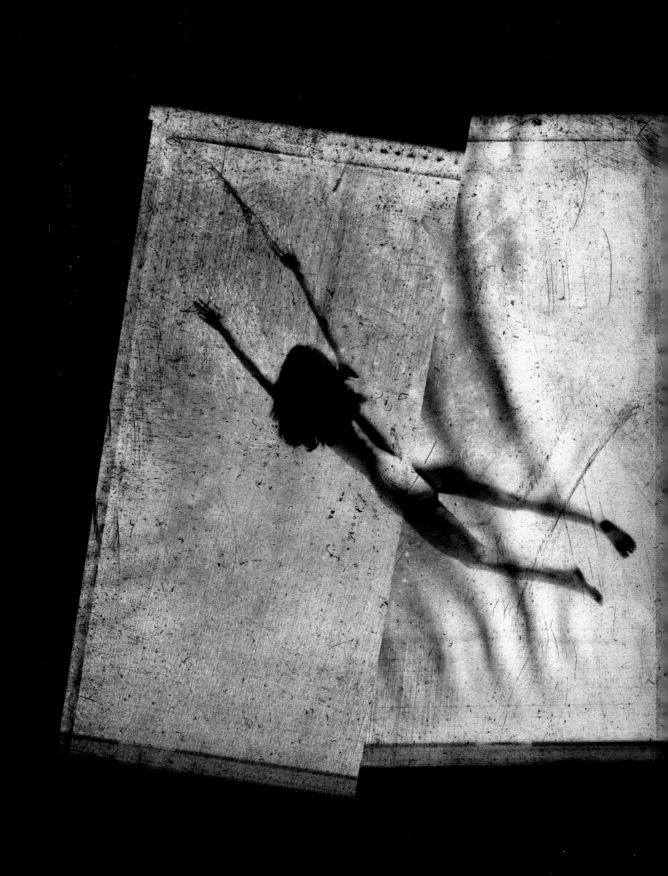

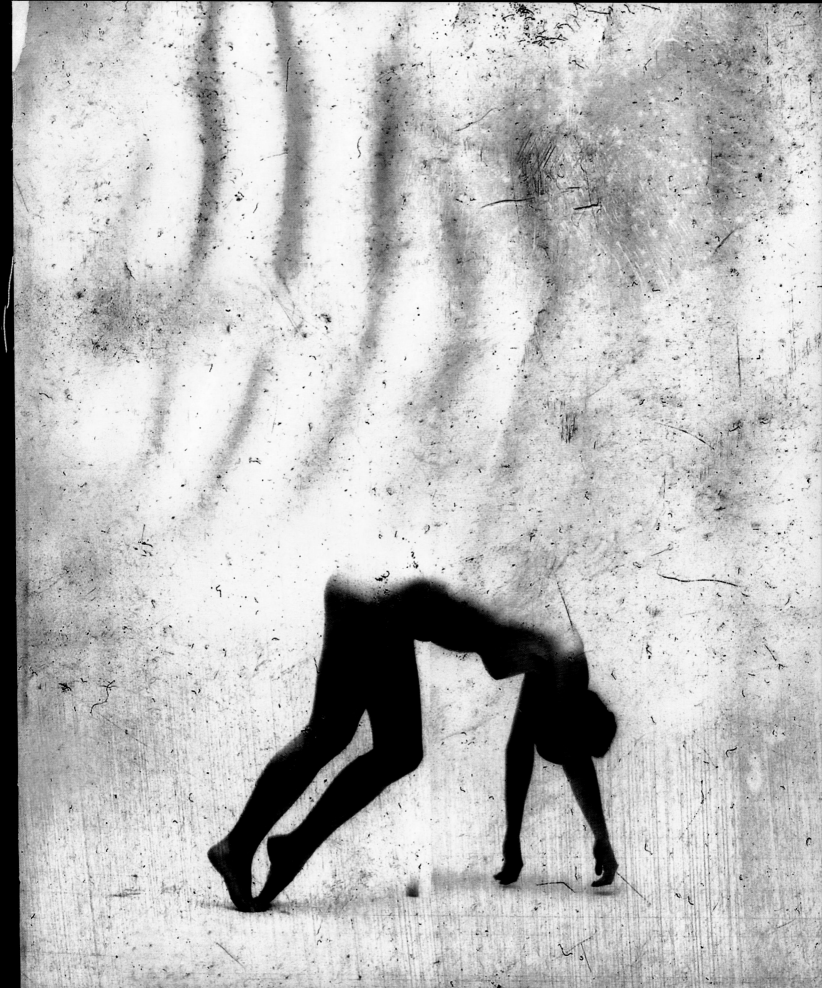

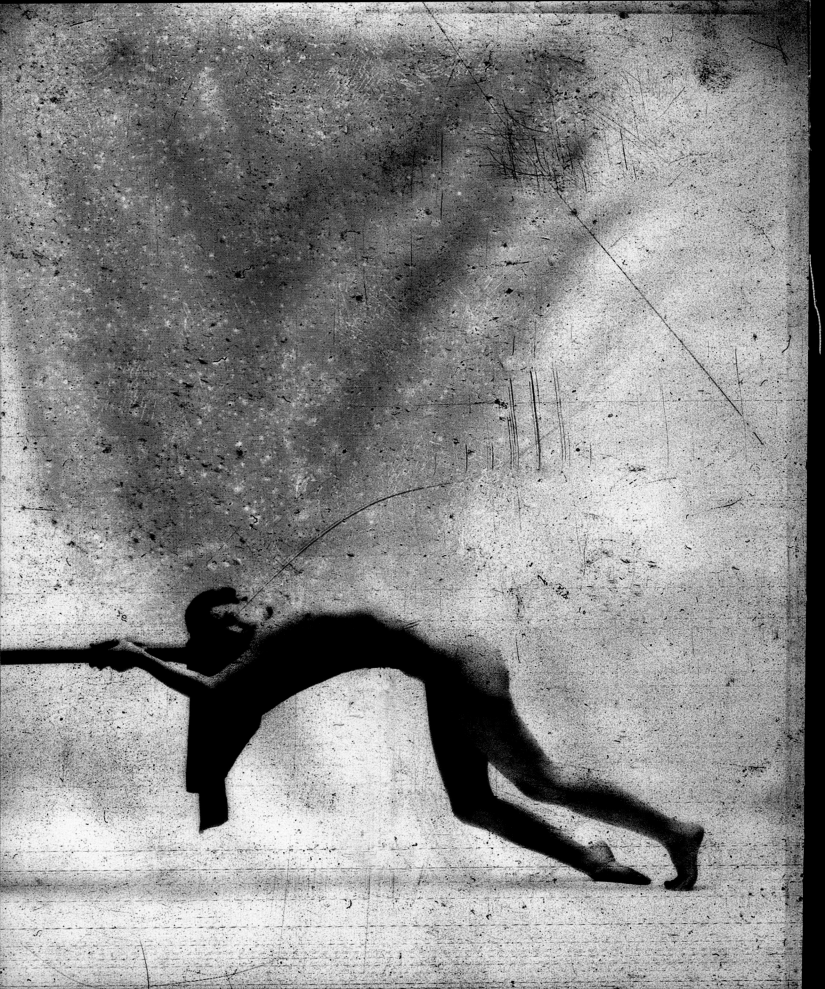

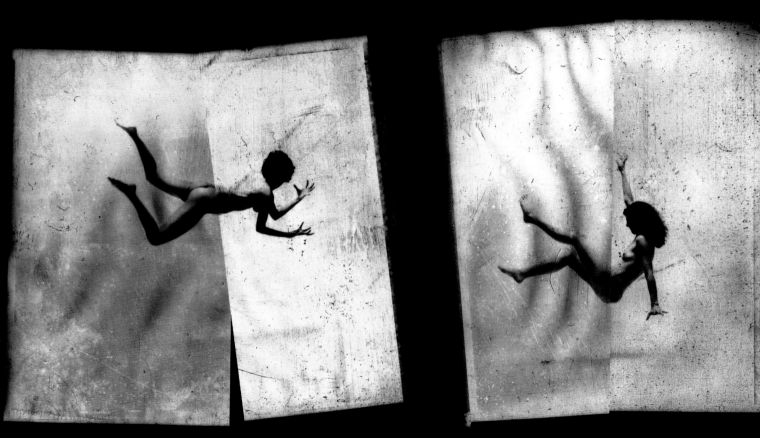

140 CONSIDER THE FLESH

How it works.

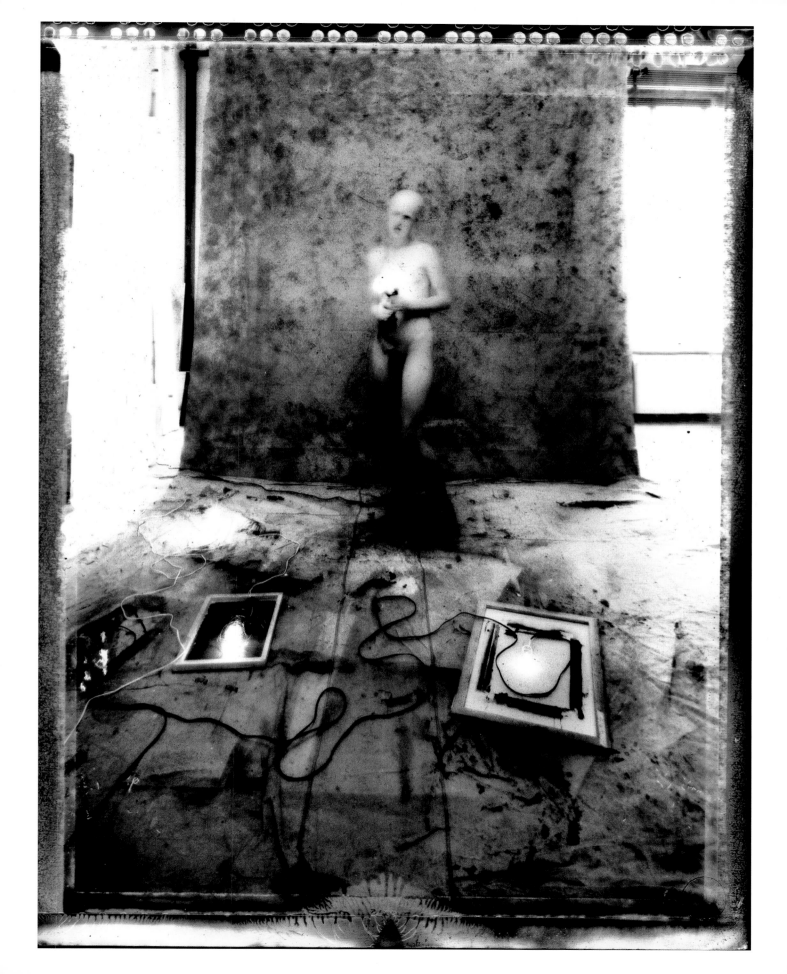

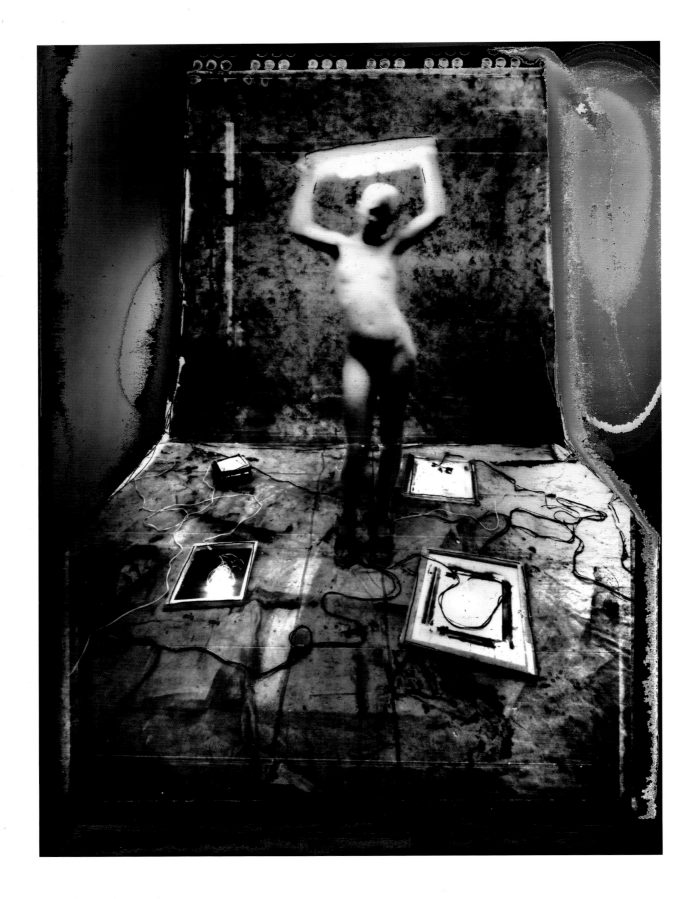

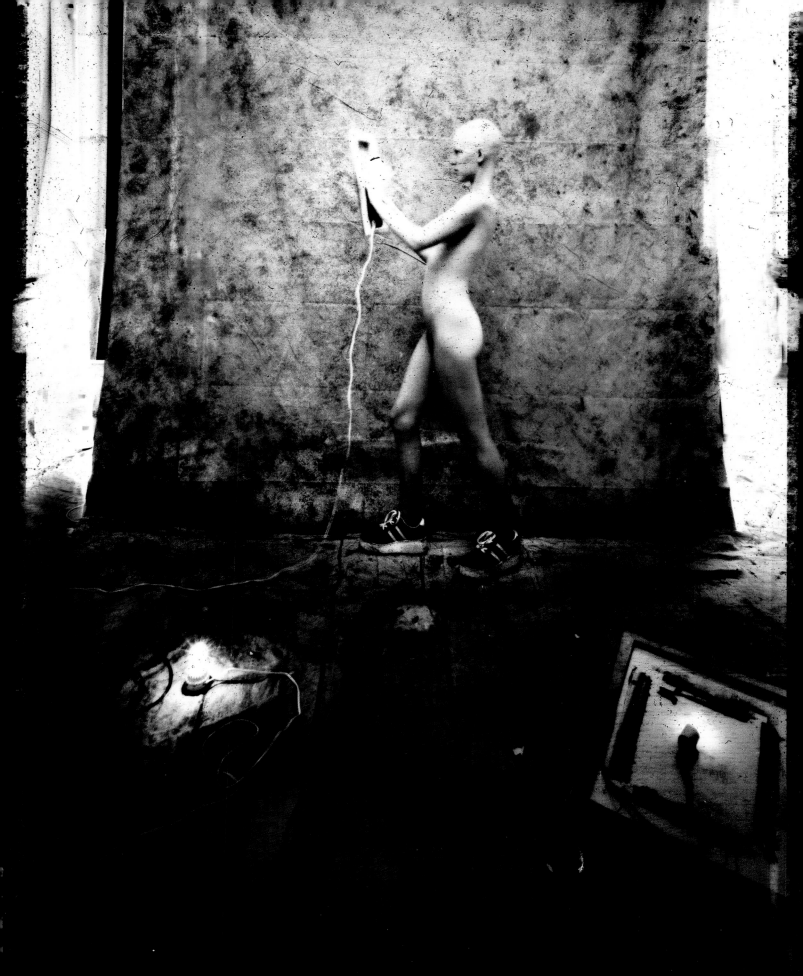

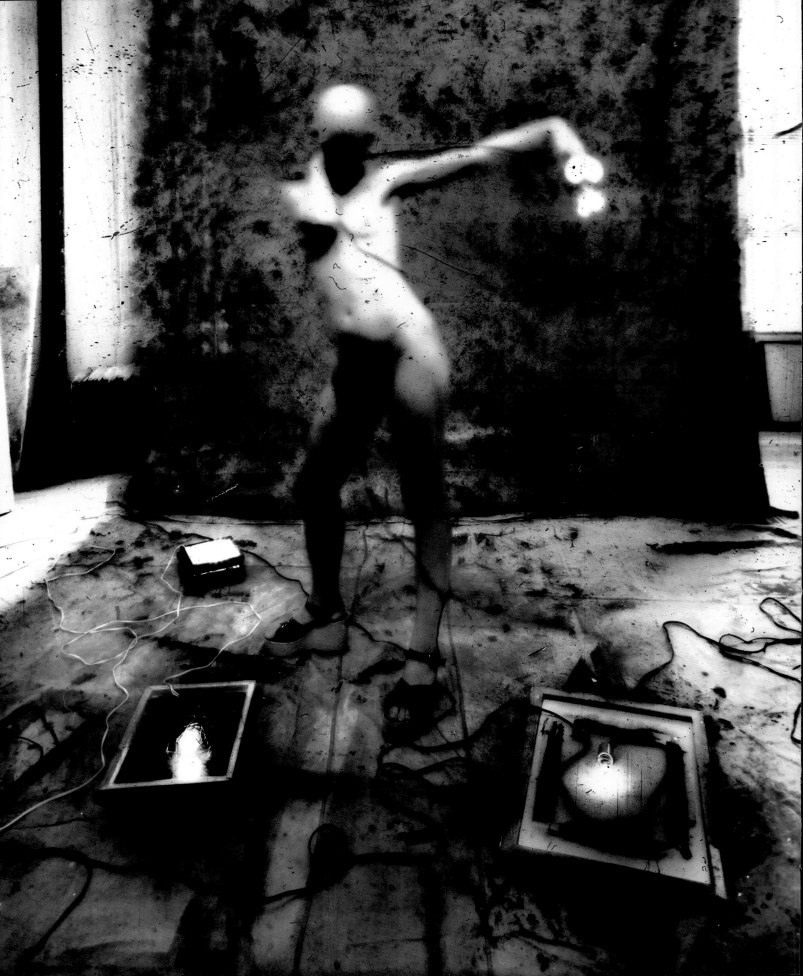

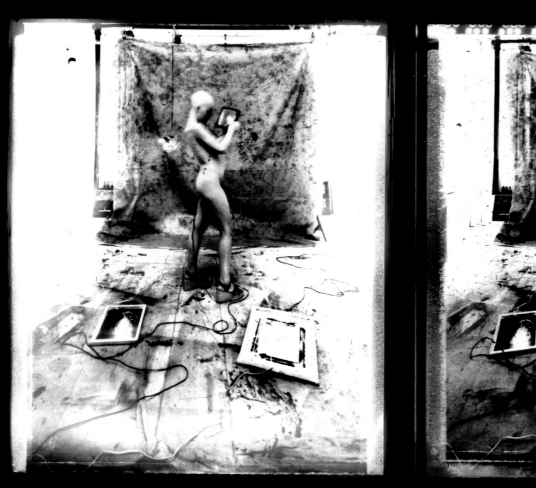
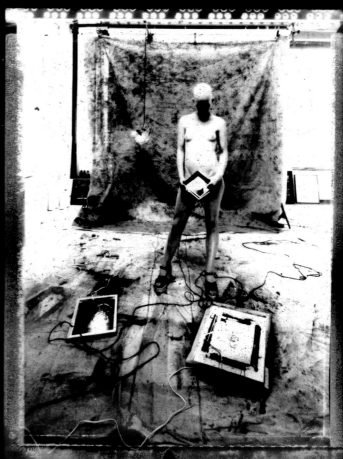

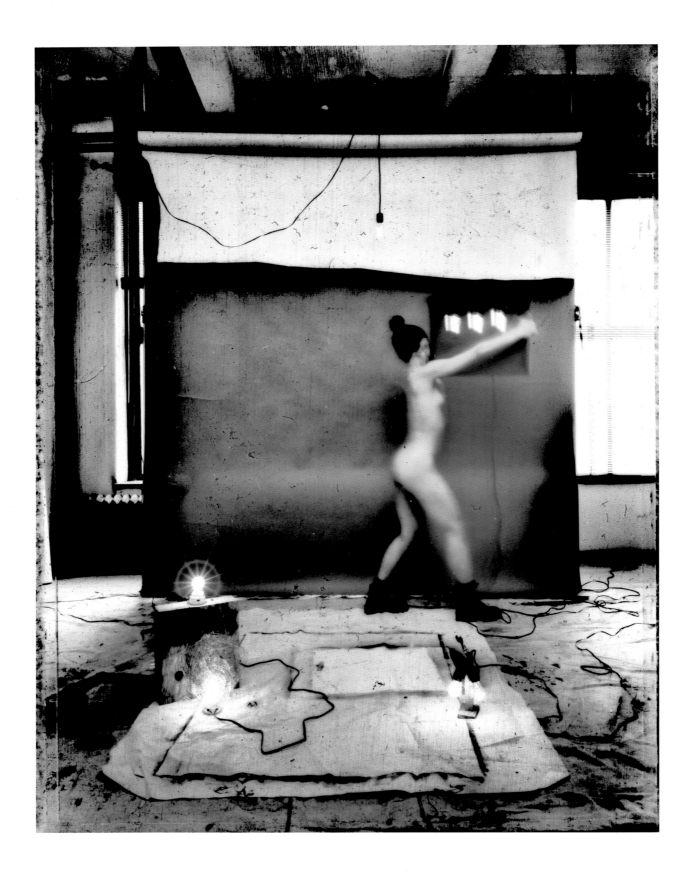

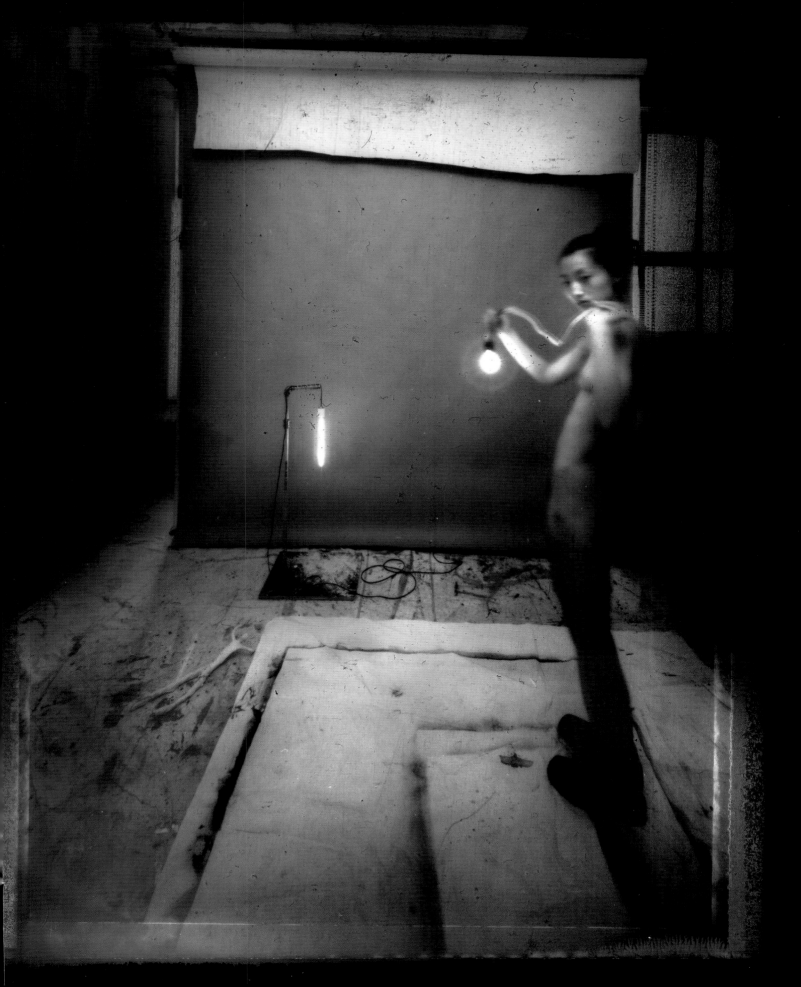

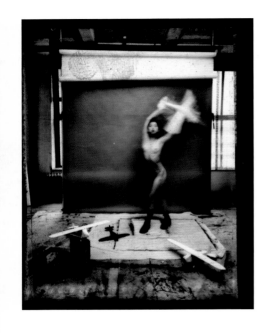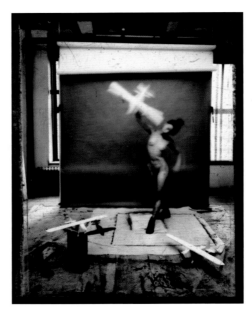

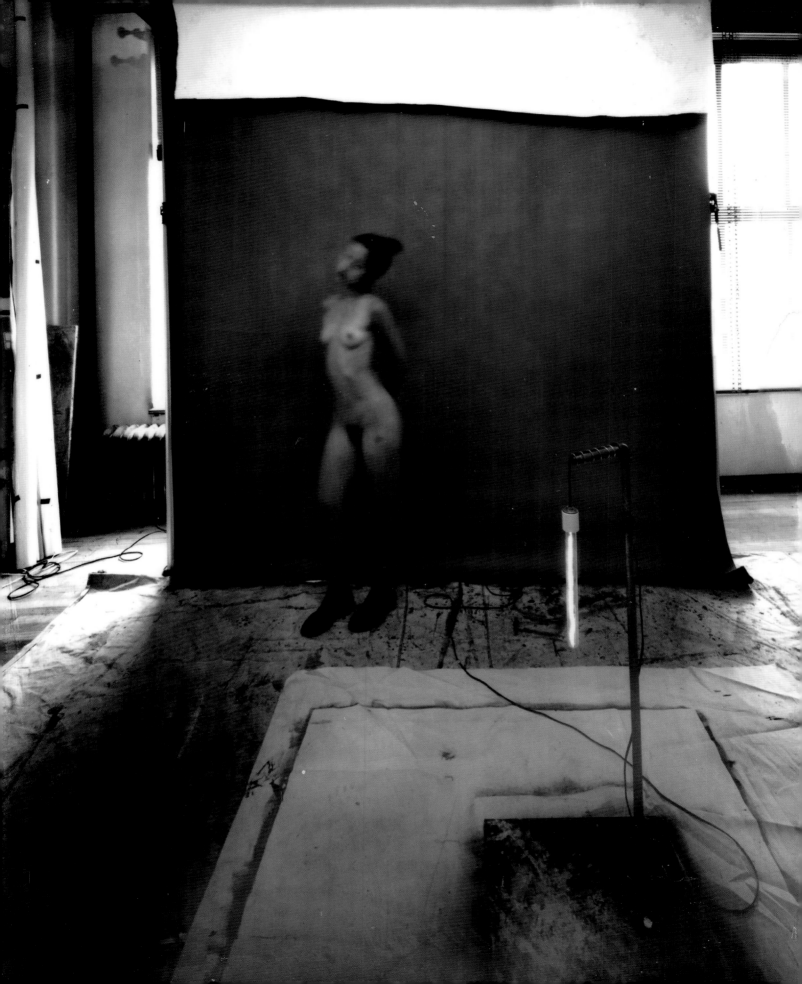

ACT 3

Portraits of the Collaborative-Self

THE HUMAN BIBLE

Man is only completely human when he plays.

—J. C. Friedrich Von Schiller,
Letters Upon The Aesthetic Education of Man, 1794

Landscape of the Soul

The invention of "portraits of the collaborative-self" is not about having your picture taken. I have learned to stop "taking" pictures—a futile effort of surface gloss at best—and have reinvented a way of seeing that affords far greater depth and fulfillment—my "portraits of the collaborative-self." By engaging the subject in the creative process, this way of portraiture opens unlimited possibilities of heart, experience, and a bounty of unexpected truths.

This process is about reclaiming the authority of body and blood, serendipitous creation and imagination. This portrait process strips the gloss of civilization to allow "the foam of the unconscious," as Francis Bacon puts it, to surface.

It's play. "I'm Nobody! Who are you?" (Emily Dickinson)

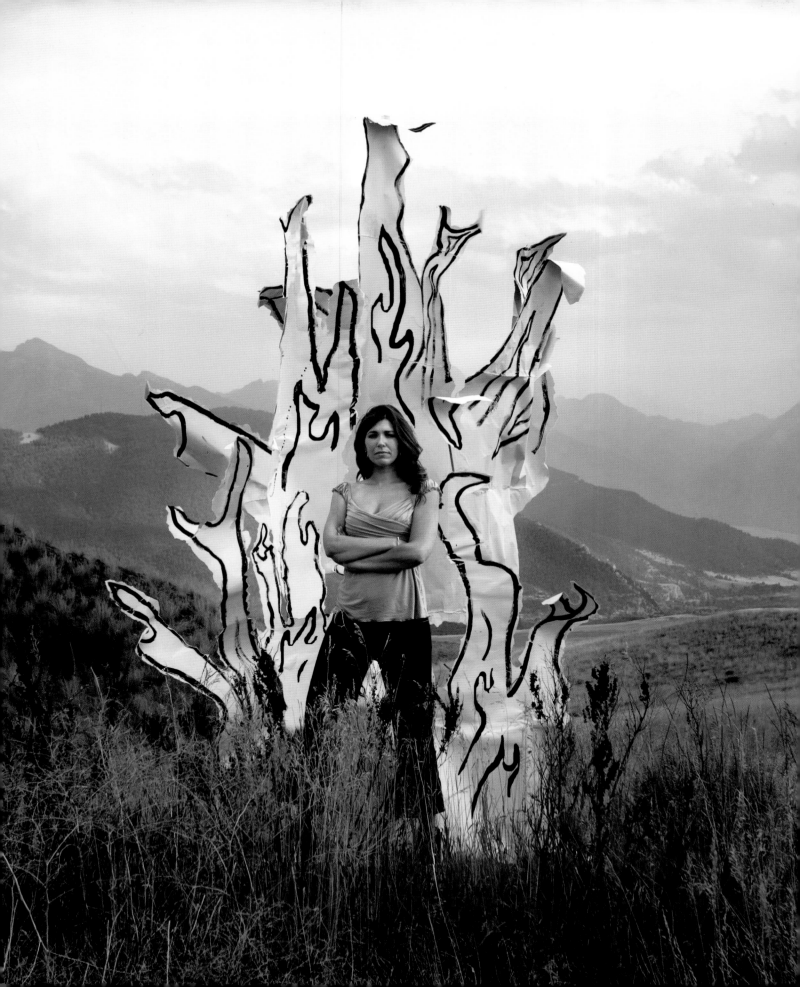

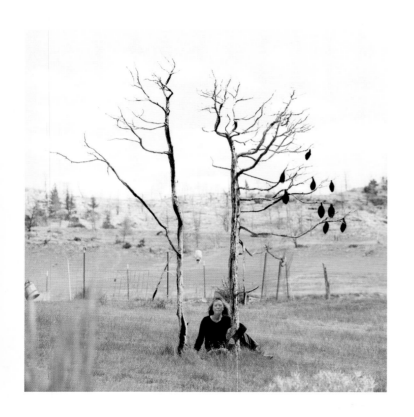

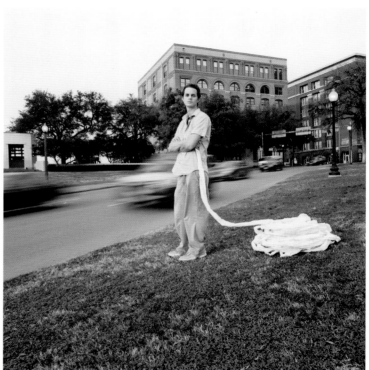

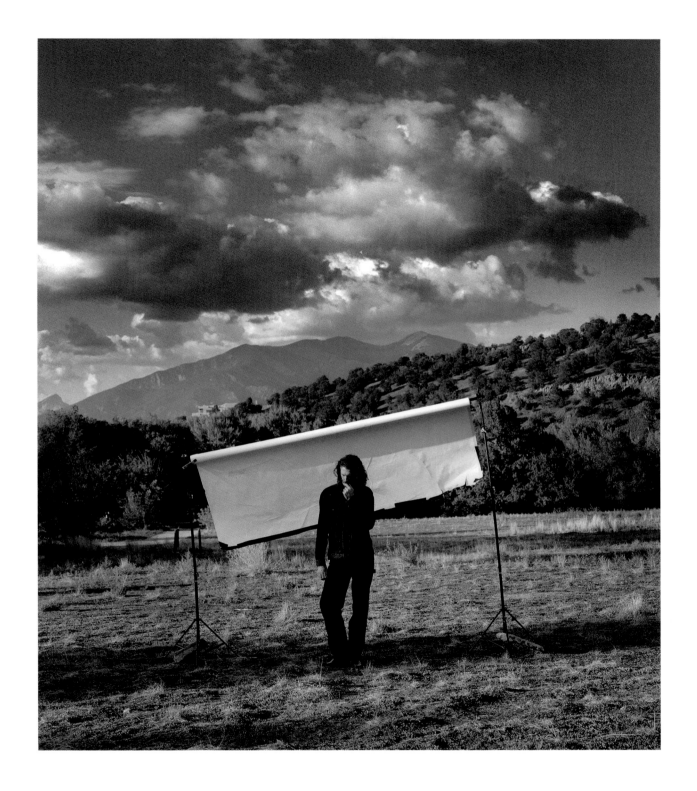

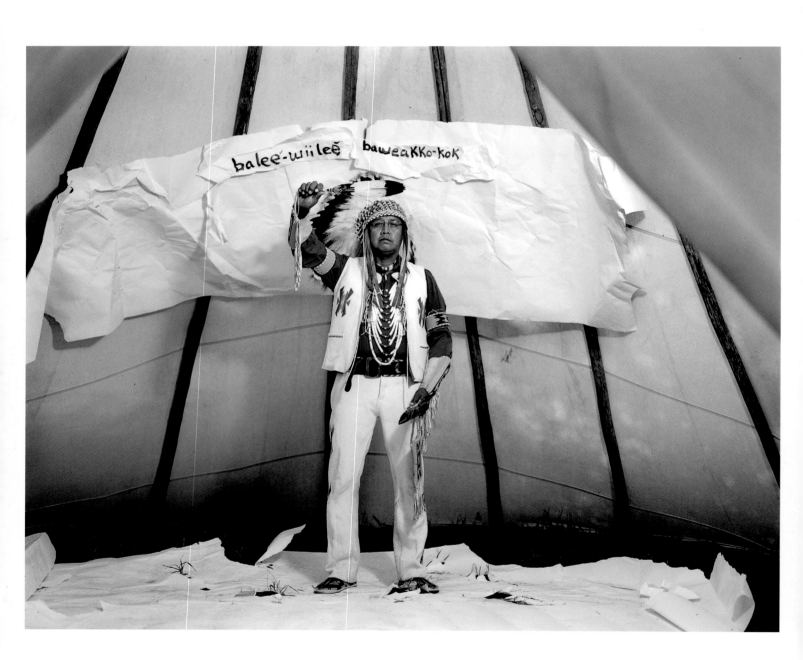

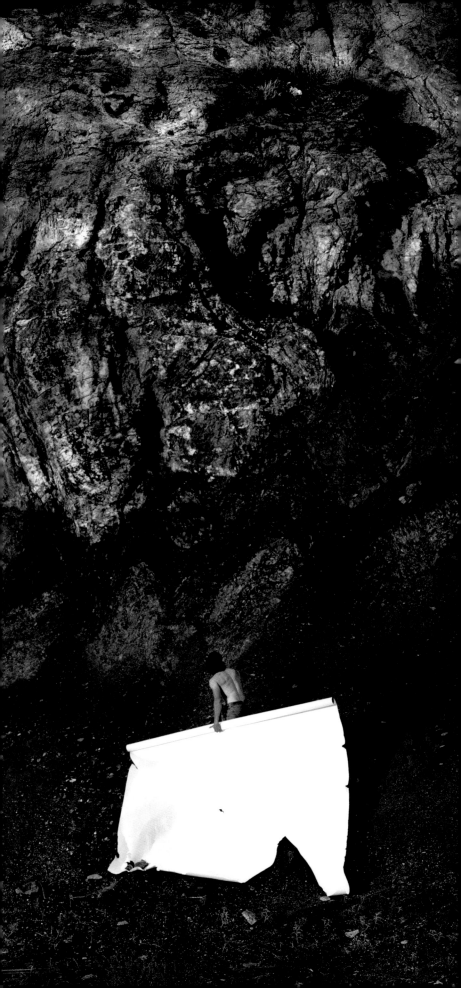

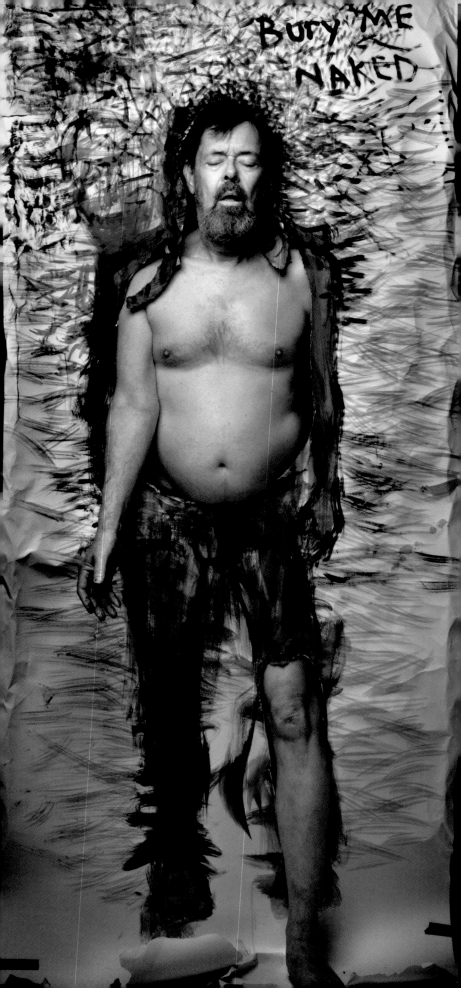

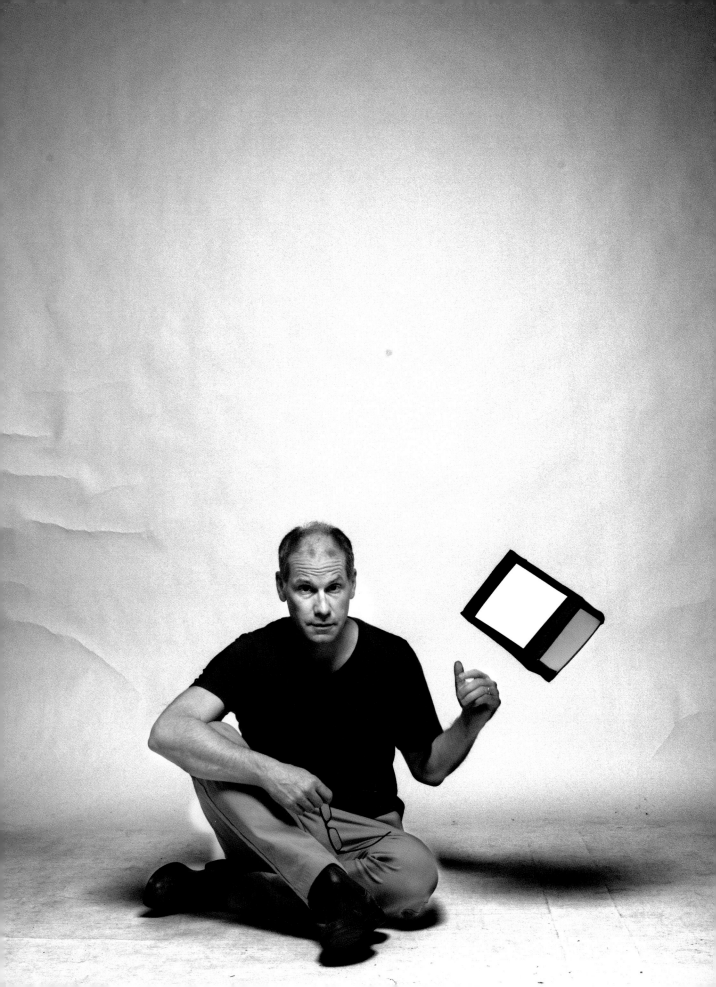

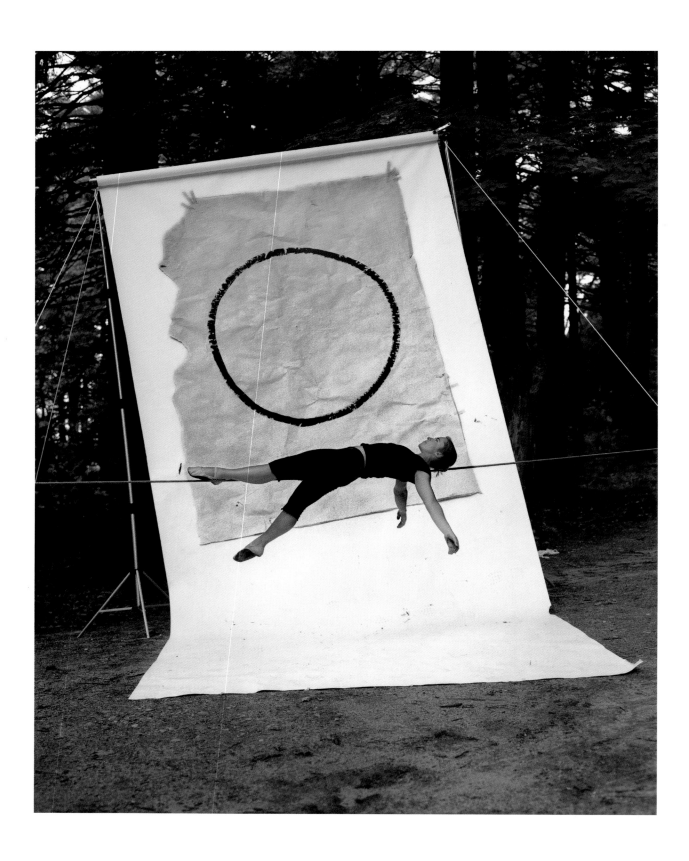

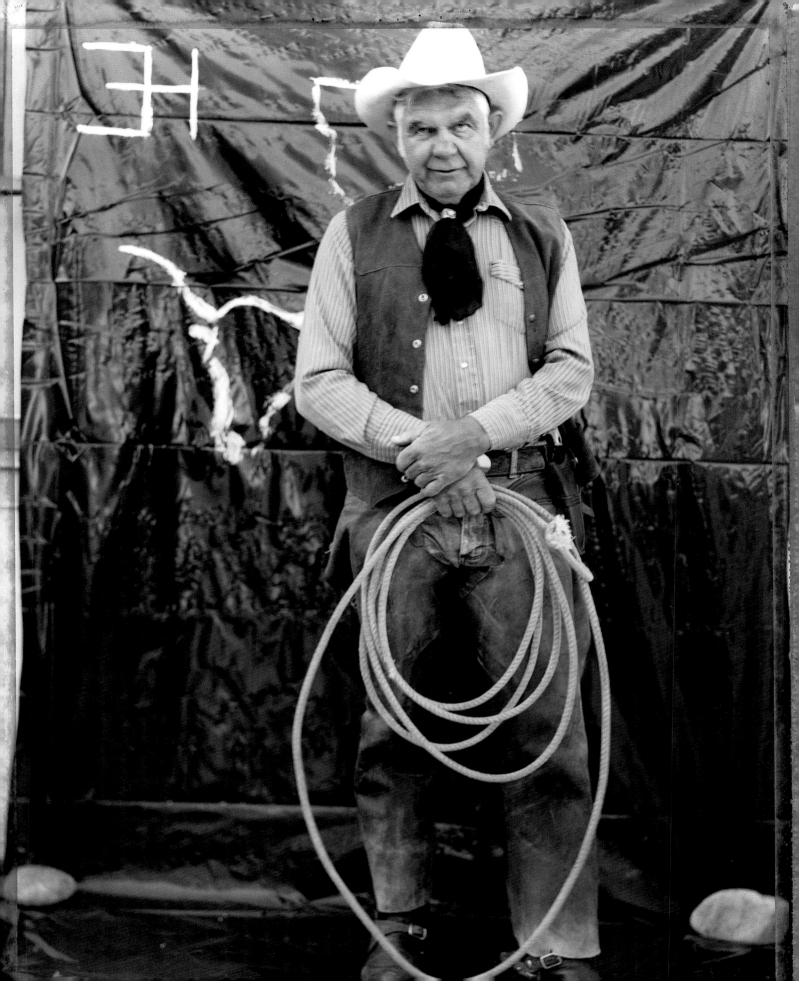

THE PORTRAIT PROCESS

Unexpected Truth of Experience

"I work with the unexpected."

—Clarice Lispector, *A Breath of Life*

A process I invented.

All of these portraits derive from a Conversation (not an interview) between myself and the subject.

In the course of this Conversation, which often goes on for hours, the subject will unconsciously strike upon some feeling that is true to them and their heart. Not a thought-out reaction, but an extemporaneous inner truth. An "unexpected truth of experience."

Working from this "unexpected truth," the subject then uses the paint and or paper to construct a setting for their portrait. They make their marks and then play in among these strokes for the portrait. All of the words, marks, constructions are executed by the subject. Their touch of hand and heart.

And there is the fulfillment of having had a real encounter, of visiting Emily's "reportless places" for the both of us.

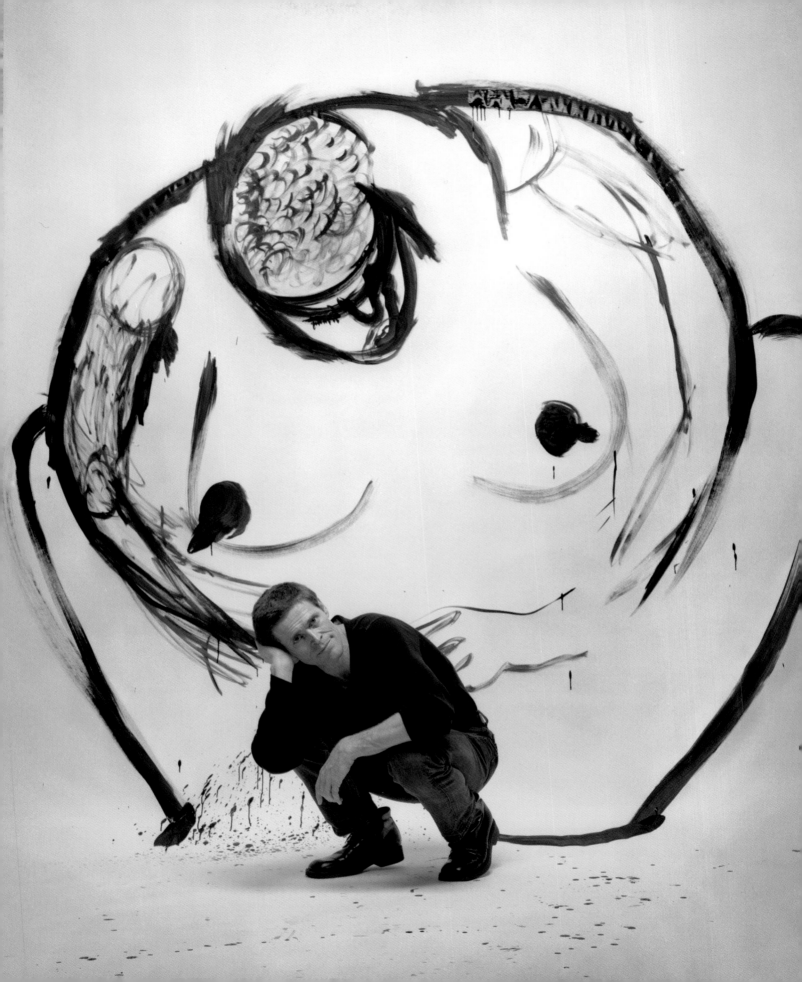

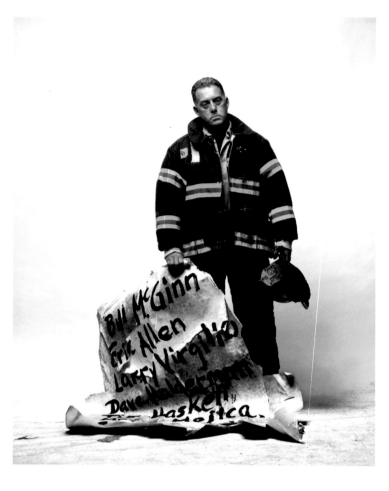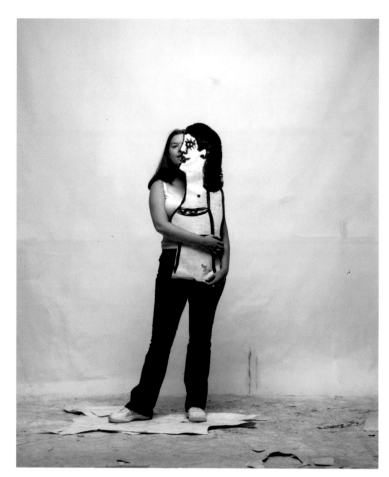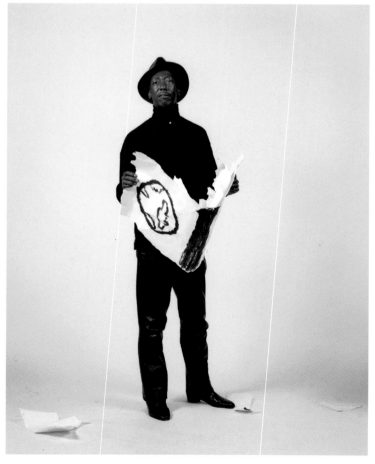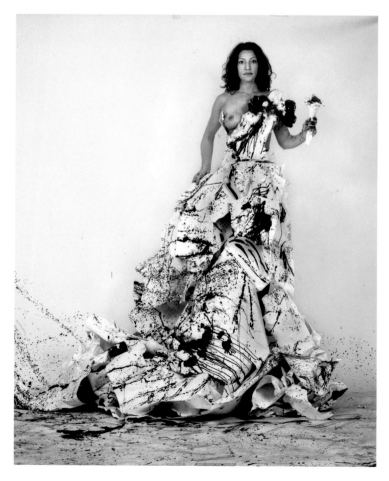

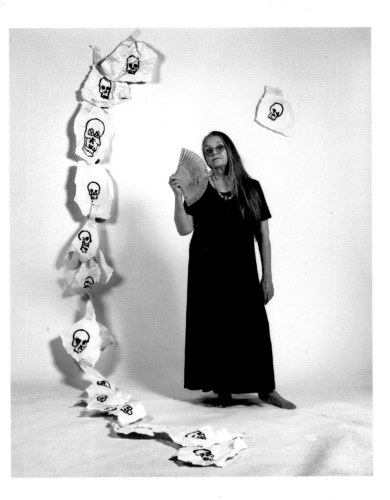

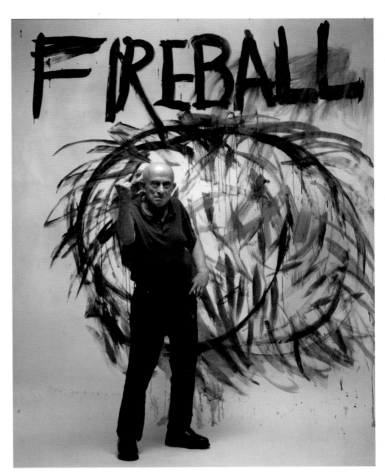

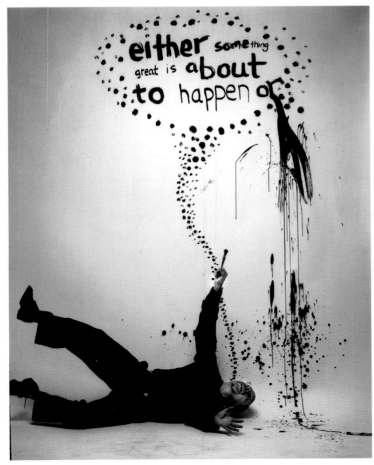

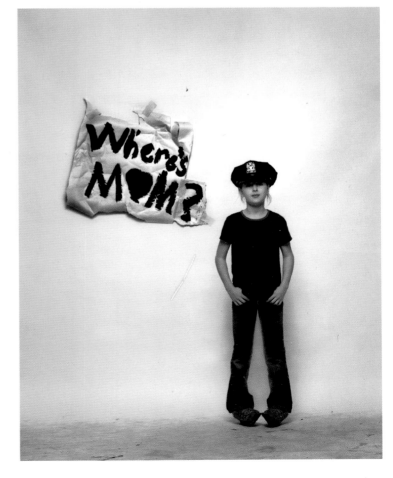

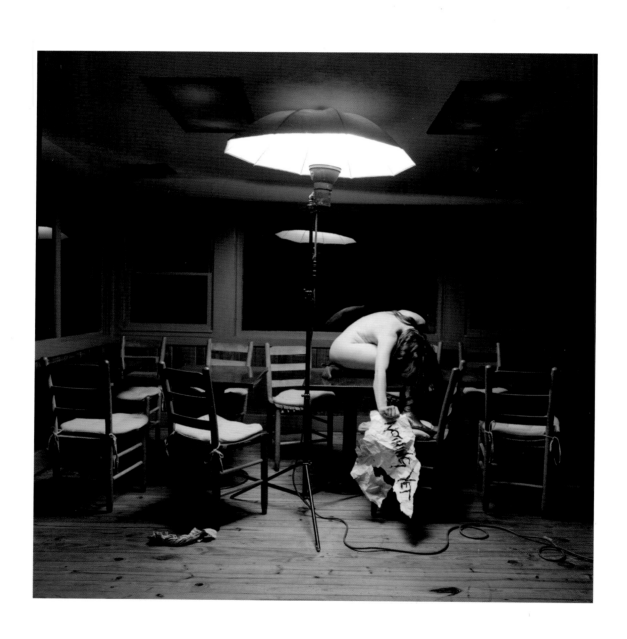

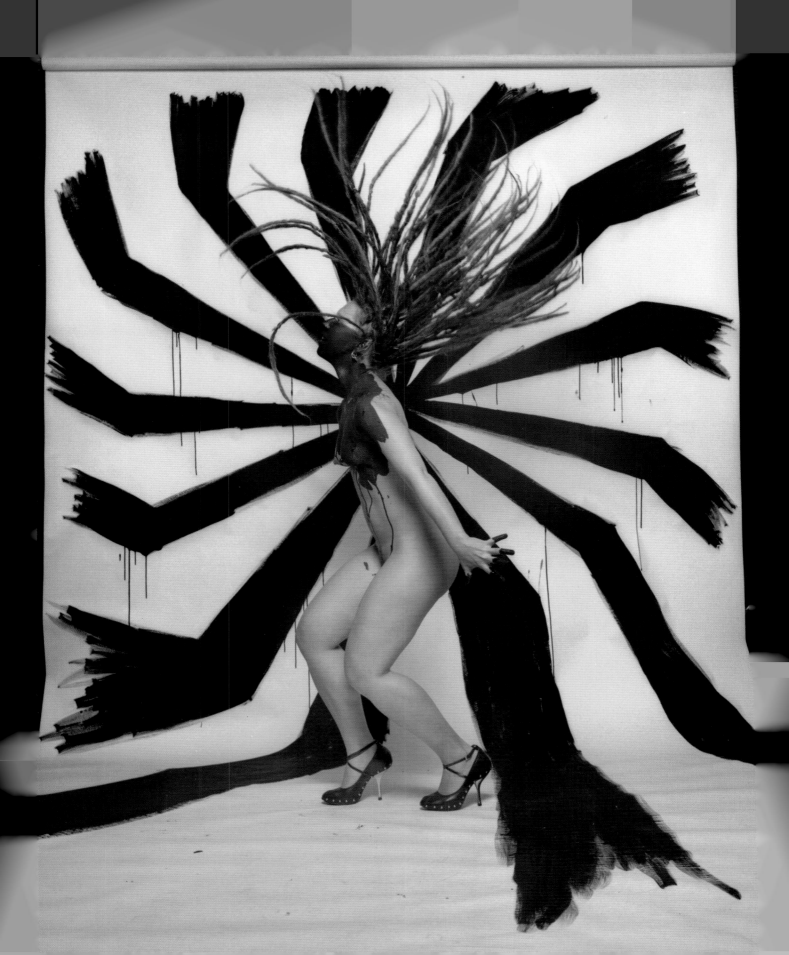

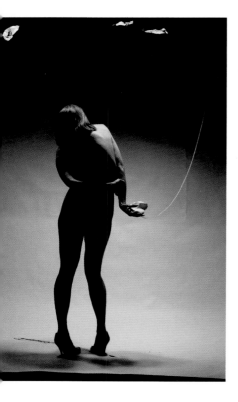
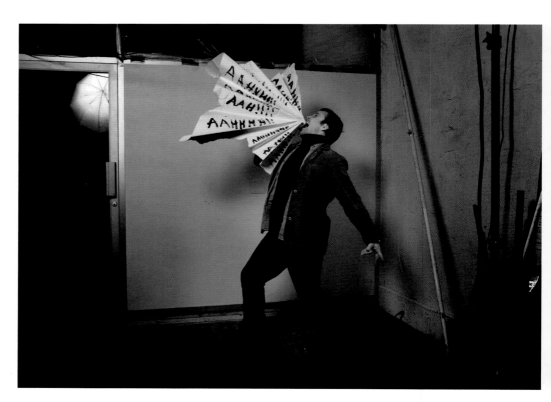
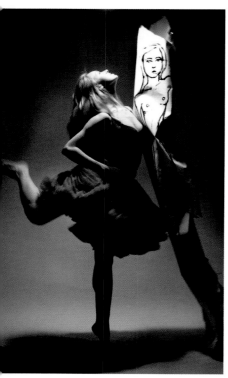
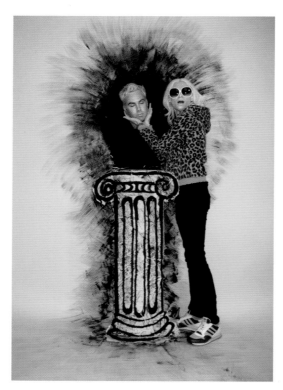
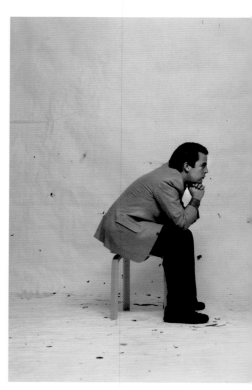

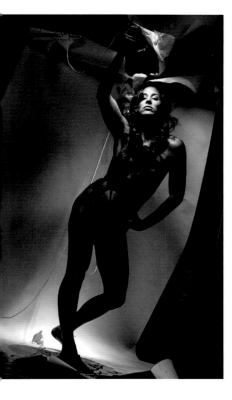

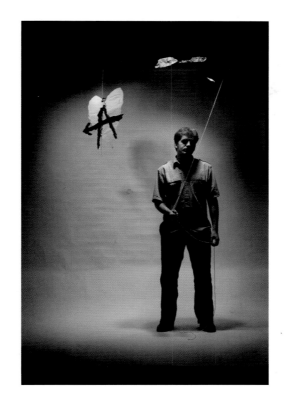

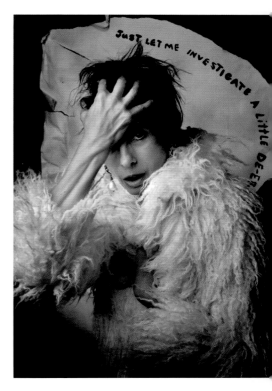

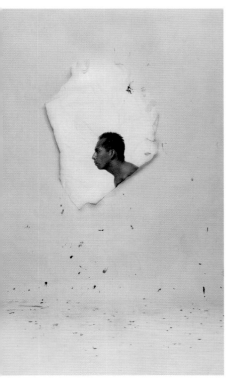

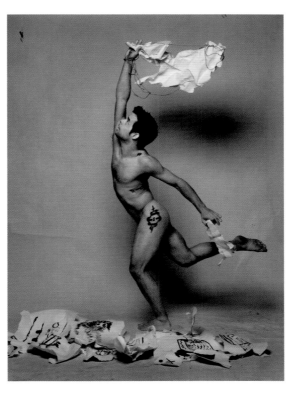

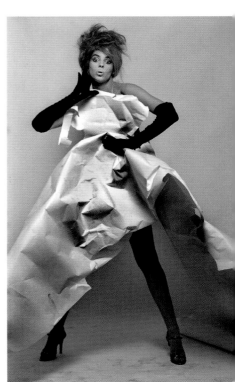

JUST LET ME INVESTIGATE A LITTLE DEEPER

THE THING ITSELF

"Hamlet or a Beethoven quartet is the truth about
this vast mass that we call the world. But there is
no Shakespeare, there is no Beethoven; certainly
and emphatically there is no God; we are the
words; we are the music; we are the thing itself."

—Virginia Woolf, *A Sketch of the Past*

In these images, we are looking inside body and blood,
into the practice of reclaiming the authority of one's
imagination. I am using art and play to look inside at
the thing itself, the weight of a human being. At what
connects us—what we all share. The images in the
human bible are creations in which people lay claim
to personal feeling—their words and their music of art,
heart, and imagination.

As I have traveled the country doing more than 500
of these portrait sessions, I find that regardless of
social and cultural affiliations, there is indeed a sense
of "being" common to us all. A place of fissionable fire
and passion that unfortunately is little nourished or
acknowledged—the sense of imagination. Imagination,
which is our only place of true freedom.

57°
unexpressed
feelings

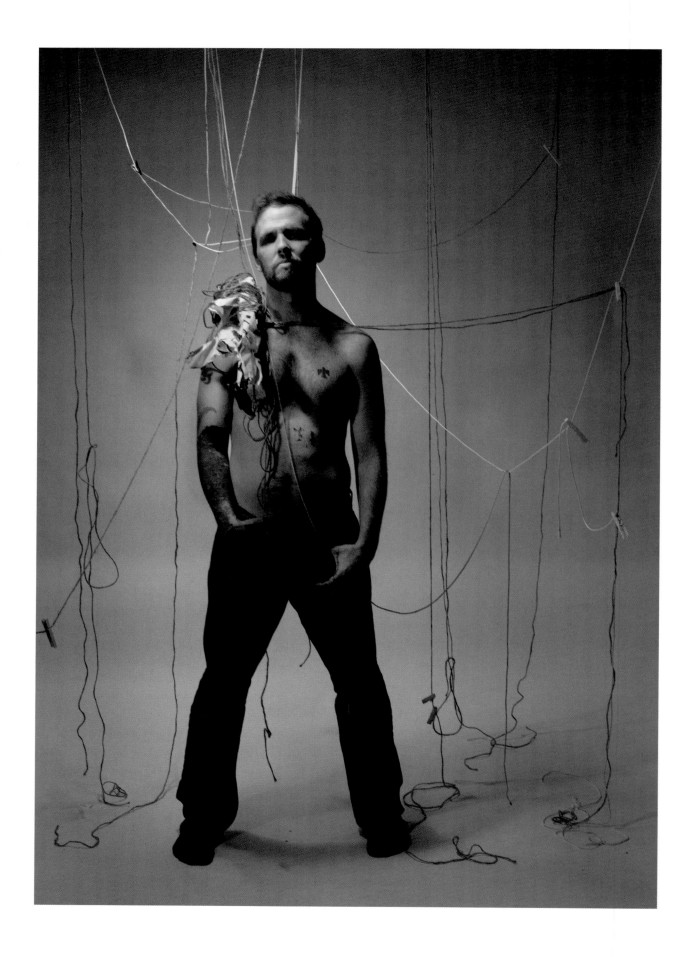

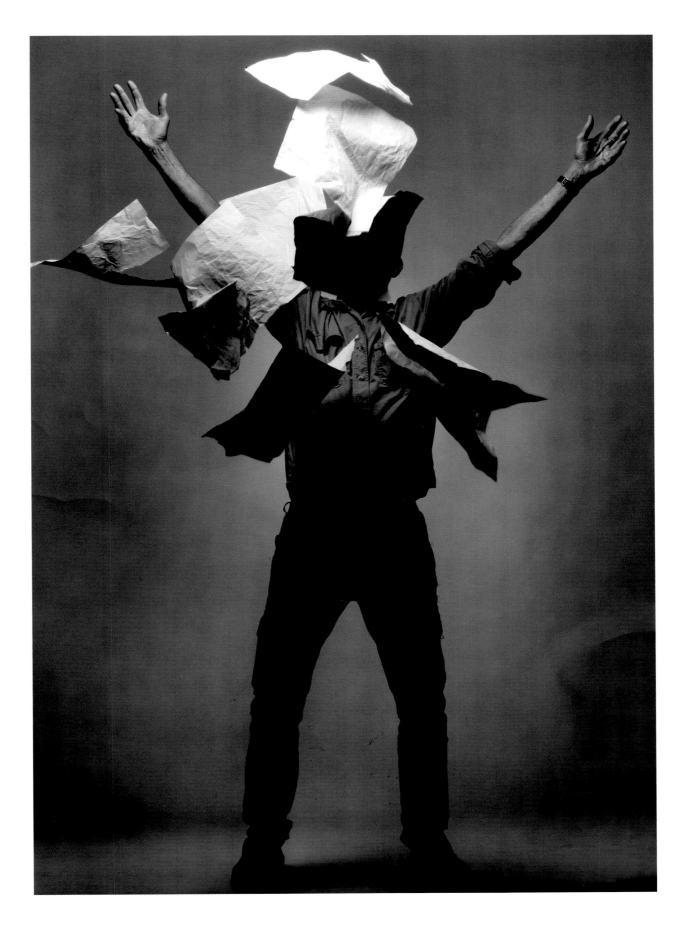

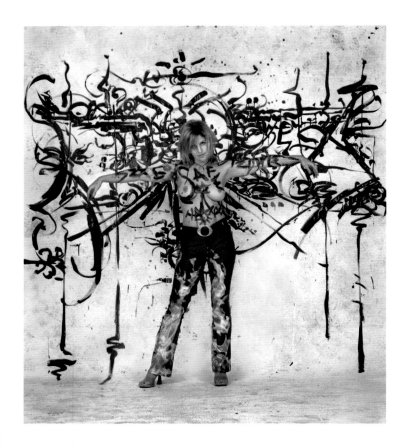

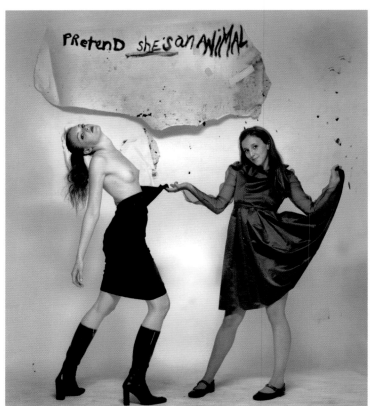

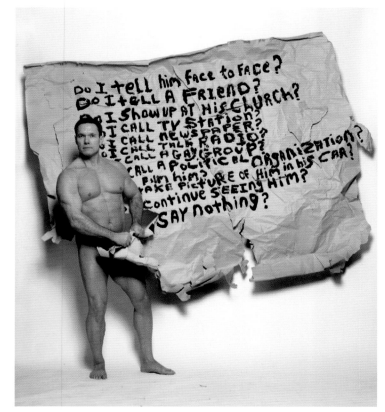

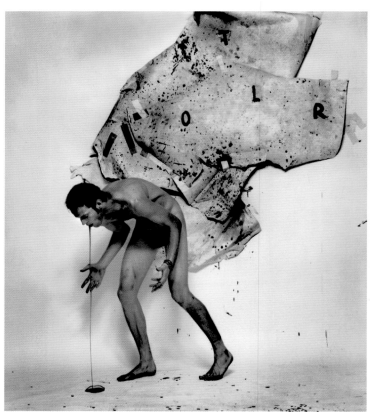

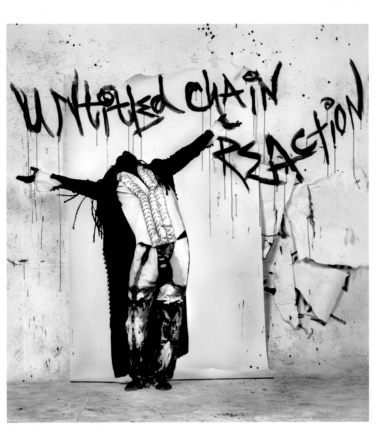

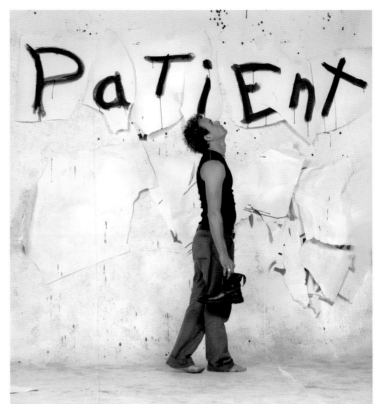

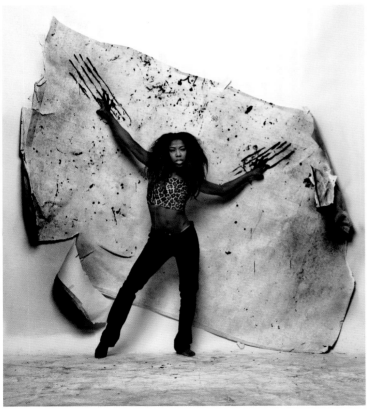

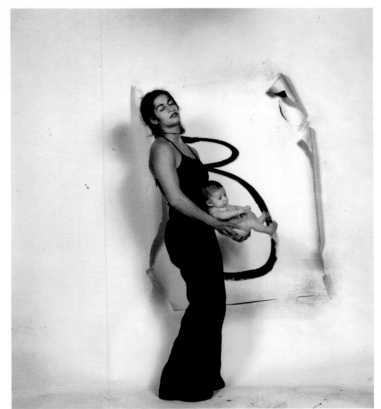

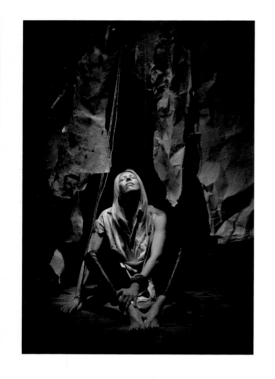
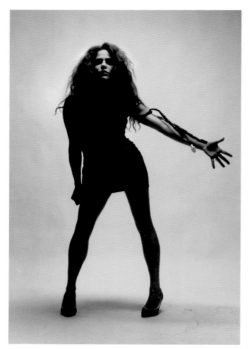
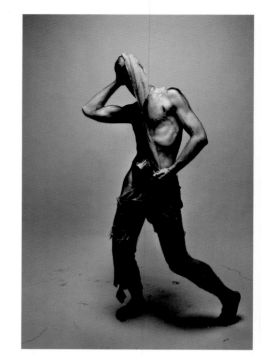
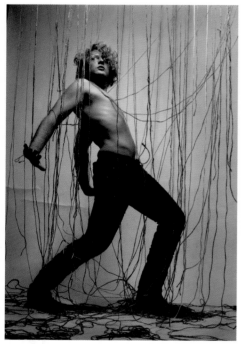
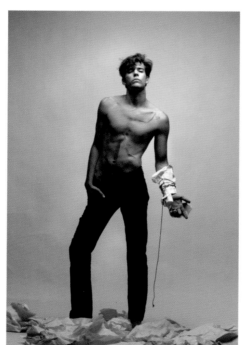

a story I never dared to tell... I'm ...
...le telling it now. I'm afraid that if I tell it tru...
...oone will believe me. Or perhaps people will believe me...
they will not like me. That is the risk you take, I
guess. But I am not happy about it. I'm scared. I
want someone to guarantee me that if I do tell the
story truthfully and fully I will not be disbelieved
or disliked. I want to know from the start that everything
will be all right once I have revealed the things I am about
to reveal. Anyway, here goes. But before I start, please
allow me a moment or two to gather my wits and
screw up my courage. I think I'll do a breathing
exercize. Also, I want to warn you that I
often make stupid spelling errors. So please
do NOT THINK LESS OV MI iff I cannot
MĀK MYself perfectly CLĒR. R U
ready for my story? OK ... goes.
It all began... forget it. Ire
NOT INTERESTED

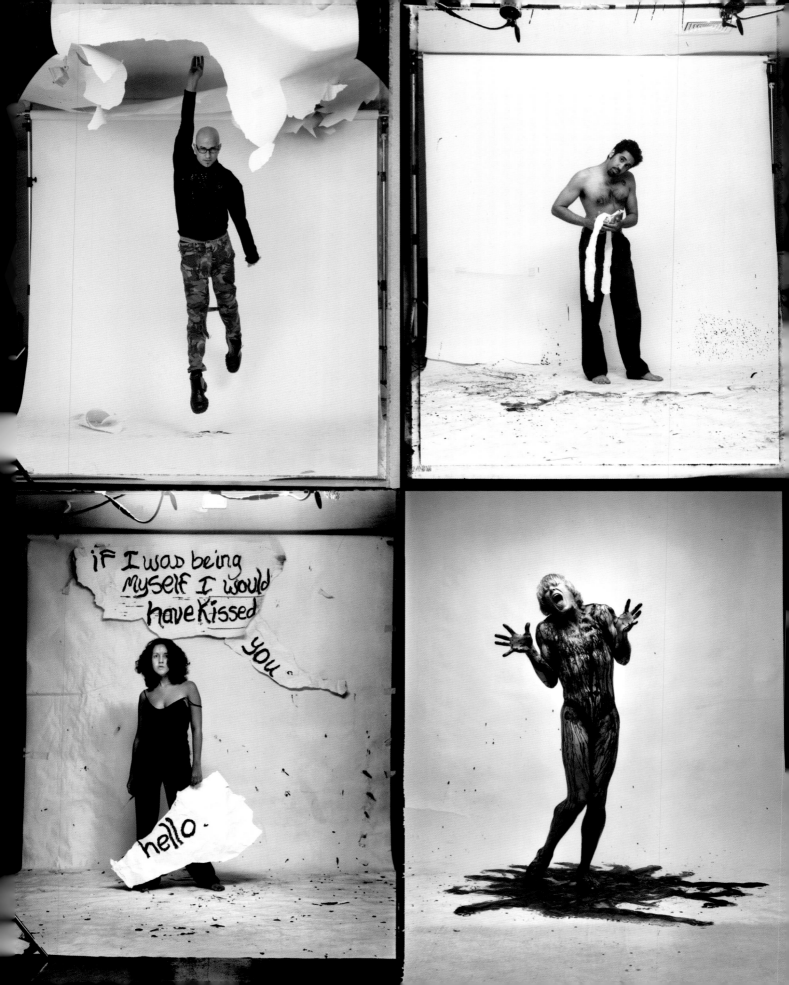

if I was being
myself I would
have kissed

you

hello -

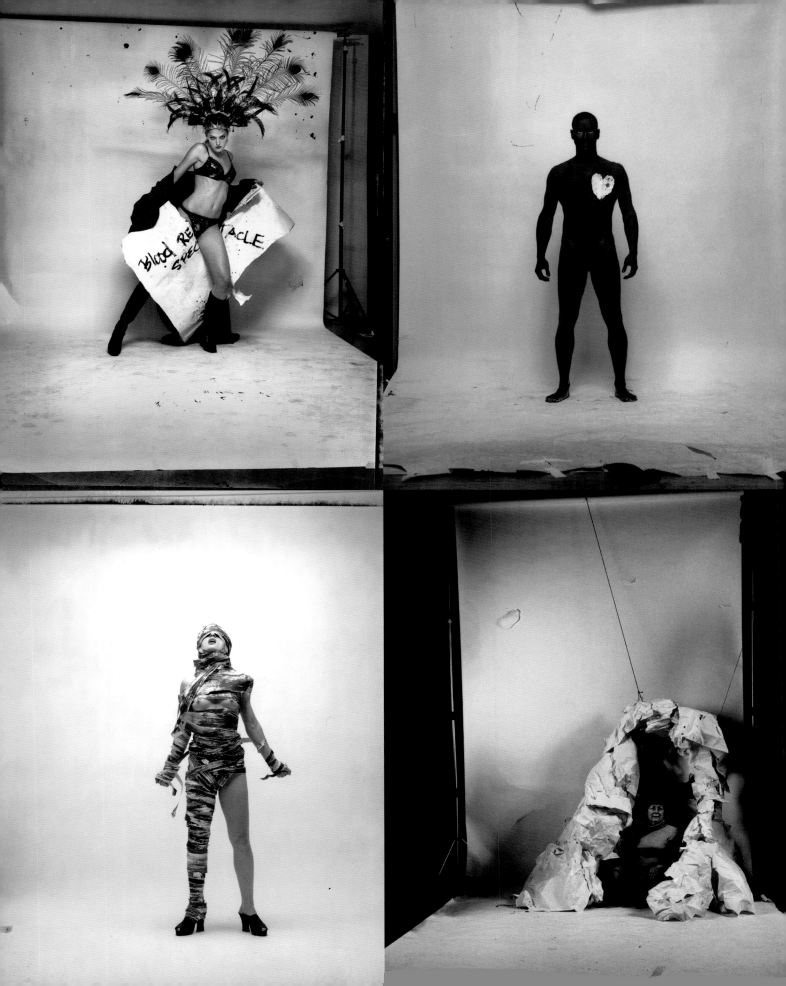

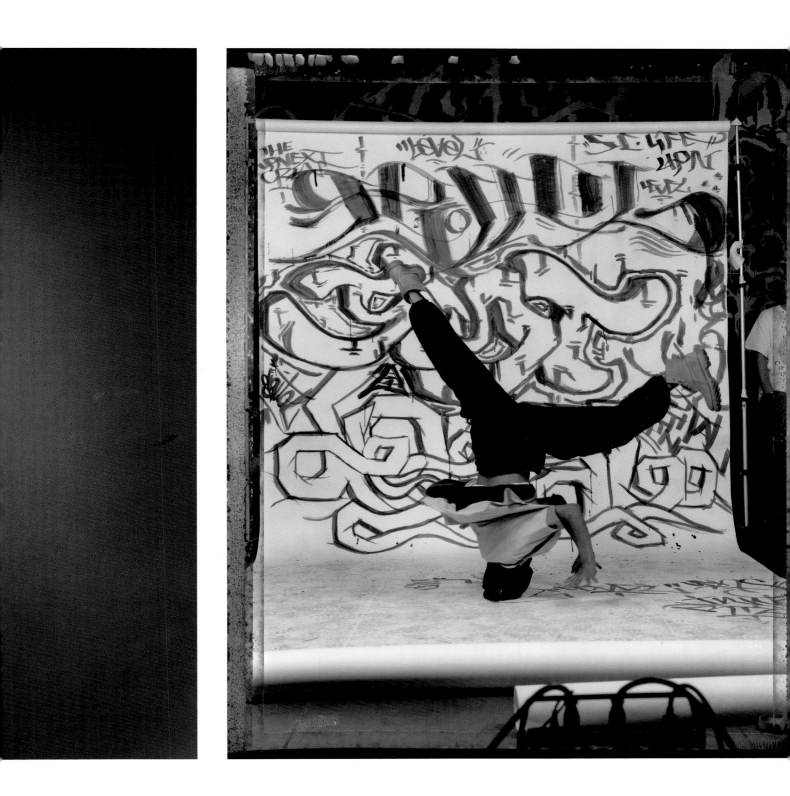

17 BEDROOMS

180 A Spaghetti Western

A collaboration with Joanne.

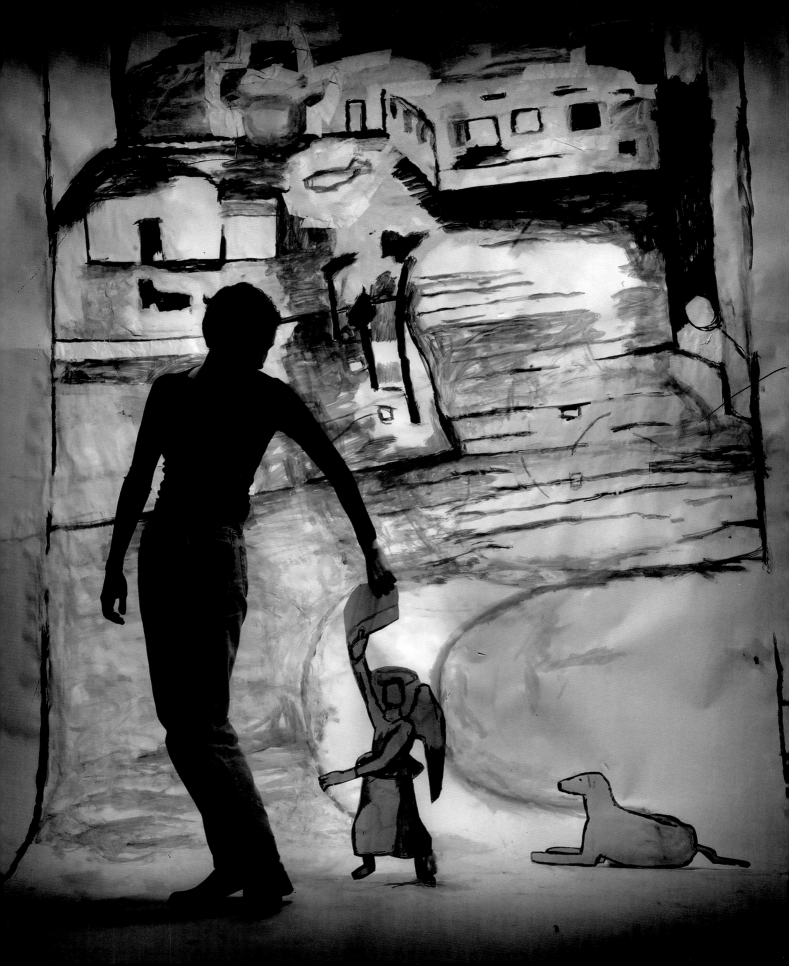

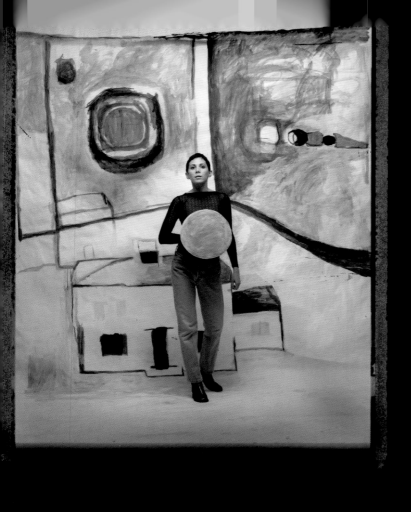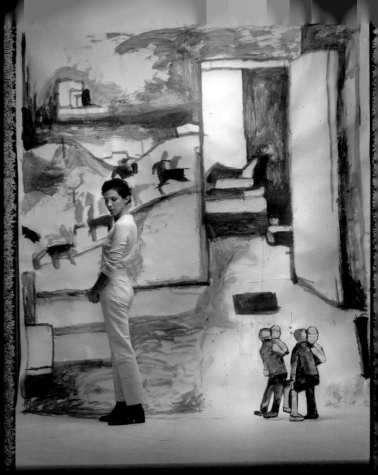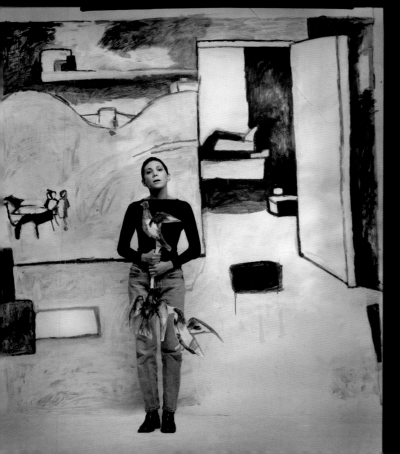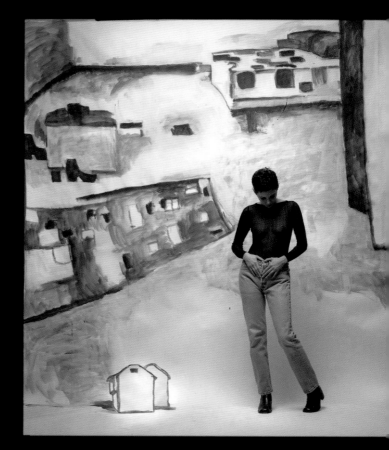

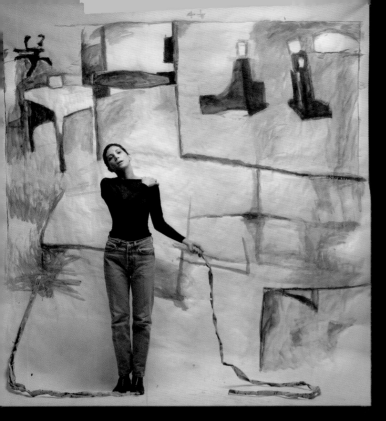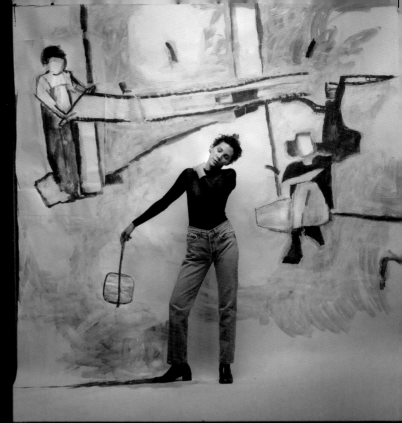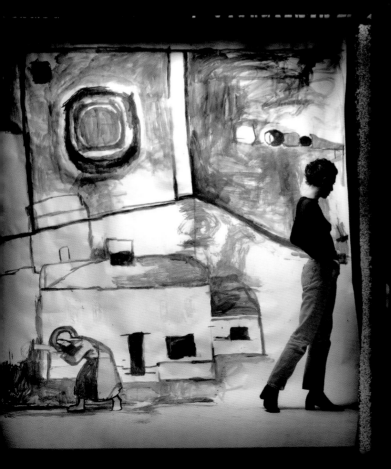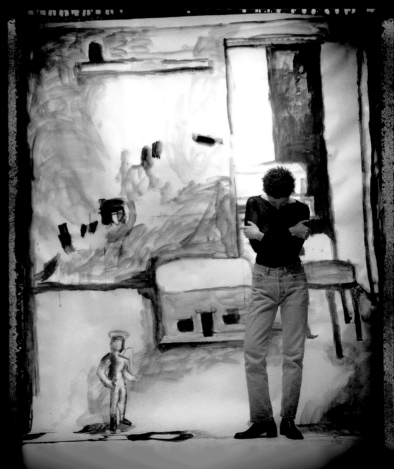

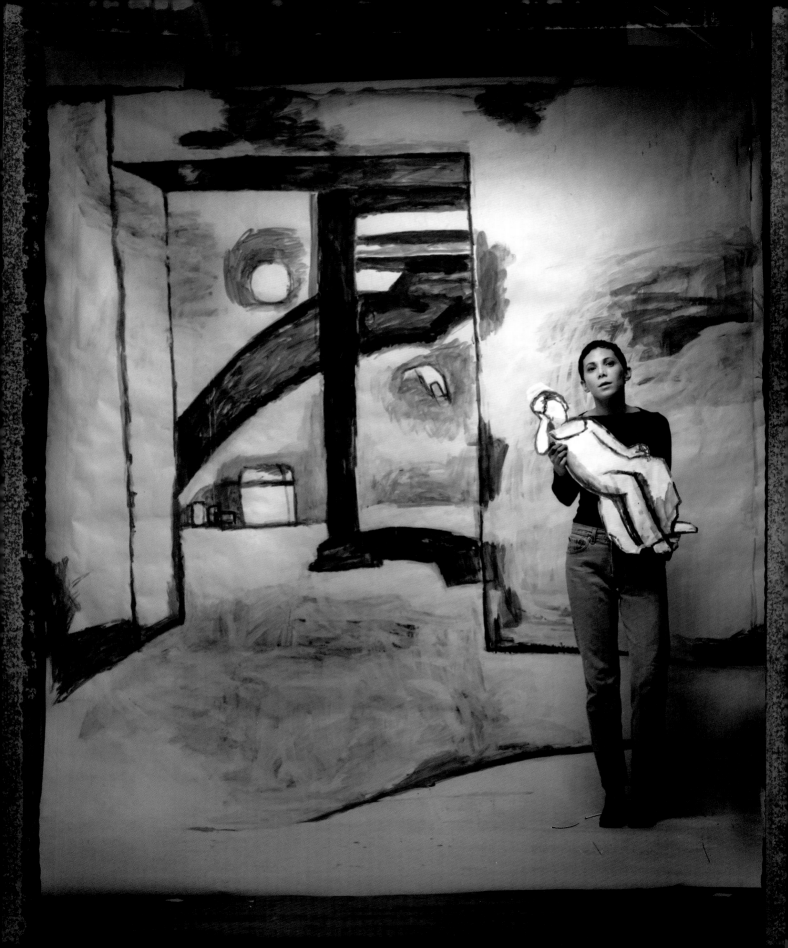

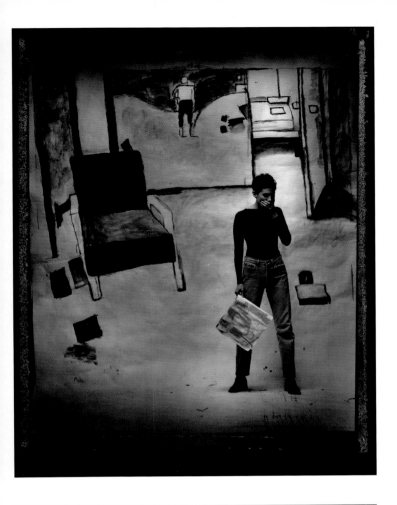
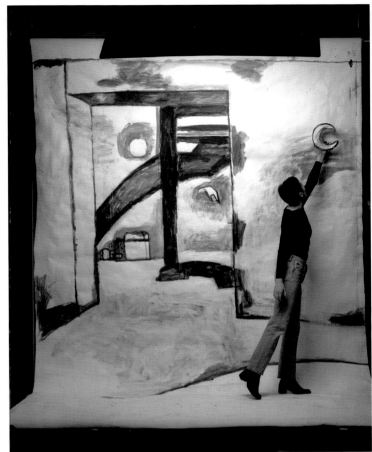
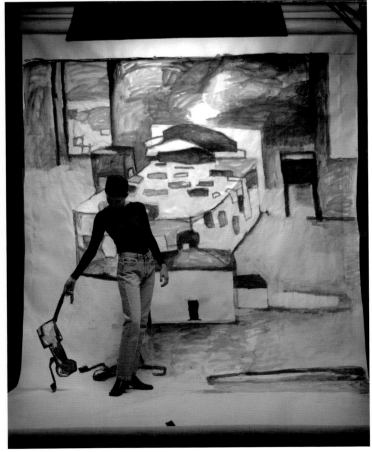
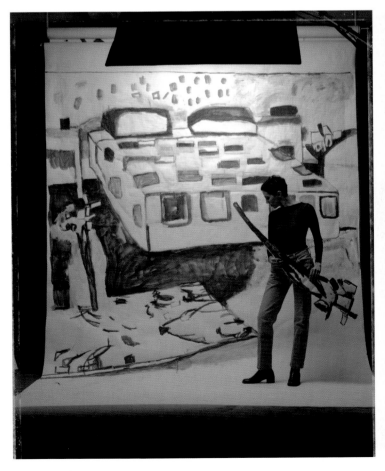

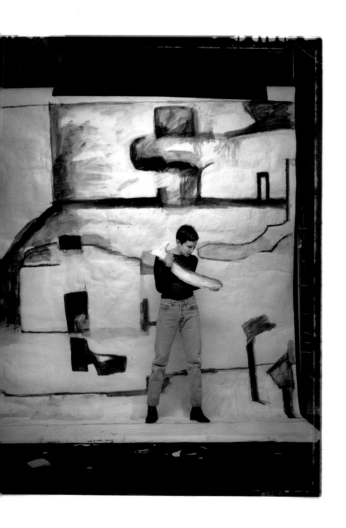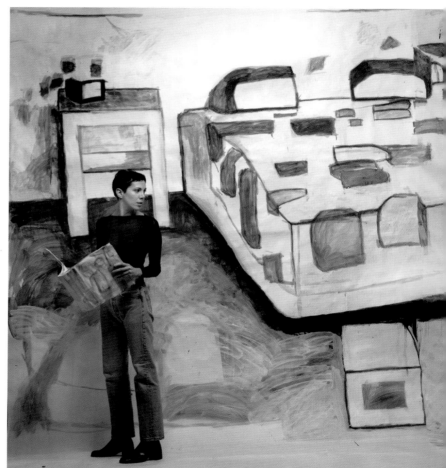

ACT 4

Going Live

DANCE AND PERFORMANCE

"Dance is the only real language."

—Pina Bausch

What is there to say? Mysteries to be unsealed,
something important. There are certain big moments.

I see huge rhythms operating. Energy furnaces in her
perpetual body. A fierce chiaroscuro and flight.

An act of meaning in and around the body.
An invocation of a new utterance.

Some time in the early '80s. I was on assignment for
GQ and spent a magical afternoon in a rehearsal studio
at Lincoln Center with New York City Ballet Principal
Dancer, Kyra Nichols.

An invocation—a big moment whose astonishment
reverberates in all the "languages" that I practice
to this day.

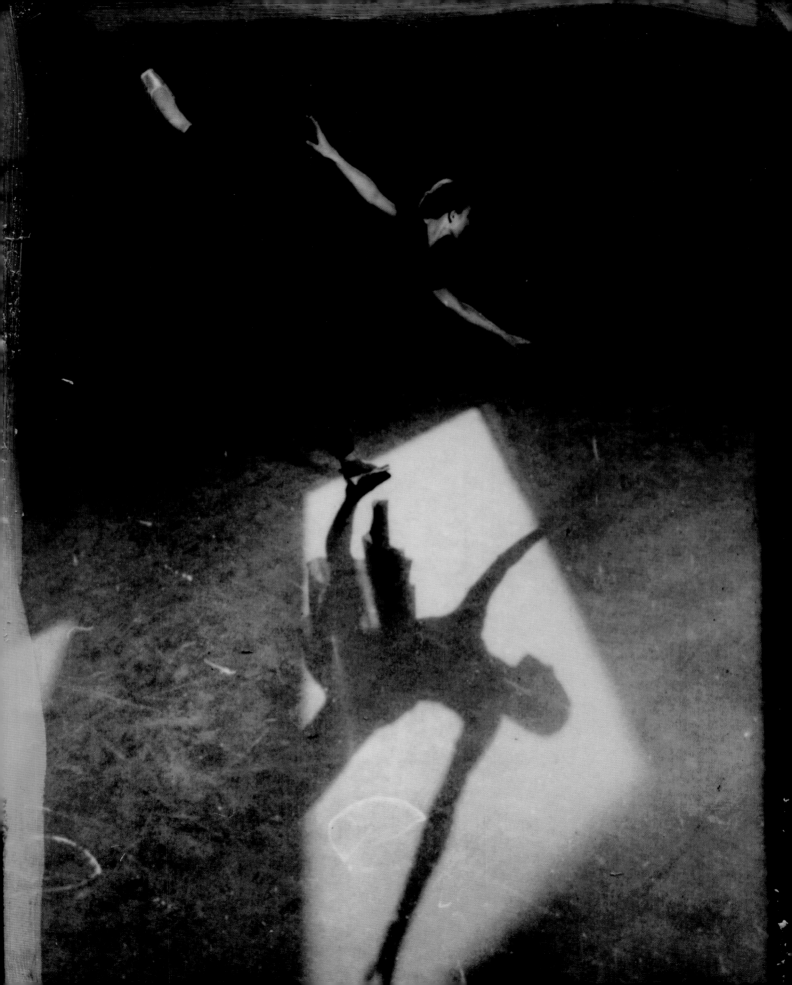

THE INTIMACIES PROJECT

"If you can't dance, nobody knows who you are."

—Wallace Coffey, Chairman of the Comanche
 Nation of Oklahoma

Because dancers know where their bodies are in space.

A series of dance, music, film, and performance
collaborations with Marinov Dance.

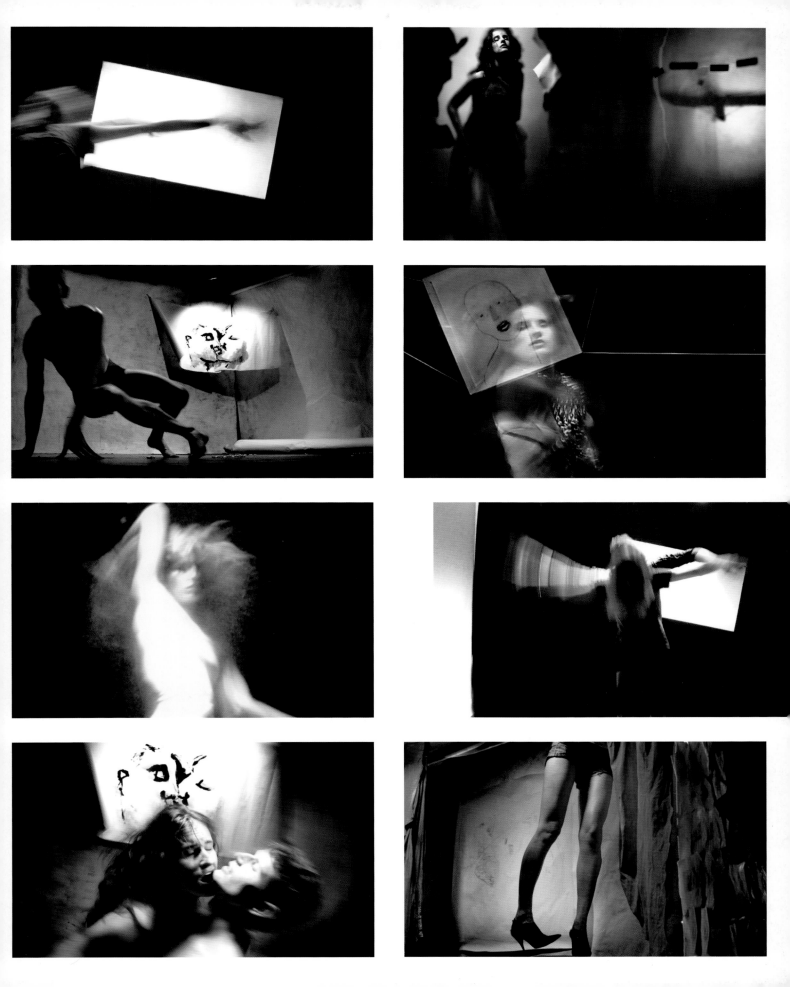

BENT

A film collaboration with Karen Furman and
Grounded Aerial.

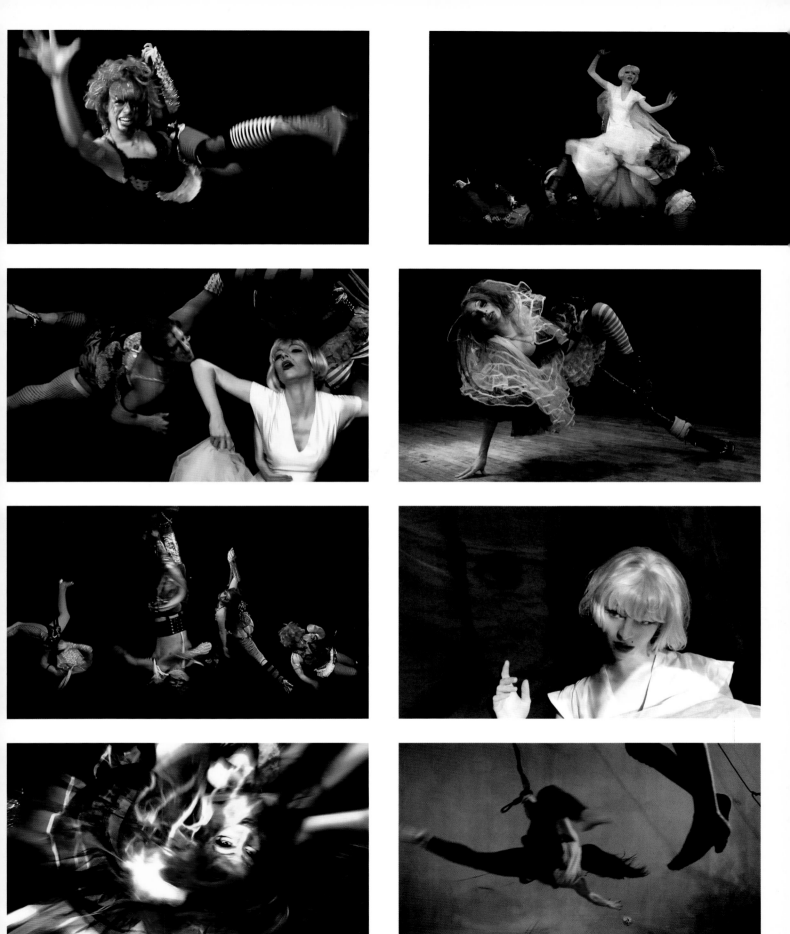

ACT 5

Film

ASPHALT, MUSCLE AND BONE
A film by Bill Hayward

"But can't you see me as a human being
he said

What is a human being
she said

I try to understand
he said

what will you undertake
she said

will you punish me for history
he said

what will you undertake
she said

do you believe in collective guilt
he said

let me look in your eyes
she said"

—Adrienne Rich,
 "From An Old House In America"

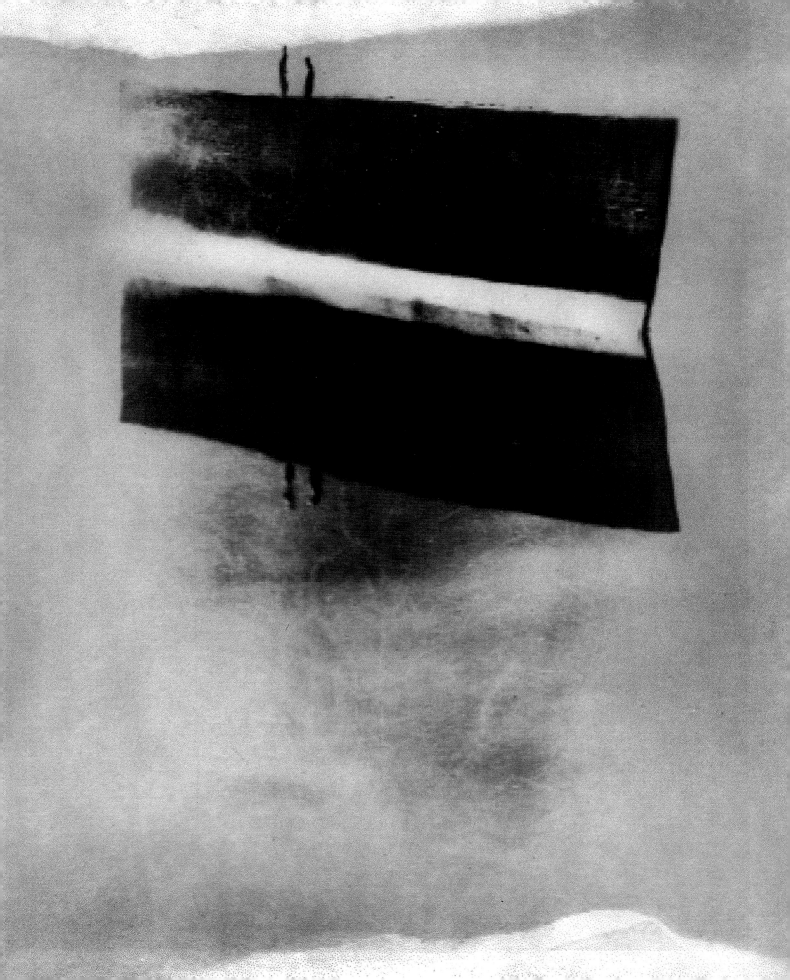

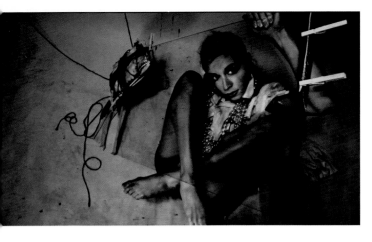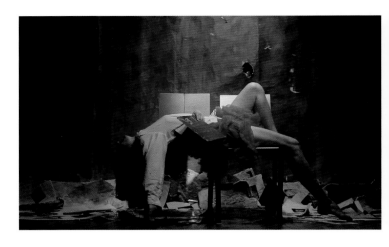
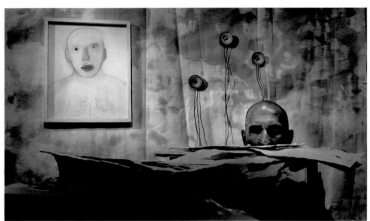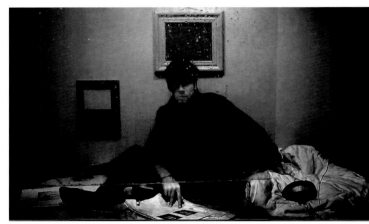
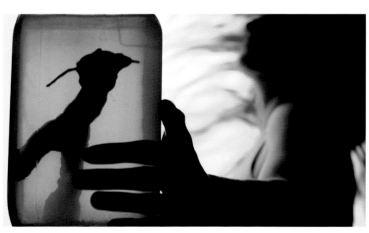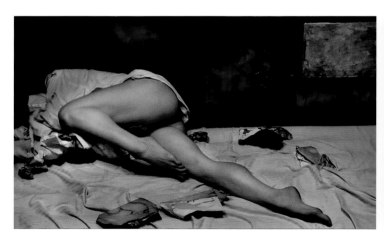
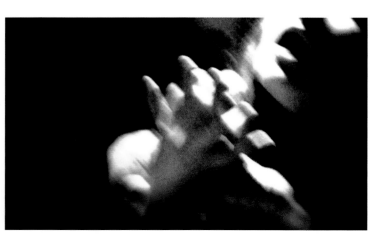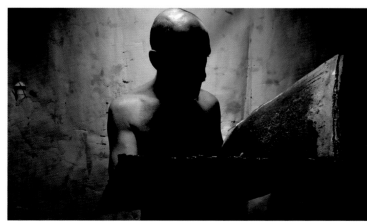

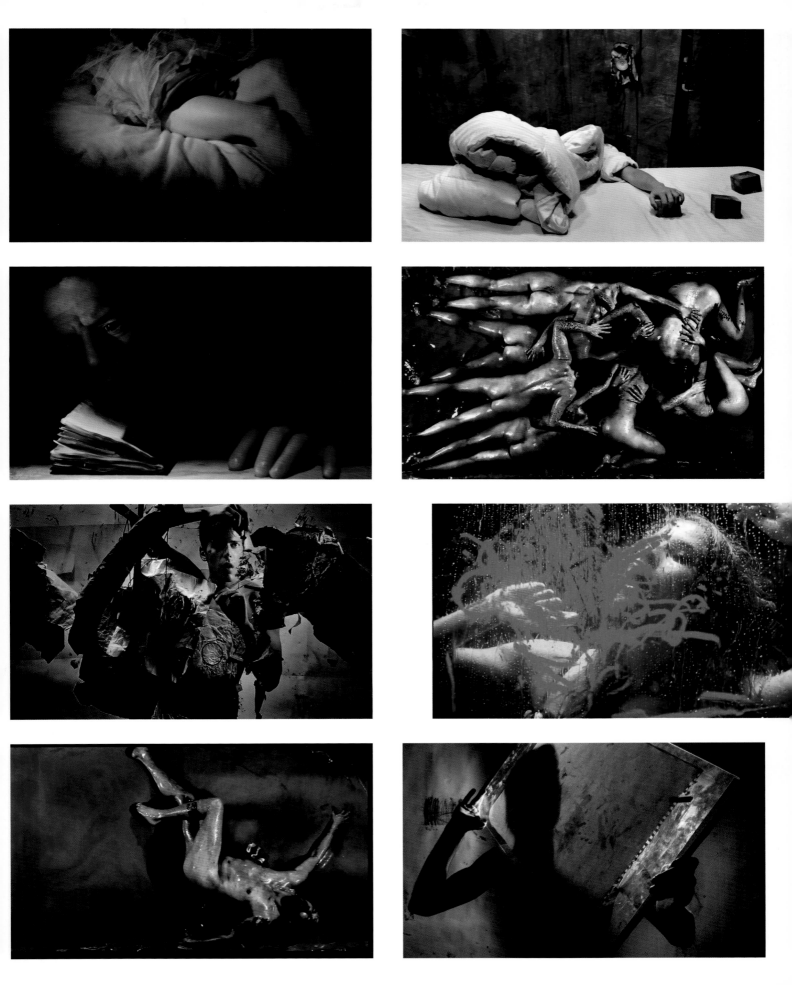

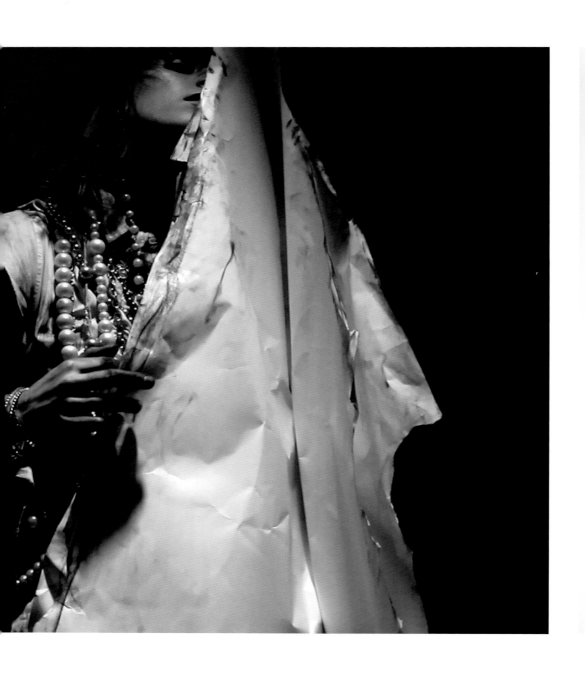

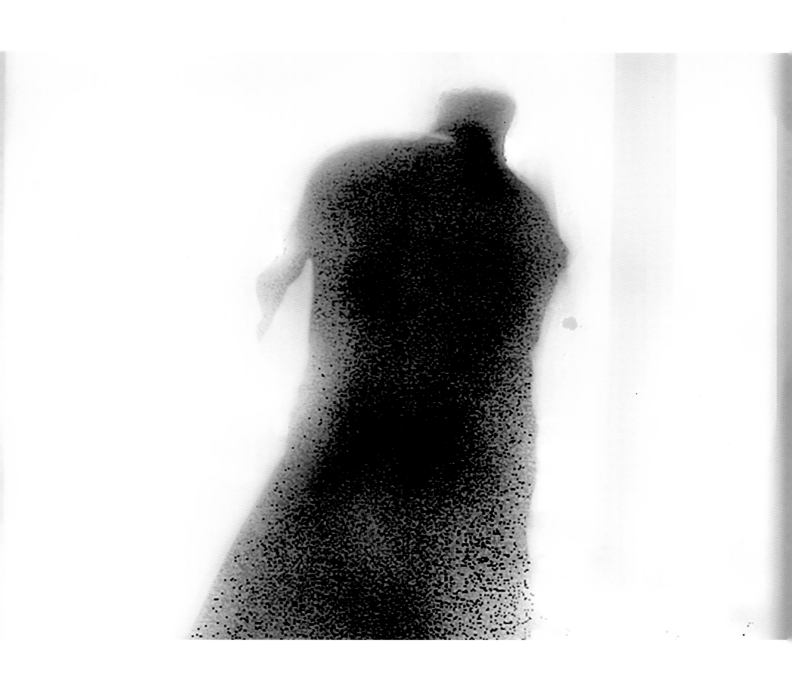

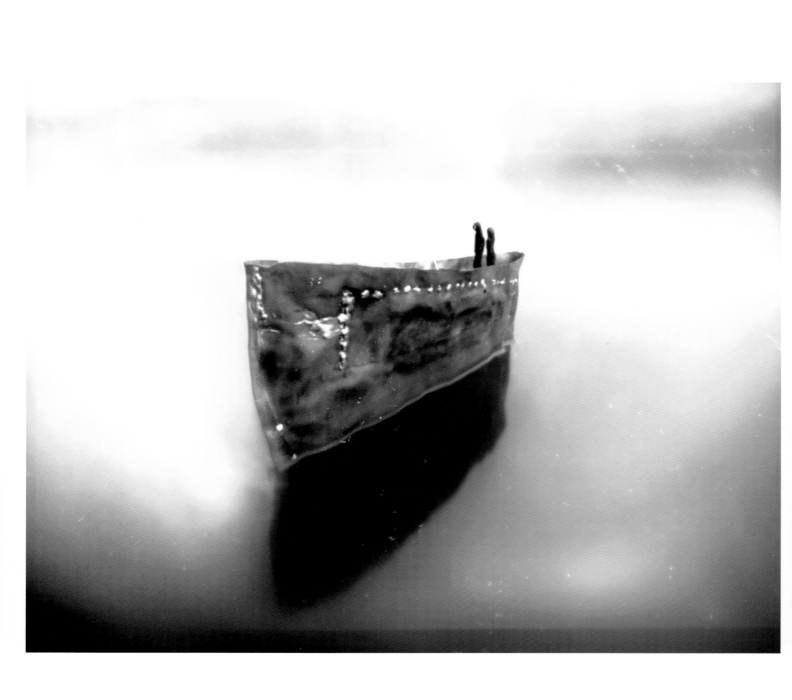

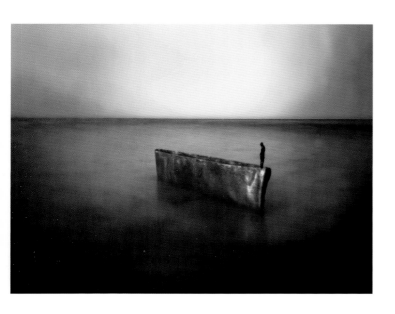
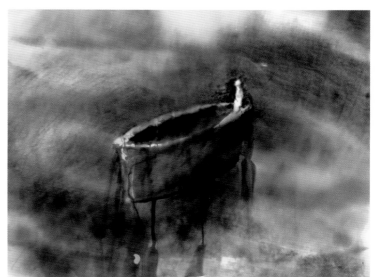
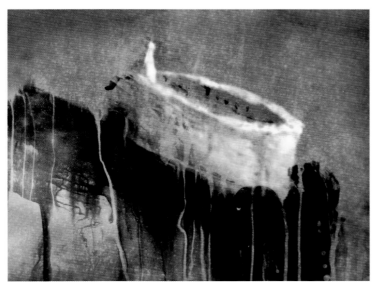
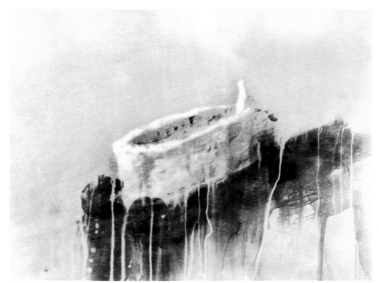

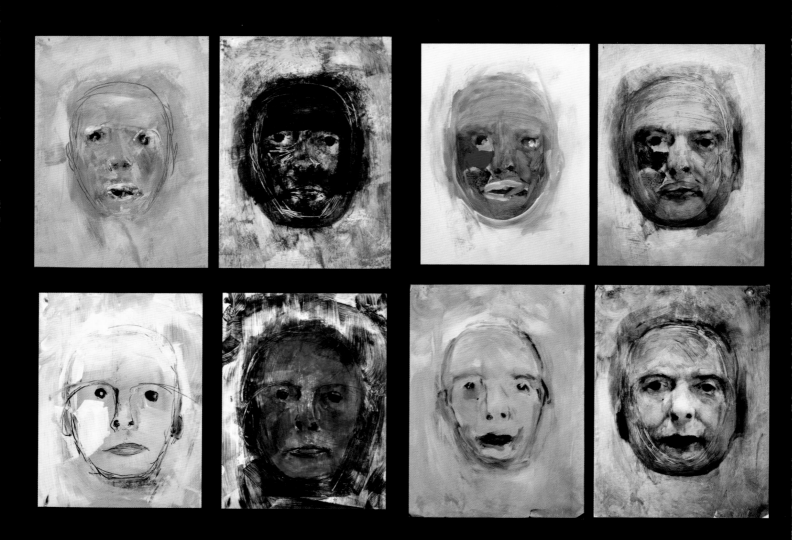

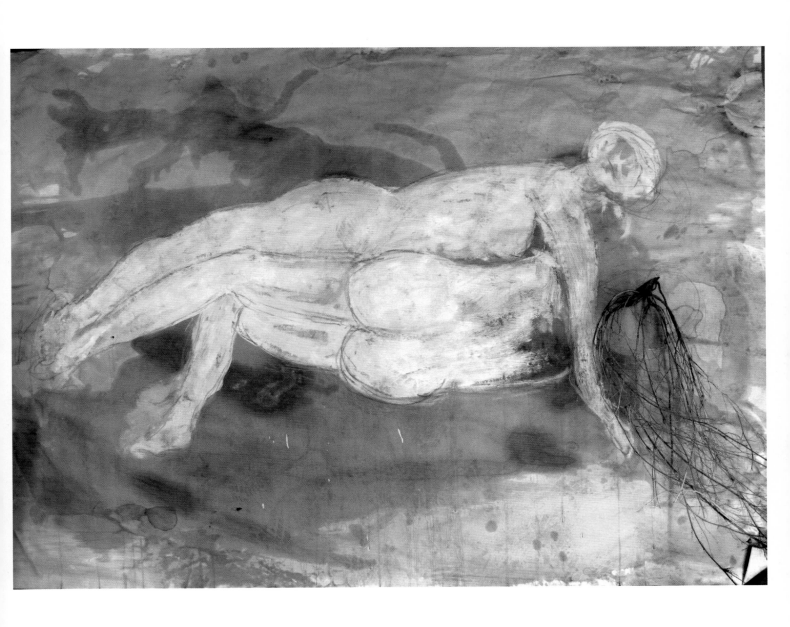

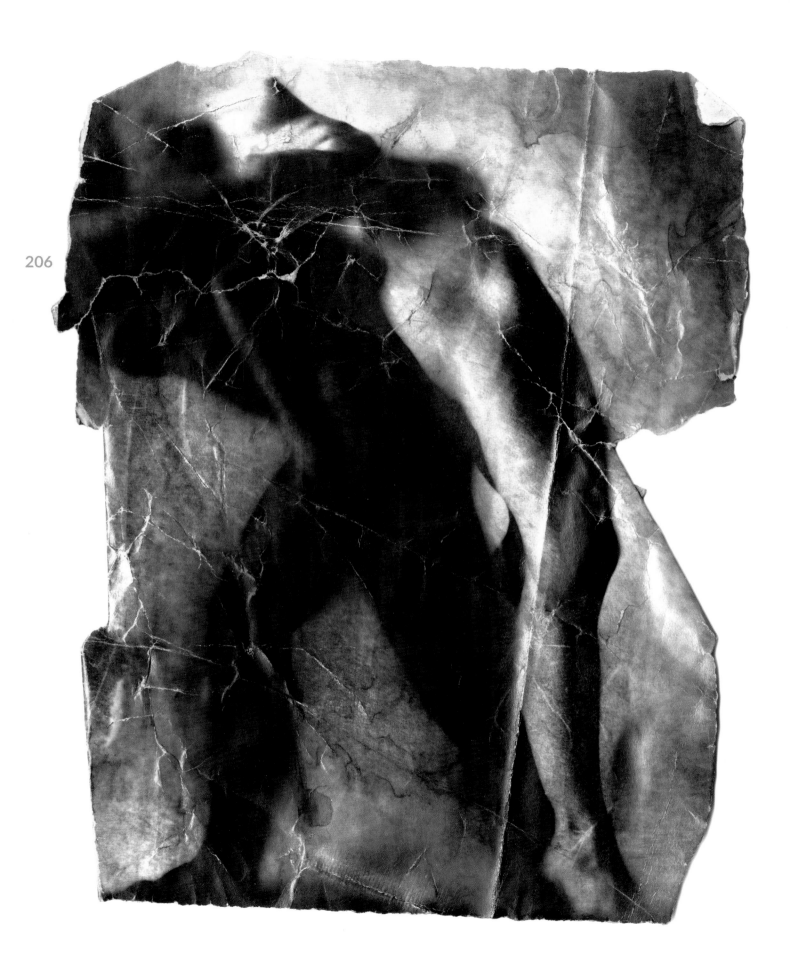

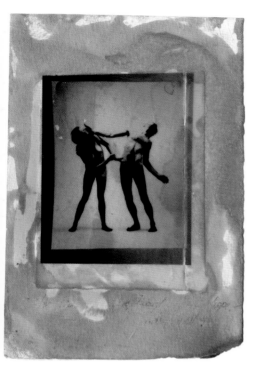
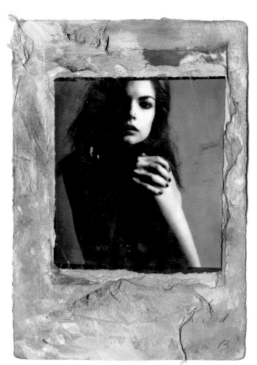
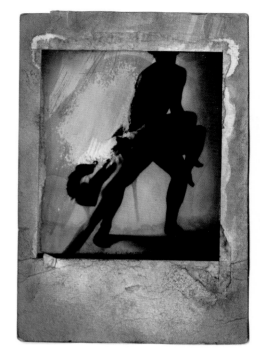
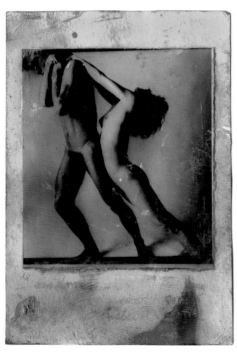
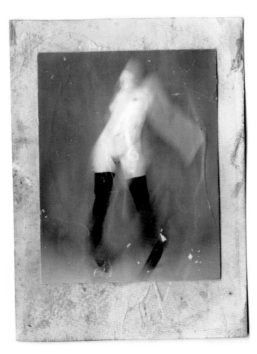
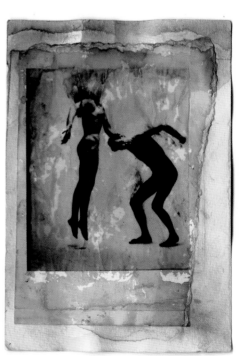

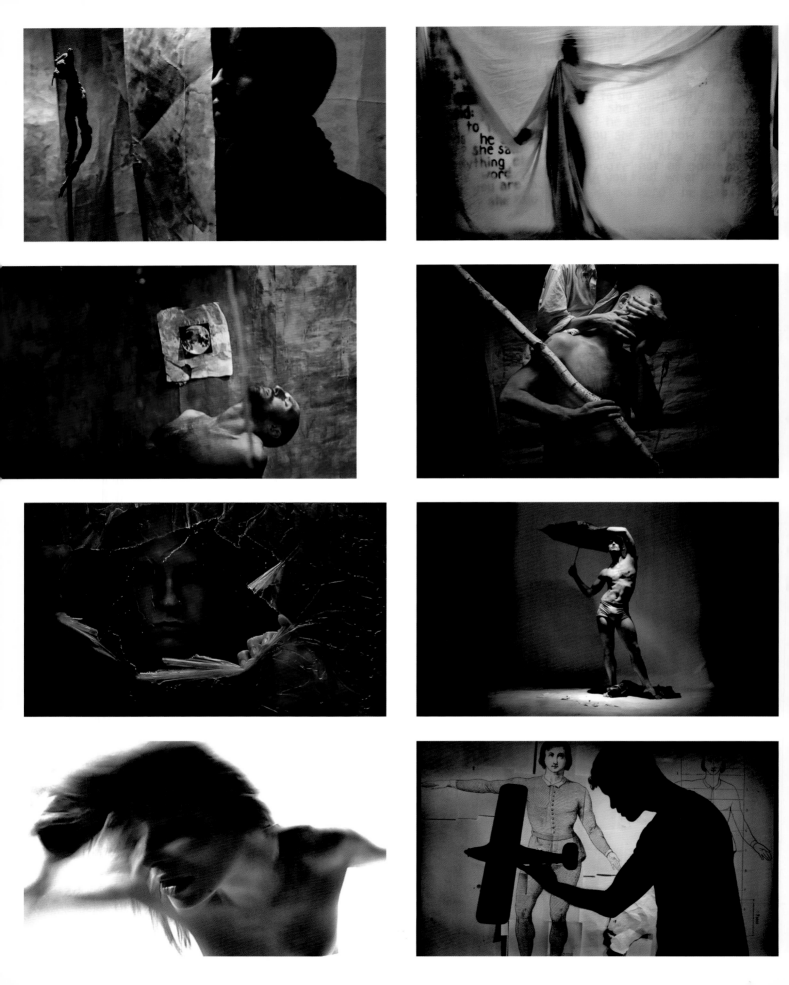

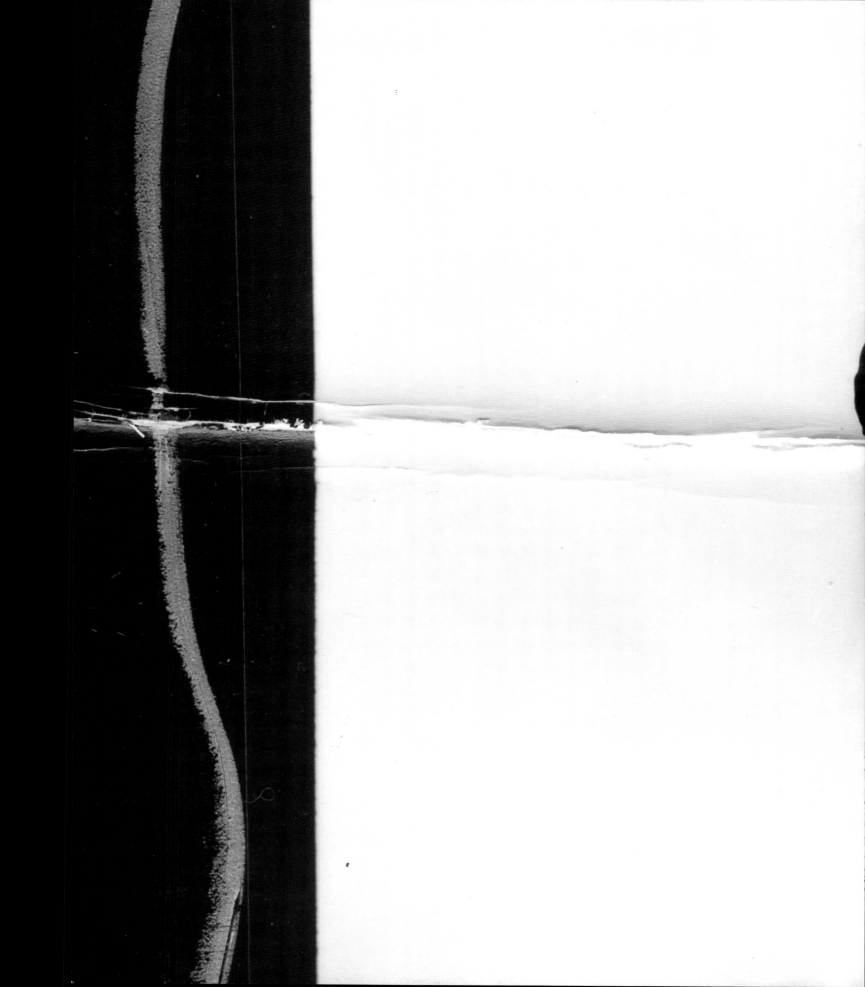

INDEX OF ARTWORKS

1: *Myth 1*; 30: *Tangle Dragon*; 32: *Melinda Roy, NYCB; Shifra*; 210-211: *Robert Duval*; 212: *Dorothy Gallagher from* Cat People; 213: *Shouts and Songs, Diptych 9; Shouts and Songs, Diptych 10*; 215: *Kyra Nichols*; 221: *Fugitive Beauty A*; 224: *Fritz*; 237: *A postcard on sale in* The Museum of Emotions *bookstore*; 240: *Sculpture Installation with Gil*

Act One

35: *Ben Kingsley*; 36-37 *Sonny Rollins; Robert LaFosse; Stephanie Saland; Yogi Berra*; 38-39: *Bob Dylan*; 40, CLOCKWISE: *David Brenner; David Murray; Darci Kistler, NYCB; Harry Dean Stanton*; 41, CLOCKWISE: *Plácido Domingo; Christopher d'Amboise; Edward Villella; Roy Cohen*; 42-43: *Ronald Reagan; Luciano Pavarotti; Dizzy Gillespie*; 44-45: *Richard Merkin; BillyBoy*; 46-47: *Milton Berle; Rudolf Nureyev; David Lynch*

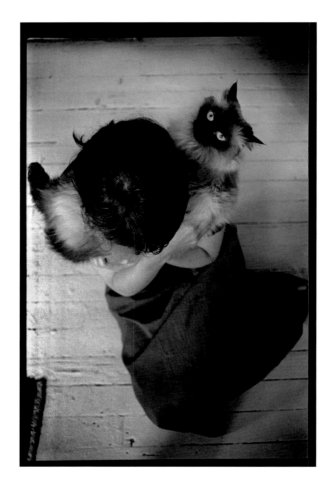

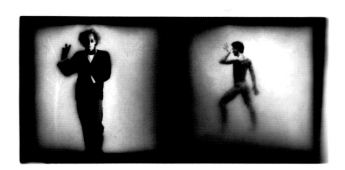
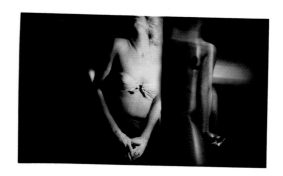

Act Two

49: *Brent*

Rackety Opinion
5: *Area #8*; 52: *Bat Girl* 53: *Julia; Jim*; 54: *Area #56*; 55: *Deborah Wardwell*; 56, CLOCKWISE: *Area #35; Area #37; Area #21; Reginald*; 57, CLOCKWISE: *Area #53; Area #26; Area #12; Christina*

Acts and Expressions
59: *Acts and Expressions 86*; 60: *Acts and Expressions 17*; 61: *Acts and Expressions 2*; 62: *Acts and Expressions 34*; 63: *Acts and Expressions 103*; 64: *Acts and Expressions J-17; Acts and Expressions Z-66*; 65: *Acts and Expressions G-55*; 66: *Acts and Expressions C-79; Acts and Expressions 44; Acts and Expressions B-62; Acts and Expressions S-115*; 67: *Acts and Expressions C-17*; 68: *Acts and Expressions E-3; Acts and Expressions CS -99; Acts and Expressions M-8; Acts and Expressions MM-101*; 69: *Acts and Expressions M-88*; 70: *Acts and Expressions Noor-400; Acts and Expressions Noor-410*; 71: *Acts and Expressions Noor-431*

Gesture and Invention
73: *Ancient Figure*; 74-75: *Figure III; Figure I; Figure II; Silent Figure*; 76: *Consistent Figure*; 77: *Solemn Figure*; 78: *Strident Figure; Mute Figure*; 79: *Impossible Figure*; 80: *Flamboyant Figure*; 81, CLOCKWISE: *Secret Figure; Shadow Figure; Fervent Figure; Renown Figure*; 82: *Explicit Figure*; 83: *Staccato Figure IV*

Shouts and Songs
85: *Shouts and Songs, Diptych 1*; 86: *Shouts and Songs, Diptych 2; Shouts and Songs, Diptych 3; Shouts and Songs, Diptych 4*; 87: *Shouts and Songs, Diptych 5; Shouts and Songs, Diptych 6; Shouts and Songs, Diptych 7*; 88-89: *Shouts and Songs, Triptych 1; Shouts and Songs, Diptych 8*; 90-91: *Shouts and Songs, Triptych 2*

A Hundred Words
93: *Lucille 1*; 94: *Lucille 2*; 95: *Zoe 1*; 96-97: *Zoe Diptych*; 98: *Lucille 3*; 99: *Zoe 2*; 100: *Zoe 3*; 101: *Zoe 4*; 102: *Zoe 5*; 103: *Lucille 4*; 104: *Lucille 5*; 105: *Lucille 6*

Certain Dances
107-115: *Figures 1-17*

Dismantled Myth
117: *Myth 2*; 118: *Myth 3*; 119: *Myth 4*; 120: *Myth 5*; 121: *Myth 6*; 122: *Myth 7*; 123: *Myth 8*; 124: *Myth 9*; 125: *Myth 10*; 126: *Myth 11*; 127: *Myth 12; Myth 13*; 128: *Myth 14*; 129: *Myth 15*; 130: *Myth 16; Myth 17*; 131: *Myth 18; Myth 19*

Broken Odalisque
133: *Odalisque 1*; 134: *Odalisque 2*; 135: *Odalisque 3*; 136: *Odalisque 4*; 137: *Odalisque 5*; 138: *Odalisque 6*; 139: *Odalisque 7; Odalisque 8*

Consider the Flesh
141: *Consider the Flesh 1*; 142: *Consider the Flesh 2*; 143: *Consider the Flesh 3*; 144: *Consider the Flesh 4*; 144: *Consider the Flesh 5; Consider the Flesh 6*; 146: *Consider the Flesh 7*; 147: *Consider the Flesh 8*; 148: *Consider the Flesh 9, 10, 11*; 149: *Consider the Flesh 12*

Act Three

214

the human bible
151: *Paige*; 152: *Linda Iverson; Adam Hazlett*; 153: *Walter Parks*;
154: *Dr. Lanny Realbird*; 155: *Al Pacile*; 156: *Nace*; 157: *Will Dana*;
158: *Ariel*; 159: *Don Ellis*

The Portrait Process
161: *Willem Dafoe*; 162: *Lt. Pete Campanelli; Thomasin Franken;
Arvell; Abby*; 163: *Anita Rodriguez; Leon Golub; Bob Balaban;
Freedom*; 164: *Avalon*; 165: *BEC*; 166-167, TOP ROW: *Brooke Bennett;
Bret Mosley; Eva; Justin Taylor; Wilhelmina*; BOTTOM ROW: *Sofie
Flack; The Blondes; Salvador Carrasco; Damián Delgado; Shane
Rutkowski; Lucille*

Portraits of the Collaborative-Self
*Given enough paint, paper, and permission,
you never know where you might end up.*

"*Demographers, advertisers, marketers, and many others hand us
readymade images of ourselves. These images are convenient, no
doubt, but ultimately useless—or useless at best. Hayward has
invented a kind of portraiture that invites his subjects to be full
collaborators in their own self-definition. No wonder they respond
with such passion.*"

—*Carter Ratcliff, author, art critic*

"*The process of shooting my portrait with Bill made me realize that
I wasn't living my truth in my then job at* Seventeen. *That's my
way of saying that shooting with Bill isn't like shooting with any
other photographer. It's all about looking at your truths.*"

—*Atoosa Rubenstein, former editor-in-chief of*
Seventeen *magazine*

"*Everyone should have this portrait experience at least
once a month.*

*The moments we find ourselves in…because this moment
happened the next moment is going to be different, and the
moment after that and the moment after that, and the moment
after that. Authentic life and art, we were different every minute
and unfortunately in real life most of us try to pretend that we're
the same moment to moment but this reminds us that we're not…
that the next moment makes possible the next moment and if
you're in that present then the next present is different, not the
same droning on and on and then life becomes dynamic. It is
made dynamic by these kinds of encounters.*

*One of the things I didn't expect about this experience was that
it would be an experience…I thought I would just pose. I didn't
understand how dynamic it would be between you and me, I
wasn't prepared for that at all.*

*It's you and I, in discourse, in dialogue, soul to soul, mind to mind,
heart to heart; even though we had just met, and it became
an experience, a dynamic experience, and in looking at these
pictures, I realize that I was different when I left. I was changed by
the experience of this discourse and this is the evidence (holds up
her portrait).*

*Because we had the conversation, and I wrote this out, this
became a kind of gate to walk through for relief from carrying
that gravity, the gravity that I was feeling then, the responsibility
of carrying a point of view…that I do not feel now. Having said
this, I can walk away from it. I feel it very, very moving to look at
these, more than I thought. This image is deeply authentic.*

*In this relationship, we're in discourse with you but we're also
in discourse with ourselves, in a dialogue with ourselves as it's
happening so there's an intimate dynamic energy that's going on
and people do stuff they wouldn't think to do.*

We walk away and we're both changed."

—*Marie Howe, poet*

"Hayward has devised a means to finger-print the imagination, with forensic exactitude."

—David Cohen, Art Critical

"There's a kind of sacredness to this whole thing, which I think is really interesting...you create this ritual in which you, Bill, interact with the person who's creating the art...and it's your art and their art coming together in some way that's outside of both of you. ...

It's not having your picture taken, that's not what the deal is... it's play. You're outside yourself for a moment and you get to see what you look like, but not just what you look like in a physical way; what you look like as if you turned yourself inside out... you've accomplished that expression of who you are, and that's really rare. I think that's what we all strive to do on some level so it's rare when it happens."

—James Lecesne, playwright

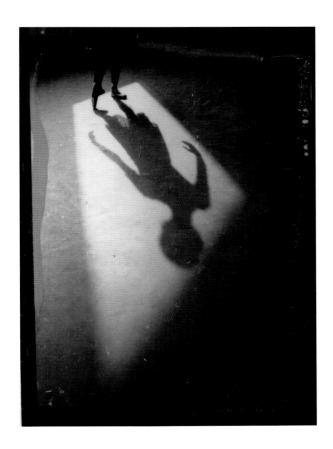

The Thing Itself
169: *Tristine Skyler*; 170: *Collin Couvillion*; 171: *Edward Field*; 172: *Susan Duval; Kate Moran and Adrienne Campbell-Holt; Brian Bickerstaff; Mike Jones*; 173: *Eve; Wade Carroll; Veronica de Soyza and Oz; Angela Phillips*; 174: *Alek; Alison Walter; Korhan Basaran; Jeff Brewer,* Beyond the hedge was a little sliver… this is between me; *Tyler Gardella; Sam Charny,* I don't know how I'm gonna feel when I'm dead; 175: *Walter Kirn*; 176-177, TOP ROW: *Stephen Petronio; Vivek Tiwary; Kate Moran; Freddy Bosche;* BOTTOM ROW: *Angie Cruz; Robert LaFosse; Caroline; Susan Niles*; 178: *Trevor Winkfield*; 179: *Edgar Delgado*

17 Bedrooms
181-187: *Bedrooms 1–17 with Joanne Baldinger*

Act Four

Dance and Performance
189: *Kyra Nichols*

The Intimacies Project
191: *Jordan; Jordan; Billy; Jordan; Jordan; Billy/Jordan; Billy/Jordan; Jordan*

Bent
193: *Film Stills with Karen Furman of Grounded Aerial*

Act Five

ASPHALT, MUSCLE AND BONE
A film by Bill Hayward

195: *The Fat River Hotel Passenger Launch*

196-199: *Scenes in and around the grounds of The Fat River Hotel*

200-203: *Boats on the Fat River*

204: *"I am this, I am that…" exhibition at The Museum of Emotions*

205: *Artwork in The Museum of Emotions*

206: *A film prop*

207: *Postcards on sale in The Museum of Emotions bookstore*

208: *Scenes in and around the rooms and grounds of The Fat River Hotel and The Museum of Emotions*

209: *The Museum of Emotions*

AT RIGHT: *Notebooks "messing around" for the film*

SYNOPSIS: *Asphalt, Muscle and Bone* is a disruptive reclaiming the primacy of the body and blood of the feminine, the creative process. It practices instinct, mystery and imagination. It asserts mutuality, sensation and the impossibility of love. The real secret isn't even in the picture.

TIME: The "continuing present"—the only memory, only always.

LOCATION(S): The Fat River, The Fat River Hotel—guest rooms and amenities, The Museum of Emotions and Museum Store, The Territory, The Clearing and The Orchard of Burning Apples, The Ruins, The Plutonium for Incubation, Outlaw Lands where even God has not been, A Hundred-Year-Old Room.

THE CAST (PARTIAL): There are women, there are men. Hotel guests, museum goers, wanderers, the front desk, the watchers, questiarii, shadows and shades, abandoned dragons, gasoline angels, panicked prophets, the wound bearer, witches and furies, bathing nymphs, various apparitions. There are also atmospheres of weather, celestial bodies, biology and body and blood and cicadas.

PROPS: Various to include, but not limited to: Postcards available in The Museum Store, prepared books (some of which can only be read in the dark, others that have spent time in the sea), maps, letters/messages on paper (some in envelopes), mirrors, fluids and jars of creation, pearls, broken trees, paintings, pigments, sculptures, photographs, mud, roots, stones, paints, paper, canvas, drawing and painting implements, recipes, an eros box, vision machines, intercoms, notebooks, a radio transmitter, rafts, boats, planes, a moon, windows, water, tables, chairs, book boots, carbon, a sad toy, umbrellas, cameras, flowers of the world, a sphinx, a white weapon, wonders of nature, horizon o, horizon a, horizon b and horizon c, the sperm of angels, canvas virgins, backyard gods, bonfires, vaginal salts, relics of fugitive bodies, medieval neon.

WARDROBE: Various and often extemporaneous, to include: men's white shirts, jeans, coats, ties and jackets, red dresses/skirts, t-shirts, black dresses, rags, pearls, the useless dress, acid-burned talismanic lipsticks.

ACTIONS (PARTIAL): Dance, singing, alarms and diversions, "gestures accordingly," pleasures of body and flesh, weeping, vows, a game of legs, miracles of one sort or another, the baptism of the dead, "instants that drip and are thick with blood," a central crime of passion, certain big moments, habits of fire, a fierce chiaroscuro, vertical thrusts.

SOUND: Sometimes B-flat 1-1/2 steps from middle C, "accordingly," "black sounds," dead silence.

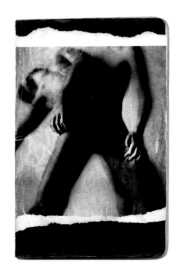
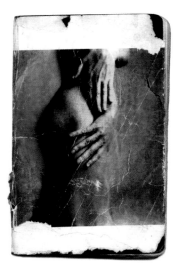

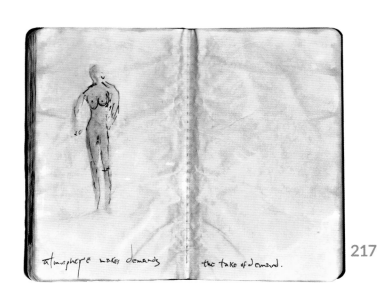

atmosphere makes demands the take of demand.

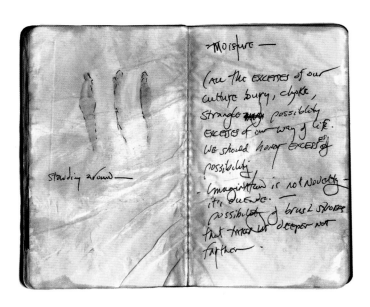

standing around —

→Moisture —

(all the EXCESSES of our
culture bury, choke,
strangle possibility
EXCESSES of our way of life.
We should honor EXCESS of
possibility.
— imagination is not Novelty
it's duende.
possibility of brush strokes
that track us deeper not
farther.

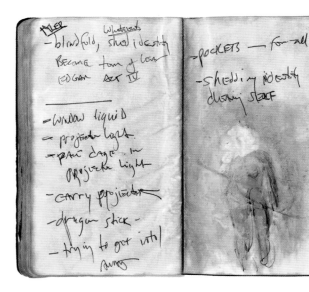

→TYLER
— blindfold, whatever,
become form of loss
EDGAR Act IV

— window liquid
— projector light
— paw cage in
 projector light
— carry projector
— dragon stick —
— trying to get into
 away

→POCKETS — for all
— shedding identity
 during stuff

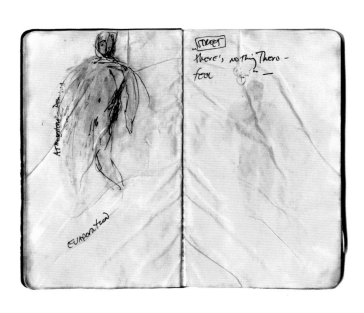

STREET
there's nothing there —
feel

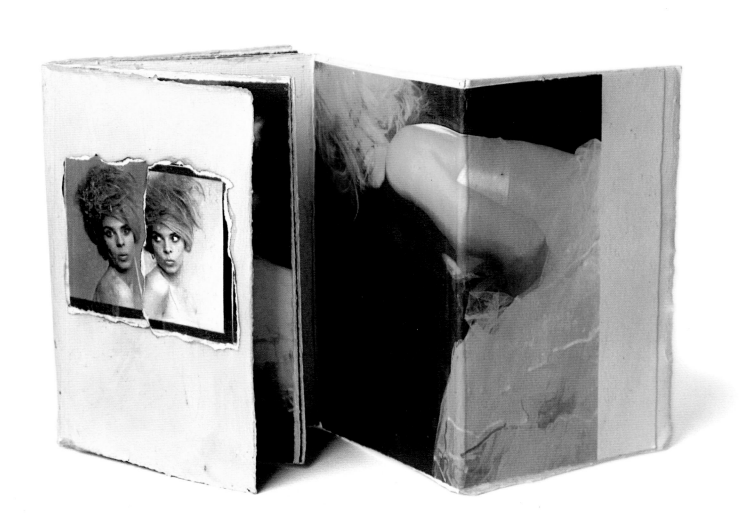

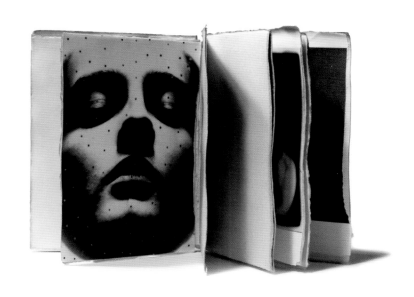

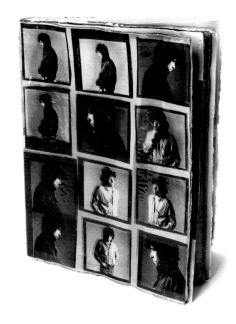

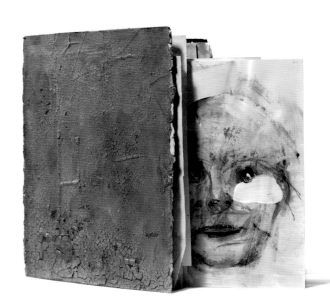

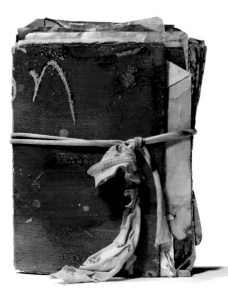

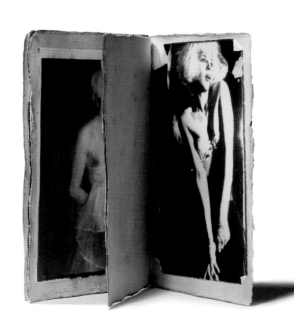

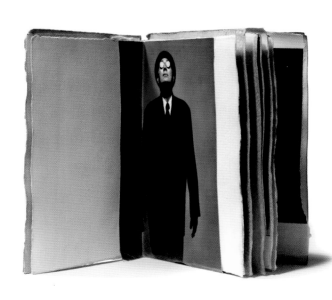

"If there is any irreverence in my own work, I hope
it is the irreverence I bear in mistrusting my own
sincere self, which then sincerely mistrusts the
irreverent me. If there is a bottom to this, I think
it is a life's work."

—Mary Ruefle, *Madness, Rack, and Honey*

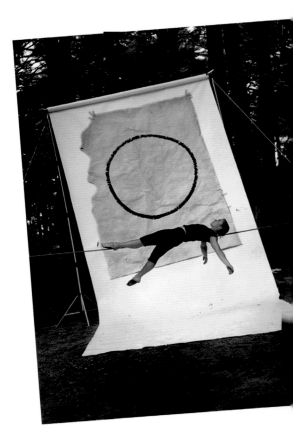

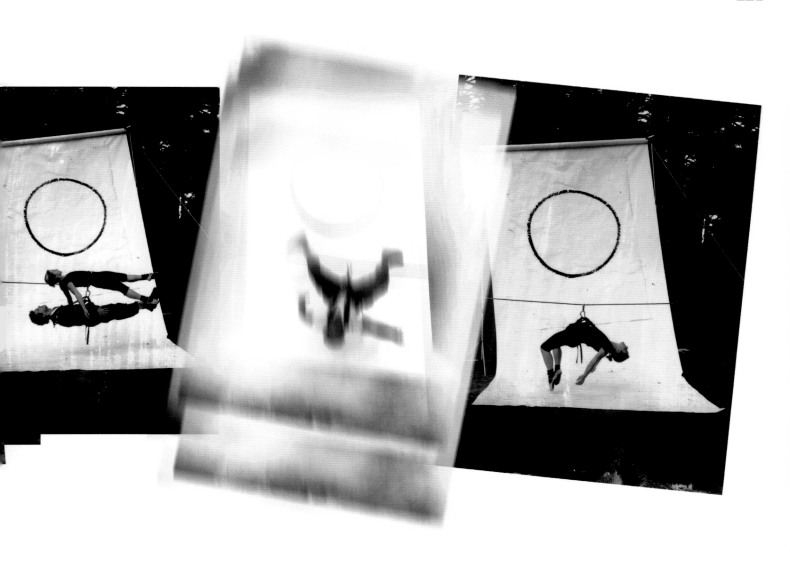

Growing Impatient

Photographers are patient, painters the opposite. Since we can all think of exceptions to that rule, it needs revision: photography is a process that requires its practitioners to exhibit whatever patience they possess, to stay calm until the world displays itself in a manner worth photographing. A portrait shoot is always tense, sometimes panicky, and the portraitist may benefit from that. Nonetheless, he must sustain a calm negotiation with the sitter, patiently inducing believable postures and expressions to manifest themselves. Bill Hayward does that masterfully. Yet the portraits in this exhibition show signs of the painter's impatience, the desperation of the artist who grabs his medium with both hands and pushes it around until the image looks right.

I'm not saying that photography is passive and painting active. The splashiest painters sometimes say their medium carries them along, helpless, to results they cannot foresee. By contrast, a portraitist like Hayward always stays in charge of his face-off with a subject. He exercises a will whose demands we may not even notice because, to get what he wants, he has to be so tactful, so calm, so patient. Then, with a sudden gesture, Hayward throws a face out of focus. He sends a blurry, translucent cloud across a sitter's garish outfit. He violently warps the contours of a woman's face, suggesting that the strain of staring at the lens has, as the saying goes, cracked her composure. Her expression remains impassive, so the crack-up must be inward. Hayward has begun to attack appearances in the spirit of an Expressionist painter. He tries to look past the images people offer him, hoping always to see through the motives behind the offerings. These urbanites are hip, no question about it. But are they ultra-hip? The question comes up because they all would like the camera to take their ultra-hipness as unquestionable truth.

Hayward's new photos suggest that he has grown impatient with his own patient command of photography as a conscientious record of surfaces. He has begun to seek out sitters whose images—their visible surfaces—make claims that must be accepted entirely or just as thoroughly rejected. Either the blonde with dark lipstick is the personification of vampirish femininity or she is absolutely nothing of the sort, sheer sham. Either the short-haired blonde is a totally stunned, hence stunning, night-robot or she is simply lost. But in questioning his sitter's images, Hayward doesn't reject their claims out of hand. Nor does he satirize them.

Insistently but gently, he imposes on his camera's tactful findings, with results that often recall the effect of time on photographic prints—fading, darkening, cracking, bending. Sometimes he evokes the look of a torn-up photo taped back together and damaged further by the curling, staining tape. His painterly attack on the photographic print induces the lens's instant to slip off into the past. These photos look brand new and also as if they had been retrieved from another era against their own wishes. Ultra-hipness would like to concentrate existences in the time out of time when images looked perfect. Hayward supplies high style with a memory; he induces sheer surface to have a history. By undermining the camera's command of appearances, he helps us sense the life, the tangled motives, behind the carefully arranged appearances his sitters offer to him and to us. And in the process, he grapples with his medium as impatiently as any painter, any collagist or, indeed, any sculptor. Yet he remains calm, despite his own agitation and that of the scene he records. And with his calm comes an astonishing sympathy.

—Carter Ratcliff, "Rackety Opinion" catalog

Cultivating Energy

For centuries, for millennia, men made images of women. This was not so much a right as an unquestioned prerogative. Now that prerogative is relentlessly questioned, and so is the male artist's traditional image of women. Though the odalisque entered Western art only in the last century, when the taste for exoticism led painters to the harems of the Near East, it looks in retrospect as though painted and sculpted women have long displayed the traits of odalisques: lush physicality, passivity, a willingness to be securely contained by their roles. And such imagery continues to appear in contemporary art. Bill Hayward's photographs offer a different sort of spectacle. I'm tempted to say that he has re-envisioned the image of woman, but it would be more to the point to point out that he has done what the most adventurous artists often do. He reveals what standard usage tries to conceal. Looking through the odalisque's passive stillness, Hayward has seen the maenad, the explosively energetic female of Western culture's ancient mythology. In Hayward's photographs, female form coils, tenses, then surges toward the edge of the image—or beyond. The artist often crops the image to emphasize the uncontainable power it represents. Centrifugal energy turns inward, impulsively, and the model swirls expanses of cloth in patterns that gather the image toward an imperious center—the body. Some of these photographs catch female musculature under extreme stress. The softness of breasts, stomach and thighs disappears into striated patterns of physical exertion that would be called heroic if it were male. It doesn't seem right to say that Hayward has tried to redefine the image of a heroine. Even now our notions of heroines confine them to acts of silent self-sacrifice. The powerful, even frenzied, presences in these photographs make an aggressive claim to a self—the opposite of selflessness. That women have selves is a fact, often terrifying to men, that the odalisque is designed to obscure. Hayward faces that terror by cultivating his model's bacchic energy. Responding to questions asked by feminism, Hayward's photographs argue that male images of females are not only legitimate but necessary. Nor do these images simply pay their respects to the sheer force of a woman's presence. They testify to her sexual allure, a quality to which her beauty, as defined by tradition, is incidental. In some of these photos, the minute grain of the model's skin makes itself seen despite the vaulting leap of her body and the calculated harshness of the light. Sometimes her form plays off against a pattern of softer light, as it plays across the wall. When the woman leaps past a window, the light dissolves her flesh. She becomes a careening shadow. Always, though, she insists on her prerogative to be fully, powerfully present in the image.

And Hayward's art insists on confronting her there.

—Carter Ratcliff, "Arense" exhibition catalog

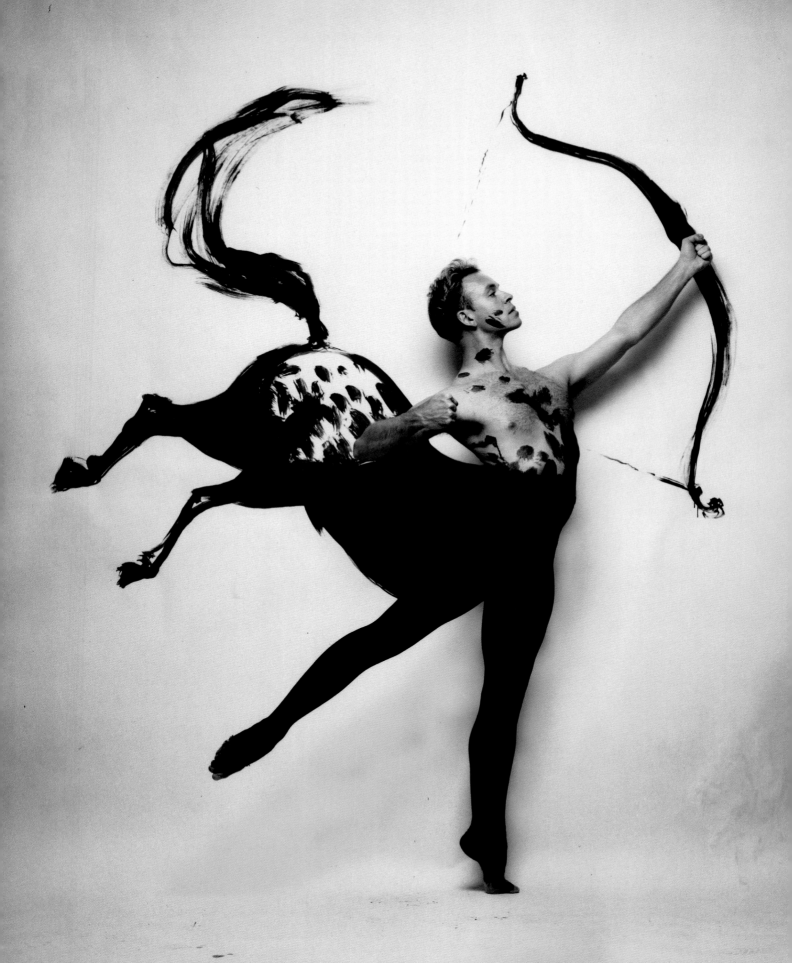

Rewriting Narratives

On the wall of the living room in my Chelsea apartment is an installation created by Bill Hayward. An unframed photograph is hung by clothespins and pulleys with long strings running across the length of the wall and attaching to a bundle of paper exquisitely crunched and twisted.

The image in the photograph is a "portrait of the collaborative-self" created with a young ballet dancer. His torso is perfectly positioned, his arms outstretched, one holding an arched bow, the other an arrow ready to eject. The lower half of the dancer's body has been painted black like the legs of a stallion to match the rear of the horse that he has painted on the scrim. He appears half man, half stallion.

Although I did not know Bill Hayward 20-odd years ago, I did, coincidentally, know the dancer—well. At the time he was married to a much older woman, but had secretly confessed to my partner, his good friend, that he was struggling with his homosexuality. The image which Bill amazingly captured, around that same time, was extracted from this man's subconscious in the process of his exchanges with the dancer during their photo shoot.

Bill Hayward is a master artist and a master psychoanalyst as well.

I have been in practice for 40 years as a psychotherapist capturing and helping patients rewrite their narratives. I often think of myself as a surgeon who can help a patient dive deep into their true selves in our initial consultation. In my 15-year friendship with Bill Hayward, I have recognized that he is just as capable of helping the subjects of his portraits discover their true selves in the studio as I am in the consultation room.

Bill Hayward is an American treasure. As a photographer he has invented an entirely new concept of portraiture that is as contemporary as the CAT scan in its ability to communicate the nuances and subtleties that make up a subject's essence.

As an artist, he can take that essence and bring it into the light in a way that strikes like an arrow in our heart. We feel the beauty, poison, and especially the enormity of the moment captured in a way that brings us, as viewers, in touch with our deepest emotional selves.

Those who have been photographed by Bill often tell me of the extraordinary psychological transformation that occurs in his studio. They begin with a preconceived idea that they bring in preparation for the session that they gradually and perhaps unwittingly abandon as Bill gently encourages them to search deeper into their psyches through questions and conversation. His natural kindness and openness give support and freedom for even the most frightened to fully express themselves, often to their own surprise. And still Bill pursues further, unafraid to cross the border into the unconscious where both subject and photographer could be lost. And because he is willing and able, so are his subjects.

Bill Hayward's 'human hible' is a world treasure. No other artists capture the diversity, breadth, and depth of the human soul. His work is not about class, identity or geography; it is about the truest mandate for living. Hayward not only captures the essence of who we are as *individuals*, free from prescribed definitions and categories, but reminds us that all we have is our selves, and that life is about our constant discovery. Hayward's images teach us that who we are is within our reach.

—Stanley Siegel, *A Human Treasure*

Projects

Asphalt, Muscle and Bone (for release winter 2015). A film about mud, blood, risk, and gesture.

Only In Bed (2014). A series of inaccurate and anomalous photographs and film. As Stanley Siegel of *Psychology Tomorrow* writes, "A bed is more than a place to rest our weary bodies or have sex with a loved one, casual friend, or ourselves. A bed is where we encounter our most intimate relationship—the one with ourselves. We retreat to our bed in times of illness and stress for solace and comfort. We entertain our deepest thoughts in daydreams or during sleep. We hide from the world, make big decisions, and sometimes surrender to stillness, to experience nothingness or a life changing epiphany. There is no other place in our lives that allows for so many possibilities in such concentration and depth. Our bed is a cauldron of self-discovery in which we encounter our darkest terrors and our greatest joy. In bed, we lose ourselves and find ourselves all at the same time."

the human bible (2010). An ongoing collection of *portraits of the collaborative-self* wherein we are engaged with the unexpected truths of the past, the present, and the future, as we get on with our hungers, dreams, and desires. This project is about reclaiming possibility and the authority of the subject's body and imagination. It honors that which makes us human: imagination. Given enough paint, paper, and permission, there's no telling where we might end up.

My Mother's Kitchen (2010). A collection of images descending from *the human bible*, these are *portraits of the collaborative-self* that are born of conversations on the theme of "my mother's kitchen." This seemingly mundane territory is, upon closer consideration, a landscape of deep and abiding physical, emotional, and cultural significance. The years of emotional and physical doings that transpire in the kitchen influence who we are in so many ways. All of the noise and sizzle inside and outside the house eventually converge in the tumult, hustle, and conversations in "mother's kitchen."

My New York (2010). A collection of images that descended from *the human bible*, these are *portraits of the collaborative-self* that are born of conversations on the theme of "My New York."

BENT (2010). A short film produced and directed in collaboration with Karen Furman and Grounded Aerial.

The American Memory Project (2001–2009). A series of more than 400 *portraits of the collaborative-self*, as well as documentary films, created at Portrait Events. This series has been presented at National Historic Sites, street corners, backyards, schools, passenger trains, garages, beaches, bars, and mountain sides, across the United States. The project explores American geography and history as reflected in the contemporary consciousness of the country's citizens. It is a rendezvous of history, heart, emotions, mind, and image.

Locations for these portrait performances and installations include: Independence Hall (Philadelphia, Pennsylvania); Martin Luther King Jr., Historic Site (Atlanta, Georgia); Golden Gate National Parks/Alcatraz (San Francisco, California); Boston African American National Historic Site and Bunker Hill/Boston National Historical Park (Boston, Massachusetts); Lowell National Historical Park (Lowell, Massachusetts); Golden Spike National Historic Site (Promontory Summit, Utah); Little Bighorn Battlefield (Crow Agency, Montana); One Room School House (Big Timber, Montana); Dealey Plaza and The Texas Theater (Dallas, Texas); Hopewell Culture NHP (Chillicothe, Ohio); Point of Beginning (East Liverpool, Ohio); Las Vegas, Nevada; LA/Hollywood/Southern California; World Trade Center (New York, New York); Medicine Wheel National Historic Site (Big Horn Mountains, Wyoming); Working Cowboys (Livingston, Montana), and Fort McHenry (Baltimore, Maryland).

The Intimacies Project (2009). An ongoing series of photography, film, and dance performances in collaboration with Marinov Dance, based on the concept of trusting in emotion and muscle to frame the image and the movement.

The Grendel Suite (2008). A collection of images that represents a whole different kind of mind—a swarm of the ceaseless and vague ancient body, full of fever, delirium, and lethal risk.

Beauty Is No Show (1997). An experiment in language and Eros that consists of (1) photographs that combine the interaction of found/accidental text with chance body gesture and (2) poems that flip and deploy these same accidents of language. The text and body mesh, slide past each other, converge, and clash, but in all cases qualify each other. Everything comes alive when contradictions accumulate. These unpremeditated/un-resembled images are their own unique inventions. In this process of exploration and unmediated invention, memory flares up, there are flashes of punctuation, and language and image are given new form and content.

Books

badBehavior (Rizzoli, 2000)
Bill Hayward (Paglia Press, 1989)
Cat People (Doubleday and Company, Inc., 1978)

Selected Exhibitions and Performances

"Bill Hayward's 'the human bible'" at Martin Art Gallery, Muhlenberg College, Allentown, Pennsylvania, 2014.

"Mother's Kitchen" at The Art Live Fair, The Intimacies Project, Miami, Florida, 2012.

"The Intimacies Project" at The Wynwood Art Fair, Miami, Florida, 2011.

"Concerning the Essentials of Existence" at Tribeca Grand Hotel, The Intimacies Project, New York, New York, 2011.

BENT at W Magazine Fashion Films, New York, New York, 2010-2011.

"The Intimacies Project" at the Center for Performance Research, Brooklyn, New York, 2010.

Hatch Presenting Project at The Intimacies Project, New York, New York, 2010.

"My Mother's Kitchen" at MAA Film Festival, Marbletown, New York, 2009.

"The Intimacies Project" at 41st and 8th, New York, New York, 2009.

"The Roethke Humanities and Performance Art Festival" at Williams Center for the Arts, Lafayette College, Easton, Pennsylvania, 2004.

"Bill Hayward's The American Memory Project" at Skillman Gallery, Lafayette College, Easton Pennsylvania, 2002.

"Gale Gates badBehavior with Bill Hayward" at The Roger Smith Gallery, New York, New York, 2001.

"Bill Hayward" at Gallery Bershad , Somerville, Massachusetts, 2000.

"The Quality of Objects: the American Way of Memory" at Monique Goldstrom Gallery, New York, New York, 1999.

"The Quality of Objects" at Galerie Markus Richter, Potsdam, Germany, 1998.

"Looking Backwards Forwards" Galerie Markus Richter, Potsdam, Germany, 1998.

Frankfurt Art Fair, Galerie Markus Richter (Potsdam), Frankfurt, Germany, 1995, 1998.

"The Dark Chamber: Photography + Body" at Galerie Markus Richter, Potsdam, Germany, 1997.

"Beauty Is No Show" at Fischhaus, Postdam, Germany, 1997.

"Decaying Humanity" at Knickerbocker Gallery, New York, New York, 1996.

"Bill Hayward" at Galerie Pons, Paris, France, 1996.

"Let's Play House" at Wustum Museum of Fine Arts, Racine, Wisconsin, 1995.

"badBehavior" at Foster Goldstrom Gallery, New York, New York, 1994.

"The World's Most Memorable Poster" at UNESCO, Paris, France, 1994.

"Bill Hayward" at The Gallery at Studio 27, Boston, Massachusetts, 1992.

"Bill Hayward" at Zero One Gallery, Los Angeles, California, 1991.

"Bill Hayward – Portraits" at Books and Co., New York, New York, 1980 and 1989.

"Bill Hayward" at the Maine Photographic Workshops Gallery, Rockport, Maine, 1983, 1984, 1985, 1986, 1987, 1989.

"Portraits — Bill Hayward" at Ted Greenwald Gallery, New York, New York, December 1986 – January 1987.

"Arense" at Photography Gallery, Drew University, Madison, New Jersey, 1985.

"Dances Moves/Irene Feigenheimer and Co." and "Trio with Bill" at Riverside Dance Festival, New York, New York, 1985.

"Lucille," 80 Washington Square East Galleries, New York, New York, 1985.

"Cat People" at The Reinhold Brown Gallery, New York, New York, 1979.

"Bill Hayward – Grand Central" at New York Municipal Arts Society Gallery, New York, New York, 1979.

"Bill Hayward" at The Gallery, Green Mountain College, Poultney, Vermont, 1973–1974.

"Bill Hayward" at The Fine Arts Gallery, Castleton State College, Castleton, Vermont, 1972–1973.

"Sprint for the Finish" at The Atlanta Film Festival, Atlanta, Georgia, 1972.

Selected Publications

AVENUE magazine
February 1986; pp. 111–112
June, July, August 1984; cover, pp. 116–117
May 1984; pp. 122–123
April 1984; pp. 110–116
March 1984; pp. 114–115
February 1984; pp. 106–107
June, July, August 1983; pp. 108–109
April 1983; pp. 84–87
December, January 1983; pp. 166–167
June, July, August 1982; pp. 44–45
May 1982; pp. 46–49
April 1982; pp. 38–40
March 1982; pp. 44–45
February 1982; pp. 4, 30–31
January 1982; pp. 70–71
September 1981; pp. 56–58
March 1981; pp. 38–39, 40–41

Ballet News
November 1985; Laura Dean; p. 7
February 1984; John Curry; cover, pp. 13–15
September 1983; Agnes de Mille; cover, p. 83
May 1982; Alexandra Danilova; cover
March 1982; Igor Youskevitch; pp. 16–17
June 1981; p. 20
April 1981; Baryshnikov; cover
March 1981; Nureyev; cover
November 1980; Aaron Copeland; cover, pp. 8–9

Fortune
September 15, 1986; cover portrait of President Reagan
February 20, 1984; Rupert Murdoch

GQ
March 1983; pp. 186–187
March 1982; p. 201
May 1979; p. 177
Winter 1978; pp. 196–199

INTERVIEW
October/November 2009; 40th Anniversary Issue; p. 183
June 1987; p. 78.
January 1987; pp. 66–68, 89
December 1986; p. 70
March 1986; p. 55
February 1986; pp. 56–57
August 1985; pp. 78–80, 82-84
April 1985; pp. 106, 113, 114, 201

New York Times Magazine
January 30, 1983; "The Well-Tempered Tenor" by Placido Domingo; pp. 28–29

Opera News
February 1988; Hildegard Behrens; cover, pp. 26, 29
September 1987; Placid Domingo; cover, pp. 14–17
January 1987; Renata Scotto; pp. 10–12
March 1986; Pavarotti; cover, p. 11
June 1983; Robert Stewart; cover, pp. 8–9
December 1982; Joan Sutherland and Richard Bonynge; cover, pp. 8–9
March 1982; Placido Domingo; cover
January 1982; Leontyne Price; cover
November 1981; Richard Thomas; pp. 28–29
April 1981; Robert Penn Warren; cover

Psychology Tomorrow Magazine
"Portraits of the collaborative-self" in Issues 1–15, 2012-2015

Seventeen magazine
(a monthly column of *portraits of the collaborative-self*)
April 2007; 17 *Mission*, pp. 128–129
March 2007; 17 *Mission*, pp. 164–165
February 2007; 17 *Mission*, pp. 80–81
January 2007; 17 *Mission*; pp. 98–99
December 2006; 17 *Mission*, pp. 144–145
October 2006; 17 *Mission*; p. 136
September 2006; 17 *Mission*; pp. 214–215

Bust Magazine "Let Loose This Thursday at Alternative to NYC Fashion Week" by Emily Robinson, September 3, 2014.

HTML Giant "NOON Annual 2012: Blunt Reality as Source" by Ethel Rohan, March 2012.

DC's "Maximum Etc. presents...Bill Hayward Day" by Justin Taylor, May 30, 2009.

artcritical "Nice Photos of Naughty Bohemians" by David Cohen, February 23, 2001.

ASPP, Book Review *badBehavior* by Bill Hayward by Timothy S. McDarrah; "Bill Hayward's work is portraiture for the new century," 2001.

BOMB Magazine "Art on the page: Bill Hayward," Fall 1997, pp. 64–66.

Flash Art "The Dark Chamber: Photography + Body," pp. 77 October 1997.

COVER "Writing with A Lens" by Bonny Finberg, p. 17, November 1994.

International Photography "Bill Hayward USA," Number 1, pp. 29–30, 1991.

NOON
"Photographs – Bill Hayward," pp. 106–7, 2012.
"Photographs – Bill Hayward," pp. 79–101, 2011
"Photographs – Bill Hayward," pp. 45–61, 2009.
"Photographs – Bill Hayward," pp. 73–89, 2008.
"Photographs – Bill Hayward," pp. 25–43, 2007.
"Photographs – Bill Hayward," pp. 21–39, 2006.
"Photographs – Bill Hayward," pp. 95–113, 2004.
"Photographs – Bill Hayward," pp. 88–99, 2003.
"Photographs – Bill Hayward," pp. 37–49, 2002.
"Photographs – Bill Hayward," pp. 39–51, 2001.

Numéro Cinq
"Swarming Sensation/Fracturing the Fascism of the Frame - Bill Hayward's manifesto" by Douglas Glover, 2013.
"Bill Hayward's Postcards from the Museum of Emotions" by Douglas Glover, 2013.
"Gordon Lish: Photographs — Bill Hayward" by Douglas Glover, 2013.
"*Asphalt, Muscle and Bone* — a film by Bill Hayward/Online scenes and script snippets" by Douglas Glover, 2013.
"'Postcards from 'The Museum of Emotions' from Bill Hayward's film *Asphalt, Muscle and Bone* featured in *The Coffin Factory*, Issue 4" by Douglas Glover, 2013.
"*the human bible* — Bill Hayward @ *Psychology Tomorrow Magazine*" by Douglas Glover, 2013.

Psychology Tomorrow Magazine
"Night Blood (Some adjustments midst life and death)" by Bill Hayward, Issue 12, May 2014
"*the human bible*" by Bill Hayward, Issue 1, July 2012.

Santa Fe-El Norte, "Making Memories" by Michelle Pent Glave, September 1, 2002.

Ruminator Review "What Drives Creativity" by Margaret Todd Maitland, p.29, Spring 2001.

Soho Style Magazine "Bad to the Bone" by Jacqueline Micucci, 2001.

STOP "Bill Hayward" by Carter Ratcliff, Vol. 3, 1990, p. 17, p. 29.

"Rackety Opinion" catalog, by Carter Ratcliff, New York, 1987

"Arense" exhibition catalog, by Carter Ratcliff, 1985

A Human Treasure, by Stanley Siegel

The Baltimore Sun
"Patriot Frames" by Bobb Hiaasen, July 4, 2007.
"Portraits of patriotic memory" by Bob Hiaasen, April 27, 2006.
"Capturing present-day patriotism" by Anica Butler,
 April 27, 2006.

The Best American Poetry
"Bill Hayward's 'the human bible' exhibit at the Martin Art
 Gallery, Muhlenberg College" by Stacey Harwood,
 October 14, 2013.
"No Paris In Disneyland: Dwelling in Possibility with Bill
 Hayward" by Alissa Fleck, February 2, 2013.
"This Just In...Bill Hayward in *Psychology Tomorrow Magazine*"
 by Stacey Harwood, July 24, 2012.
"Bill Hayward Owns Thursday Night in NYC,"
 September 7, 2011.
"Dwelling in Possibility with Bill Hayward at Apple/Soho"
 by Justin Taylor, August 17, 2011.
"One Night Only! Bill Hayward at the Apple Store, Soho —
 Meet the Artist," August 8, 2011.
"I knew a guy once..." The Bill Hayward/Marinov Dance/
 Reddress Films "The Intimacies Project" by Stacey Harwood,
 January 18, 2011.
"This Just In...Live Blogging from Bill Hayward's Intimacy
 Project" by Stacey Harwood, October 24, 2009.
"Bill Hayward's American Memory Project: Jason Shinder on
 Howl" by Stacey Harwood, May 28, 2009.
"Intimacies 2 — Vulnerability" by Stacey Harwood,
 April 6, 2009.
"Film Still Series" 2009, Nos. 4, 5, 6, 7, 8, 120, 124, 125, 127,
 130, 137.
"Letter to Harwood and Lehman from Livingston"
 by Bill Hayward, I-V, 2008.
"Another Side of Bob Dylan," July 19, 2008.
"About Bill Hayward" by Stacey Harwood, May 2, 2008.
"Ashbery on the Roof, 1981," April 14, 2008.
"Film Still Series" 2008, Nos. 1, 3, 14, 25, 27, 35, 42, 46, 53, 56,
 58, 72, 85, 87, 92, 94, 97.

The Boston Globe, "And now a word from the subject"
by Michael Kenney, June 30, 2002.

The Coffin Factory
Photographs from Bill Hayward's film '*Asphalt, Muscle and
Bone*,' Issue 5, 2013,
 inside front cover, pp. 18, 21, 23, 24, 26, 27.
"The Museum of Emotions" by Bill Hayward, Issue 4,
 front cover, pp.34-36, 38-40, and back cover, 2012.
"Notes on the Inconsolable" by Justin Taylor and Bill Hayward,
 Issue 3, 2012 pp. 54-57.

The Morning Call, "Encounters in black and white" by Geoff
Gehman, October 20, 2002.

The New York Times, "An Invitation to Pose for Your Supper"
by Andrey Slivka, January 19, 2003.

The Philadelphia Inquirer, "Making American Memories in the
Shadows of History" by Tom Gralish, October 31, 2002.

Vanity Fair ,"Model Behavior — The Irrational Exuberance of
Bill Hayward," by Richard Merkin, p. 296, September 2000.

Index

232

#
17 Bedrooms, 180–87

A
Abby, 162
Acts and Expressions, 58–71
Alek, 174
American Memory Project, The, 226
Area #8, 51
Area #12, 57
Area #21, 56
Area #26, 57
Area #35, 56
Area #37, 56
Area #53, 57
Area #56, 54
Arvell, 162
Asphalt, Muscle and Bone (film), 194–211, 226
Avalon, 164

B
Bacon, Francis, 48
Balaban, Bob, 163
Balanchine, George, 48
Baldinger, Joanne, 181–87
Barzilay, Sam, 5
Basaran, Korhan, 174
Bat Girl, 52
Bausch, Pina, 48, 188
Beauty Is No Show, 227
BEC, 165
Bennett, Brooke, 166
BENT, 192–93, 226
Berle, Milton, 46
Berra, Yogi, 37
Bickerstaff, Brian, 172
Billy, 191
Billy Boy, 45

Blondes, the, 166
Bosche, Freddy, 177
Brenner, David, 40
Brent, 49
Breuer, Marco, 5
Brewer, Jeff, 174
Broken Odalisque, 132–39

C
Campanelli, Lt. Pete, 162
Campbell-Holt, Adrienne, 172
Caroline, 177
Carrasco, Salvador, 166–67
Carroll, Wade, 173
Certain Dances, 106–15
Charny, Sam, 174
Christina, 57
Cixous, Hélène, 48
Coffey, Wallace, 190
Cohen, David
 Art Critical, 215
Cohen, Roy, 41
Consider the Flesh, 140–49
Couvillion, Collin, 170
Cruz, Angie, 176

D
Dafoe, Willem, 161
d'Amboise, Christopher, 41
Dance and Performance, 188–89
Delgado, Damián, 166–67
Delgado, Edgar, 179
Dickinson, Emily, 12, 27, 48, 150
Dismantled Myth, 116–31
Domingo, Plácido, 41
Duval, Robert, 210–11
Duval, Susan, 172
Dylan, Bob, 38–39

E

Eva, 167
Eve, 173

F

Fellini, Federico
 La Strada, 9
Field, Edward, 171
Flack, Sofie, 166
Franken, Thomasin, 162
Freedom, 163
Fritz, 224
Frost, Robert, 48
Fugitive Beauty A, 221
Furman, Karen, 192–93

G

Gallagher, Dorothy, 212
Gardella, Tyler, 174
Gesture and Invention, 72–83
Gillespie, Dizzy, 43
Golub, Leon, 163
Grendel Suite, The, 227
Grounded Aerial, 192–93

H

Howe, Marie, 214
human bible, the, 150–59, 226
Hundred Words, A, 92–105

I

Intimacies Project, The, 190–91, 227

J

Jim, 53
Jones, Mike, 172
Jordan, 191
Julia, 53

K

Kingsley, Ben, 35
Kirn, Walter, 175
Kistler, Darci, 40

L

LaFosse, Robert, 36, 176
Lecesne, James, 215
Lish, Gordon, 6
Lispector, Clarice, 48
 A Breath of Life, 34, 160
Lucille, 92–105, 167
Lynch, David, 47

M

Marinov Dance, 190–91
Mendieta, Ana, 28
Merkin, Richard, 44–45
Millay, Edna St. Vincent
 Renascence, 34
Moran, Kate, 172, 177
Mosley, Bret, 166
Murray, David, 40
My Mother's Kitchen, 226
My New York, 226

N

New York City Ballet, 188
Nichols, Kyra, 188, 189, 215
Niles, Susan, 177
Nureyev, Rudolf, 46

O

O'Connor, Flannery, 48
 A Prayer Journal, 34
One-of-a-kind books, 218–19
Only in Bed, 226
Oz, 173

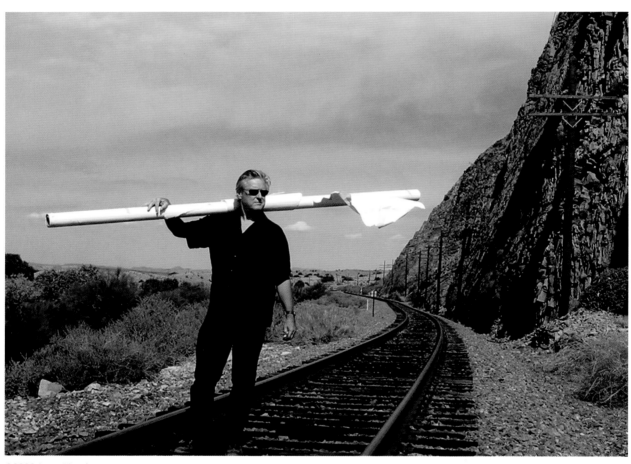

P

Pavarotti, Luciano, 42
Petronio, Stephen, 176
Phillips, Angela, 173
Portrait Process, 160–68

R

Rackety Opinion, 50–57
Ratcliff, Carter, 214
 "Arense" exhibition, 223
 "Rackety Opinion" catalog, 222
Reagan, Ronald, 42
Reginald, 56
Rich, Adrienne
"From An Old House In America," 194
Rodriguez, Anita, 163
Rollins, Sonny, 36
Roy, Melinda, 32
Rubenstein, Atoosa, 214
Ruefle, Mary
 Madness, Rack, and Honey, 10, 220
Rutkowski, Shane, 167

S

Saland, Stephanie, 37
Schiller, J. C. Friedrich von
 Letters Upon the Aesthetic Education of Man, 150
Sculpture Installation with Gil, 226
Shifra, 32
Shouts and Songs, 84–91, 213
Siegel, Stanley, 222
 A Human Treasure, 225
Skyler, Tristine, 169
Soyza, Veronica de, 173
Stanton, Harry Dean, 40

T

Tangle Dragon, 30–31
Taylor, Justin, 167
Thing Itself, the, 168–79
Tiwary, Vivek, 176

V

Villella, Edward, 41

W

Wade, Phil, 8
Walter, Allison, 174
Wardwell, Deborah, 55
Wilhelmina, 167
Winkfield, Trevor, 178
Woolf, Virginia, 48
 A Sketch of the Past, 168
 The Waves, 7, 9, 11, 29

Z

Zoe, 92–105

Credits

p. 6; Gordon Lish, from the introduction to *Bill Hayward* (Paglia Press 1989).

p. 7; Virginia Woolf, from p. 118 of *The Waves*

p. 10; "Short Lecture on Shakespeare" from *Madness, Rack, and Honey: Collected Lectures.* Copyright 2012 by Mary Ruefle. Reprinted with permission from the author and Wave Books.

p. 11; Virginia Woolf, from p. 127 of *The Waves*

p. 28; Ana Mendieta,"Pain of Cuba, body I am"

p. 29; Virginia Woolf, from p. 278 of *The Waves*

p. 34; From *A Prayer Journal* by Flannery O'Connor. Copyright © 2013 by the Mary Flannery O'Connor Charitable Trust. Reprinted by permission of Farrar, Straus and Giroux, LLC.

p. 34; From *A Breath of Life* by Clarice Lispector. Copyright ©1987 by the Heirs of Clarice Lispector. Translation copyright ©2012 by Johnny Lorenz. Preface copyright ©2012 by Pedro Almodovar and Benjamin Moser. Reprinted with permission of New Directions Publishing Corp.

p. 48; From *Interviews with Francis Bacon* by David Sylvester. Copyright ©1975,1980, and 1987 David Sylvester. Reprinted by kind permission of Thames & Hudson Ltd., London.

p. 174; Virginia Woolf, from p. 72 of *Moments of Being*, "A Sketch of the Past" second edition

p. 194; From *Pina Bausch: Dance Theatre.* Copyright ©2008 by Norbert Servos. Reprinted with permission from K. Kieser. Originally published in German language under the title *Pina Bausch Tanztheater* (Munich 2008).

p. 200; Adrienne Rich "From an Old House in America"

p. 221; Hélène Cixous, *Stigmata*

p. 226; Excerpt from "Kangaroo Beach" from *Madness, Rack, and Honey.* Copyright ©2012 by Mary Ruefle. Reprinted with permission from the author and Wave Books.

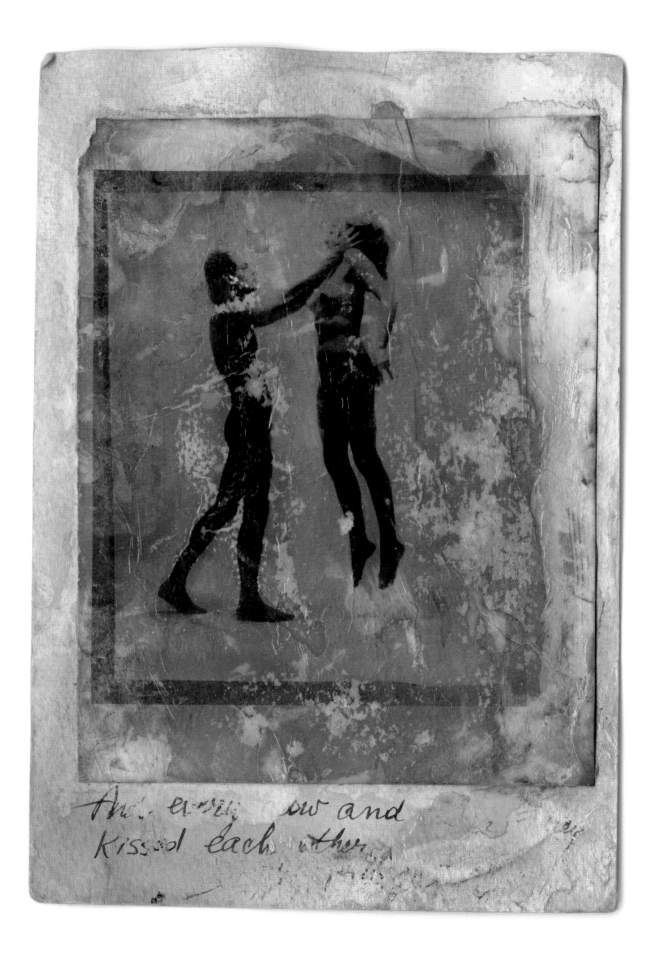

And even now and
kissed each other.

238 ACKNOWLEDGMENTS

In no particular order, which is the way in which life does present itself...

The John A. Ungar Foundation, Debbie Forsythe and Tom Gould, the Selz Foundation, the Ted Snowdon Foundation, the Berkshire Taconic Foundation, Anita Pagliaro, Brian and the crew at Foto Care, Annie Ungar, the Native American Rights Fund, the National Park Service, the Golden Gate National Parks Conservancy, Jerry Wade and the New Harmony Artists' Guild, Mara and Baron Silverstein, Lafayette College, Dynalite Corporation, Howda Designz, Kodak, the Flash Clinic, the Sea View Inn, Polaroid, Chelsea Black and White Lab, Anna Elman, Sam Charny, Fractured Atlas, Marty Blatt, Melinda Fine, Marie Rust, Maggie Perry, Cathy Barner, Terry Diamond, Linda Earle, Arwen Lowbridge, Kay Hayward, Nave, Michiko Okaya, Janice Fudyma, Anna Lee, Angela Ai, Craig Bernhardt, Alex Hoyt, Mark Von Ulrich, Wolfgang Neumann, Gay Vietzke, Jill Brienza, Diane Shaw, Carter Ratcliff, Craig Stevens, Ellen Tien, John Pochna, Walter Parks, Hallie Bulleit, Ruvane Schwartz, Ken Resen, Patience Moore, Kristin Mainhart, Allison Dennis, Anne Marie Gagnon, Marilyn Tain, Leslie Novak, Victoria Redel, Dawn Raffel, Sonya Del Peral, Atoosa Rubenstein, Brady Rymer, Collin Couvillion, Bill Campbell, Shane Rutkowski, Lindsay Gonzalez, Eva Marie Santiago, Kathy Burke, T. Ulku Tekten, Dr. Eugene Bulkin, Dr. Peter Halperin, Jody Shelton, Karen Furman, Audrey Stanley, Sarah Fink, Billy Boy, Tyler Gardella, Alison Walter, Korhan Basaran and "KB and The Artists," Jordan Marinov and "Marinov Dance," Zoë Tamerlis Lund, Lucille, Galerie Markus Richter, Galerie Jean-Luc, Billy Blanken, Claire Donato, Jeff Johnson, Arense, Ellen Rose, Joe Polillo, Karl Hartig, Aaron Verdery, Noortje Bijvoets, Michael Clinton, Claire Holt, Julia De Peyer, Laura Dean, Gregory Downer, Lisa Grunwald, Ted Greenwald, Jan Groth, Felicia Nestor, Jeanne Liotta, Phyllis Levy, Robert Meyer, Fabian Molina, *Interview* magazine, Joanne King, Robert Brown, Susan Reinhold, Phil Werber, Irene Feigenheimer and "Dance Moves," J.C. Suares, Michael Shnayerson, Ely Turrietta, Sander and Judith Witlin, David Cohen, David Selig, Roger Miller, Gaye Sandler, NACE, Lindy Hess, Timothy Manfred Hettich, Julie Stahl, Ignacio Rodriguez, Jonah Redel-Traub, Gabe Redel-Traub, Angela Valle, David Lehman and Stacey Harwood and "The Best American Poetry," Diane Williams and NOON, Gordon Lish, Jason Riker, Ginger Riker, Bianca Hirsch, Mike Levins, Harry Heleotis, Jason Novak, Justin Taylor, Wendy Beckman,

Tim Titsworth, Laura Isaacman and Randy Rosenthal at *The Coffin Factory* magazine and *Tweed's* magazine, Doug Glover and *Numéro Cinq*, Stanley Siegel and *Psychology Tomorrow* magazine, Housing Works and Amanda Bullock, Apple, chashama, Almond Restaurant, DaVinci Artists Supply, Fuji Film, Trec Rental, Times Square Alliance, Michael Miller Fabrics, Sharp, FXDD, Kelly Calabrese, The Puffin Foundation, Dawn Raffel.

Pamela Von Ulrich for her prodigious and affirming excavation of a lengthy history of negatives. Pamela created the most exacting scans of a vast number of the images included in this book.

Most certainly, the exceptional Marta Hallett, designer Sarah Morgan Karp, and the entire, incredible, outrageously talented Glitterati troupe, who have brought such a gorgeous understanding of and respect for image, text, and heart to the staging of this book. Ellen Brown, Gayatri Mullapudi, Kiara Cobb, Jessica Guerrero, Sara Rosen: you guys are so damn good!

Most recently, the staff and management of The Fat River Hotel and the staff and directors of The Museum of Emotions.

And, most absolutely, a continuing and resounding chorus of acknowledgment to Janet, Jessie, and Chuck for the crucial introduction to fire ants, dragons and all the agents of enchantment!

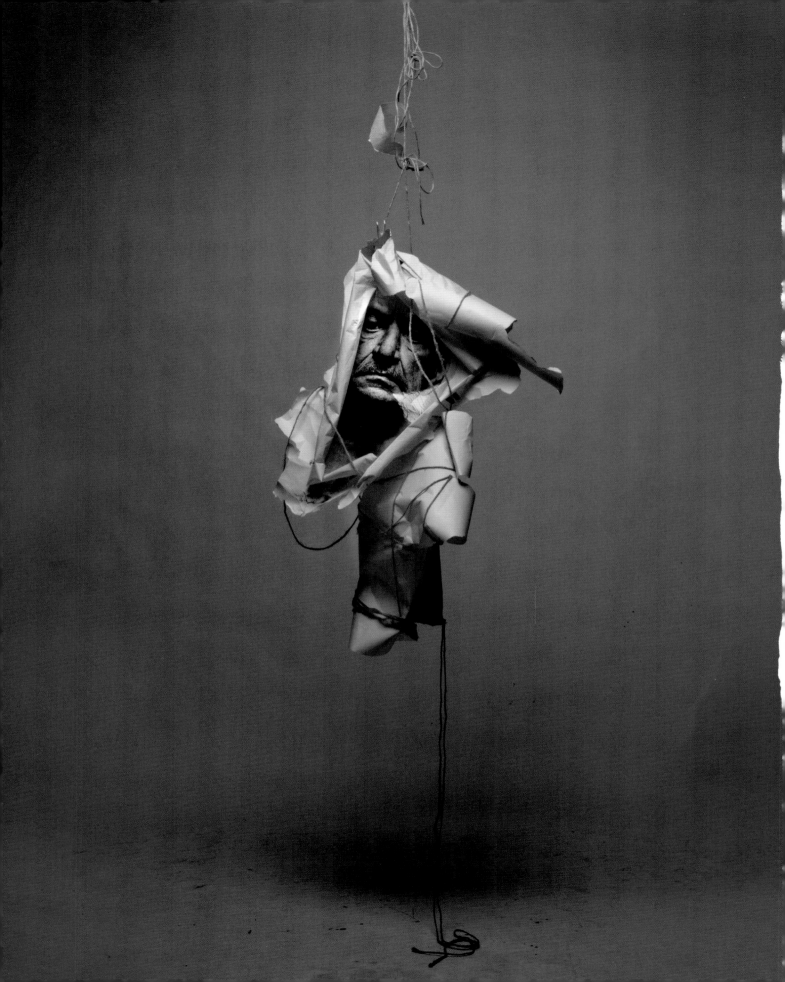